Merry Christmas
2006

Love,
Sheila Simpson

WYOMING
WILD and BEAUTIFUL II

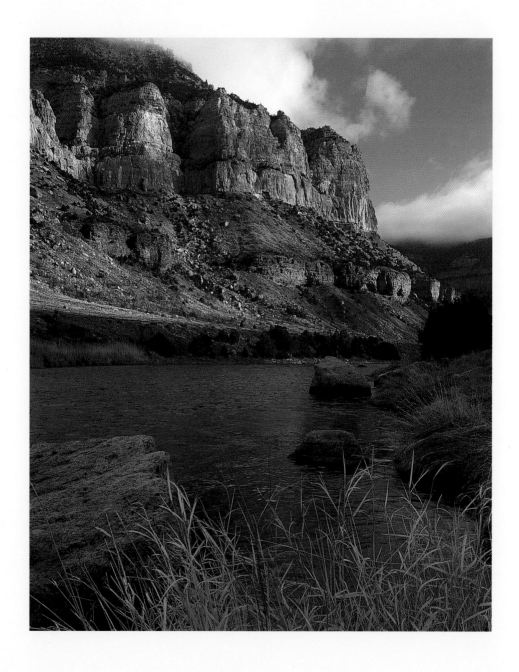

Photography by FRED PFLUGHOFT

FARCOUNTRY
PRESS

FRONT COVER: Spectacular Cirque of the Towers rises above Jackass Pass in the Wind River Mountains. The numerous precipitous spires in this relatively small cirque offer a multitude of exceptional climbing routes.

FRONT FLAP: Bull elk in the fall rut. JOHN L. HINDERMAN

BACK COVER: The snowy summits of the Gros Ventre Range gaze down upon the Bridger-Teton National Forest. The timbered slopes of this range provide good habitat for elk, deer, bears, and mountain sheep.

TITLE PAGE: The Wind River carves its way through the Owl Creek Mountains, forming sensational Wind River Canyon. Exposed sections of sedimentary rocks make this a geologist's paradise.

RIGHT: Fremont Lake has twenty-two miles of shore-line and is more than six hundred feet deep in places. It is named after John C. Fremont, a young army lieu-tenant who in 1842 led a group of explorers into the Rocky Mountains to map portions of the West. These mapmakers didn't realize that years before their expedi-tion, the lake had been christened Stewart's Lake in honor of Captain William Drummond Stewart of Scotland. He and Jim Bridger camped on its shores many times from 1833 to 1844.

ISBN 1-56037-246-X
Photographs © 2003 Fred Pflughoft
© 2003 Farcountry Press

For more information on our books write: Farcountry Press, P.O. Box 5630, Helena, MT 59604 or call: (800) 821-3874 or visit our website: www.montanamagazine.com

Created, produced, and designed in the United States. Printed in China.

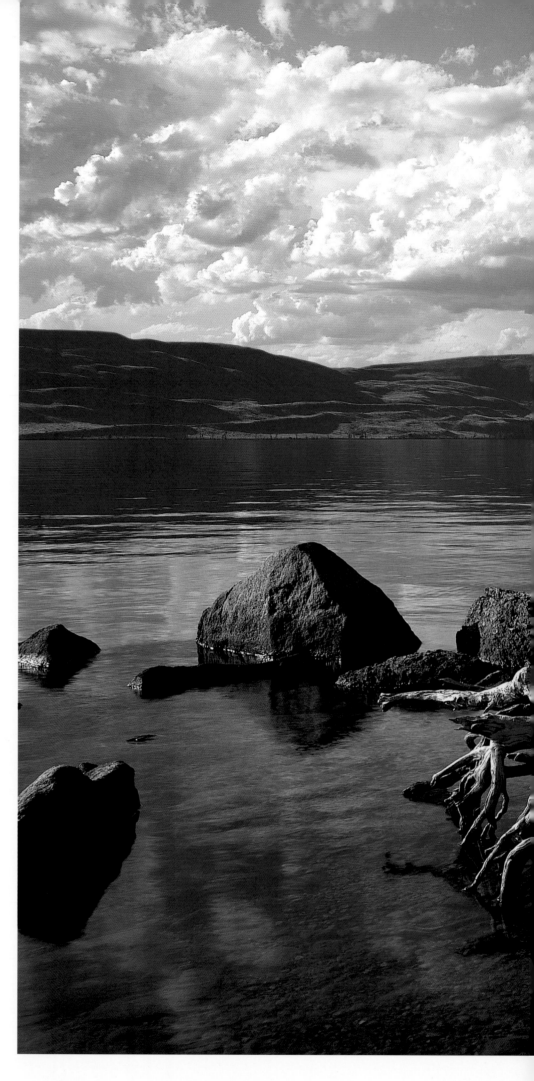

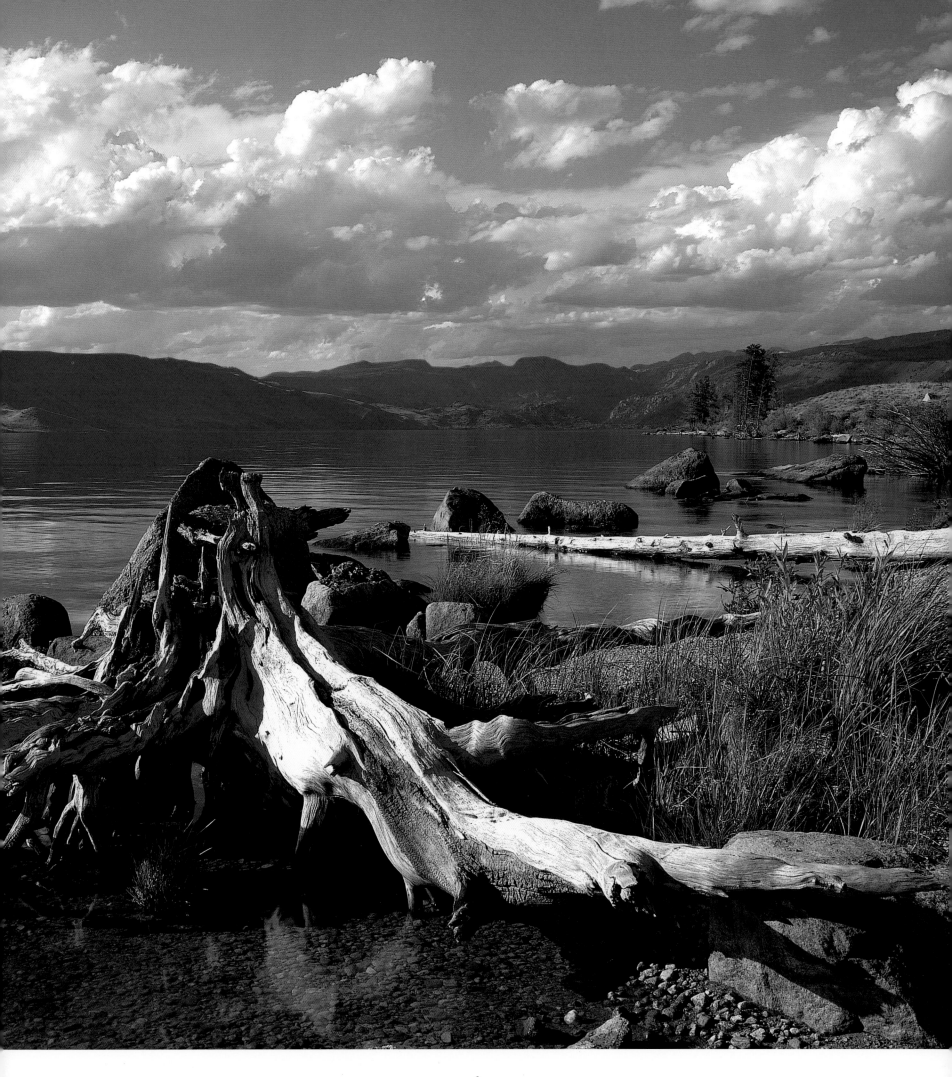

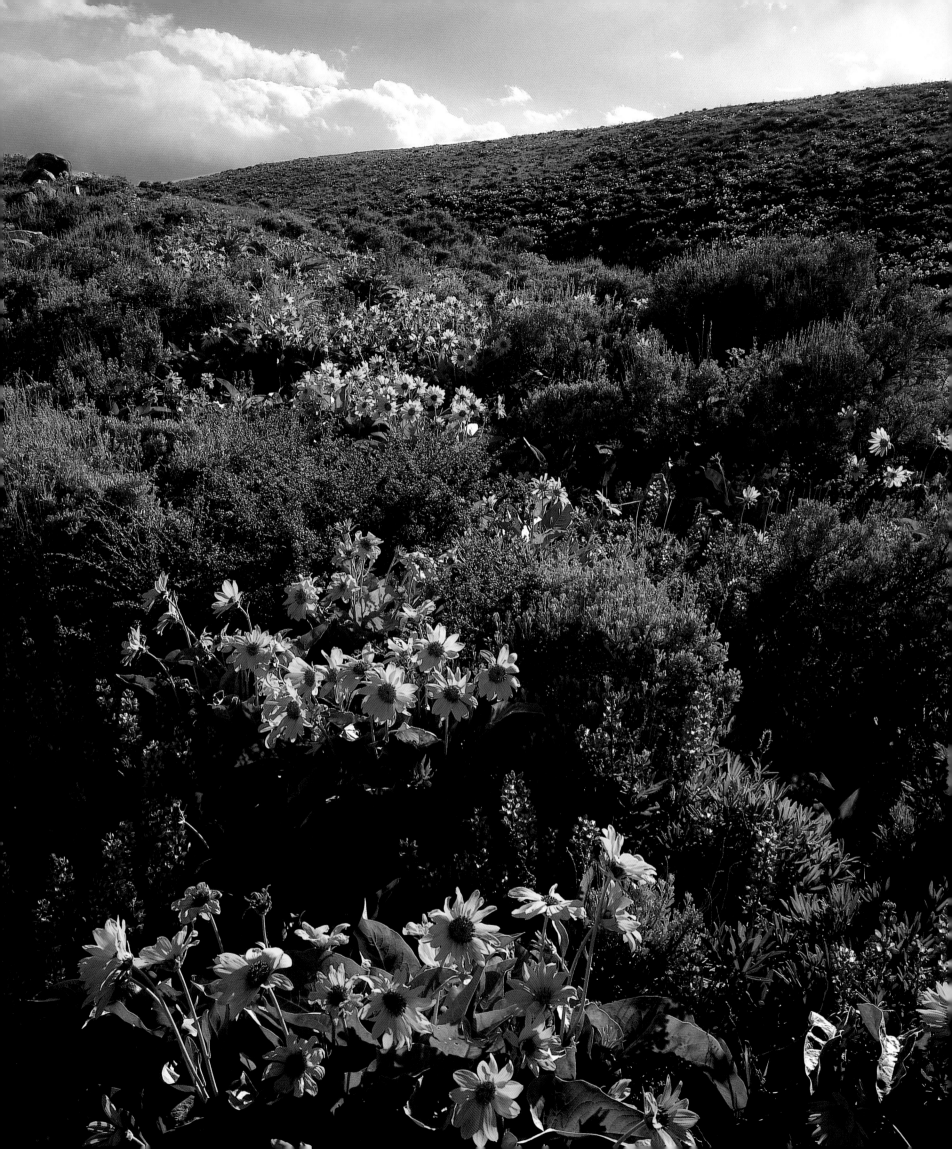

FOREWORD

BY FRED PFLUGHOFT

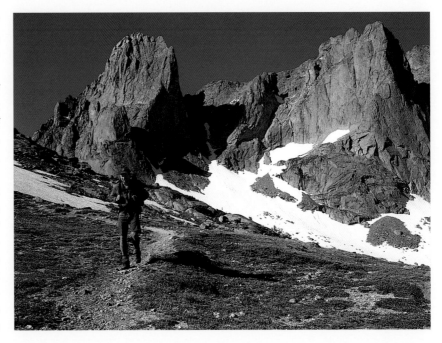

As I wrote in my first pictorial essay, *Wyoming Wild and Beautiful*, this state has such diversity that it "offers a surprise around every bend in the road or trail." I was hoping that held true as I started my journey to re-photograph this wondrous place for the collection of images that is before you. I soon discovered that I couldn't even begin to come close to tapping out the abundance of physical beauty available to put on film. Even after I'd done six photo books on Wyoming and its parks, there was still a plethora of incredible sights to capture with my cameras.

As in all my photographic undertakings I had to do a great deal of planning to make this book happen. I spent hours pouring over maps of the state, travel brochures, and other photo books to find new and interesting places to photograph. With those places written down I then began to plan my itinerary. I had to be at each of those places in the right season, at the right time of day, and hopefully with the perfect light. It is that perfect light that makes everything come together for that "eye-popping" image. What I have found to be true in Wyoming is that perfect light comes frequently, thanks to the right atmospheric conditions, and many times all you have to do is be at the spot you wanted to photograph in the right season and time of day.

So with map in hand I set off across this great state in search of the perfect images. Along the way I discovered a few things about myself. I found out I'm amazingly quick when being struck at by a surprised rattlesnake. I found out I can be so focused on getting an image that I can lock my keys in my car, almost in the middle of nowhere. I want to thank again the gentleman who came along with just the right tools before I had to break a window to get in. When I trekked the route again to capture some of the images for this book, I discovered that a backpacking trip I did twenty years ago with my young bride was a large undertaking for us two greenhorns. I found out that the top of high mountains is where I feel most at home, and I came to the conclusion that no matter where I go to take photographs, the trip is more enjoyable when someone who enjoys getting out into the wilds as much as I do comes along.

This book wouldn't have been possible without the special help of some very special people. First and foremost I want to thank Merle Guy for his confidence in my abilities and for letting me do all the books that I have. Much thanks is due my good friend Christine Barnes, whose book, *Central Oregon—A View from the Middle*, brought my photographic skills to the attention of Farcountry Press. Next I want to thank Lisa Mee, who designed both of my *Wyoming Wild and Beautiful* books. We almost always see eye-to-eye, and her creative genius is evident in the layout of this volume. I want also to thank Rex and Linda Poulson for allowing me to take so much time off from my "real" job to pursue my creative passion. They have been a blessing to me, and someday when I'm famous they can say they helped make it happen. It goes without saying that I owe a big, hardy thanks to all my close friends and dearest relatives who have constantly encouraged me as I pursue my dream. Finally, none of this would have come to pass without my loving family's support. To my wife, Sue, and sons, Drew and Kit: you're the greatest and I thank you for being so patient waiting those many hours while I chased the perfect image.

As you let your hand guide you through the pages in this book, remember that each of these images has a story to tell. These stories involve determination, diligence, encouragement, faith, friendship, God-given artistic ability, hard work, perseverance, physical endeavor, planning, and a passion for all things wild and beautiful. This is the essence of my photography and what allows me to cherish each of these images. Through this book, I share these stories with you.

You are part of my dream. Without your passion for things wild and beautiful, books like this would not be published. I hope you enjoy *Wyoming, Wild and Beautiful II*, and I hope you will discover some new Wyoming treasures via these pages.

Happy Trails from the Cowboy State.

ABOVE: This is an image of me as I make my way down the Jackass Pass Trail to Lonesome Lake in the Popo Agie Wilderness of the Wind River Mountains. I framed Warbonnet Peak and Warrior I in my viewfinder and then had a friend fire off a few frames as I hiked toward him.

FACING PAGE: Spring ushers in a grand bouquet of balsamroot and lupine in the eastern foothills of the Wind River Mountains.

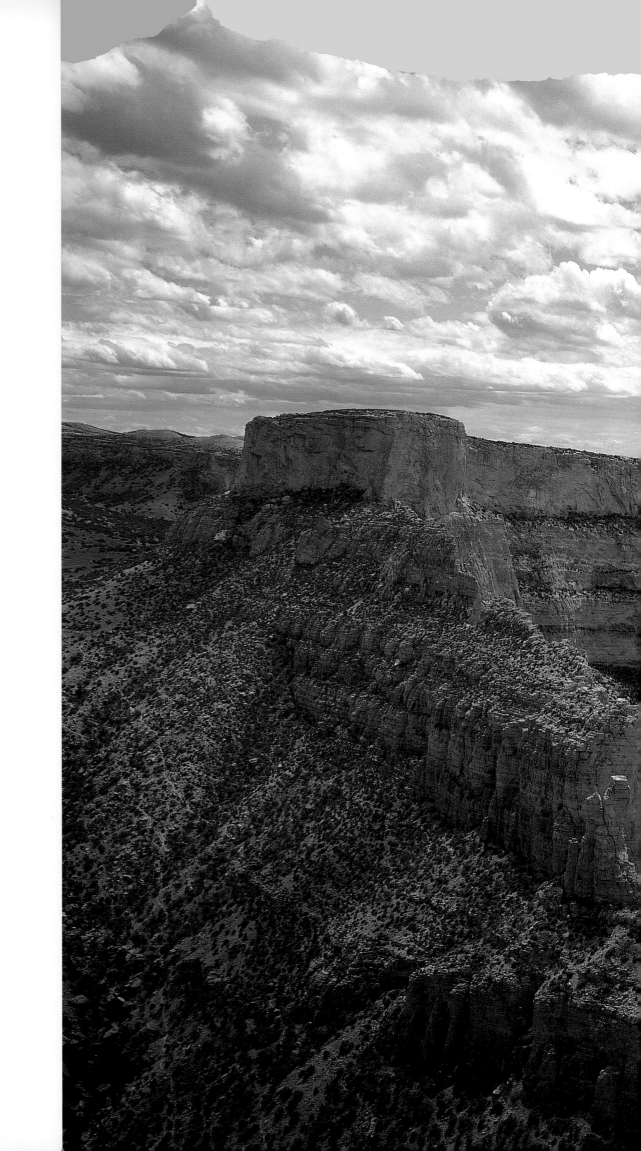

A window in time frames the Bighorn
River as it courses through Bighorn
Canyon National Recreation Area.
Taken from Devil Canyon Overlook
in Montana, this view looks south
into Wyoming.

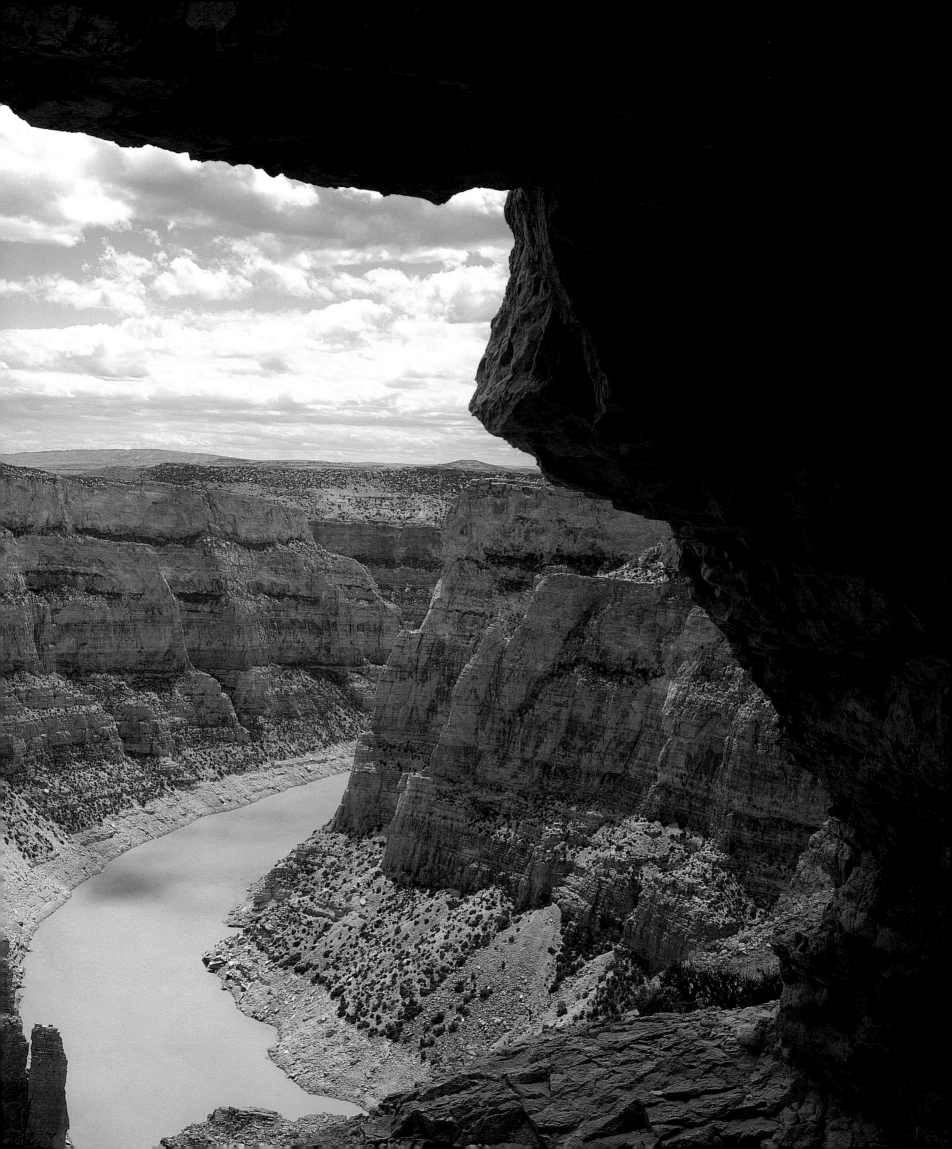

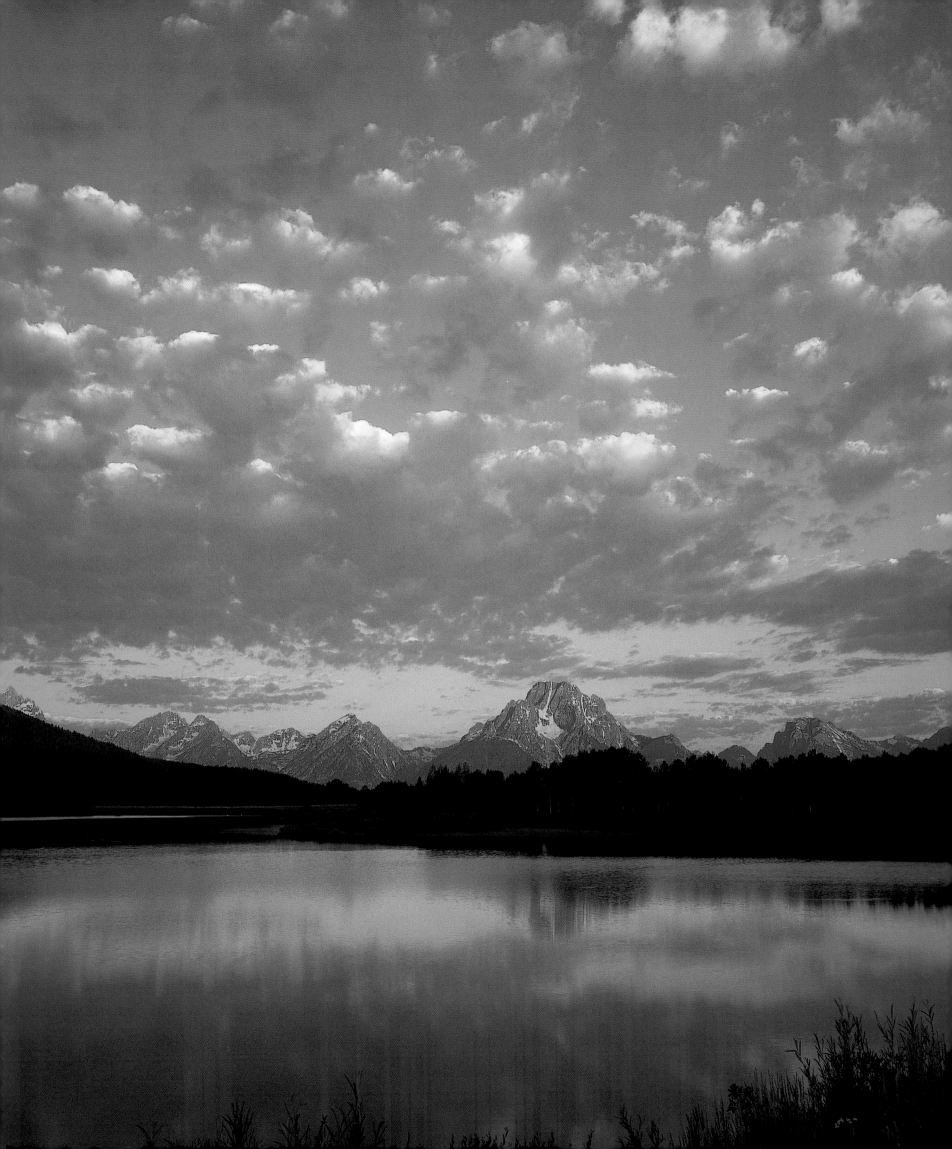

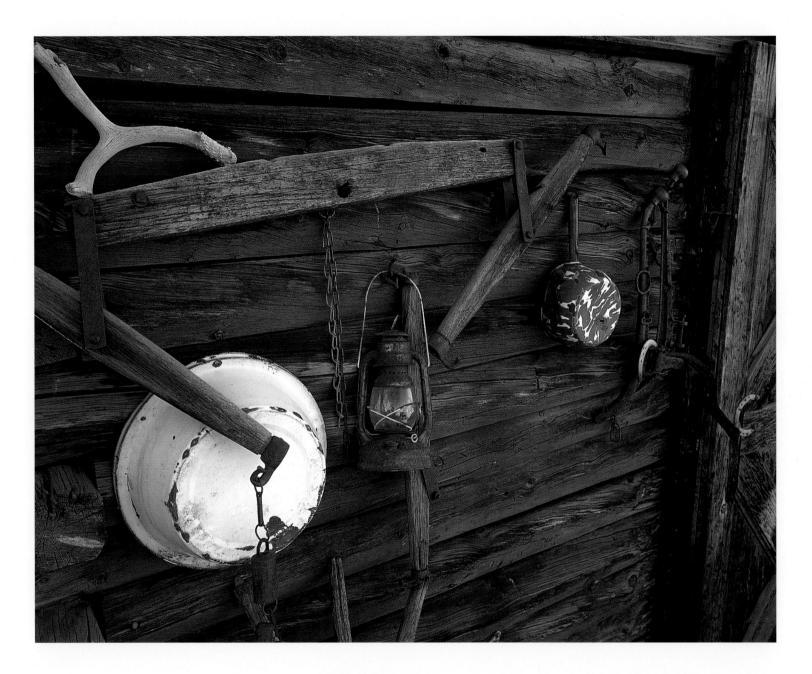

ABOVE: Check out the new decor at an old tack repair shop at Boulder Lake Lodge.

FACING PAGE: Clouds drift into place for the perfect picture of Mount Moran from Oxbow Bend on the Snake River. This view of the Tetons is one of the most photographed in Grand Teton National Park.

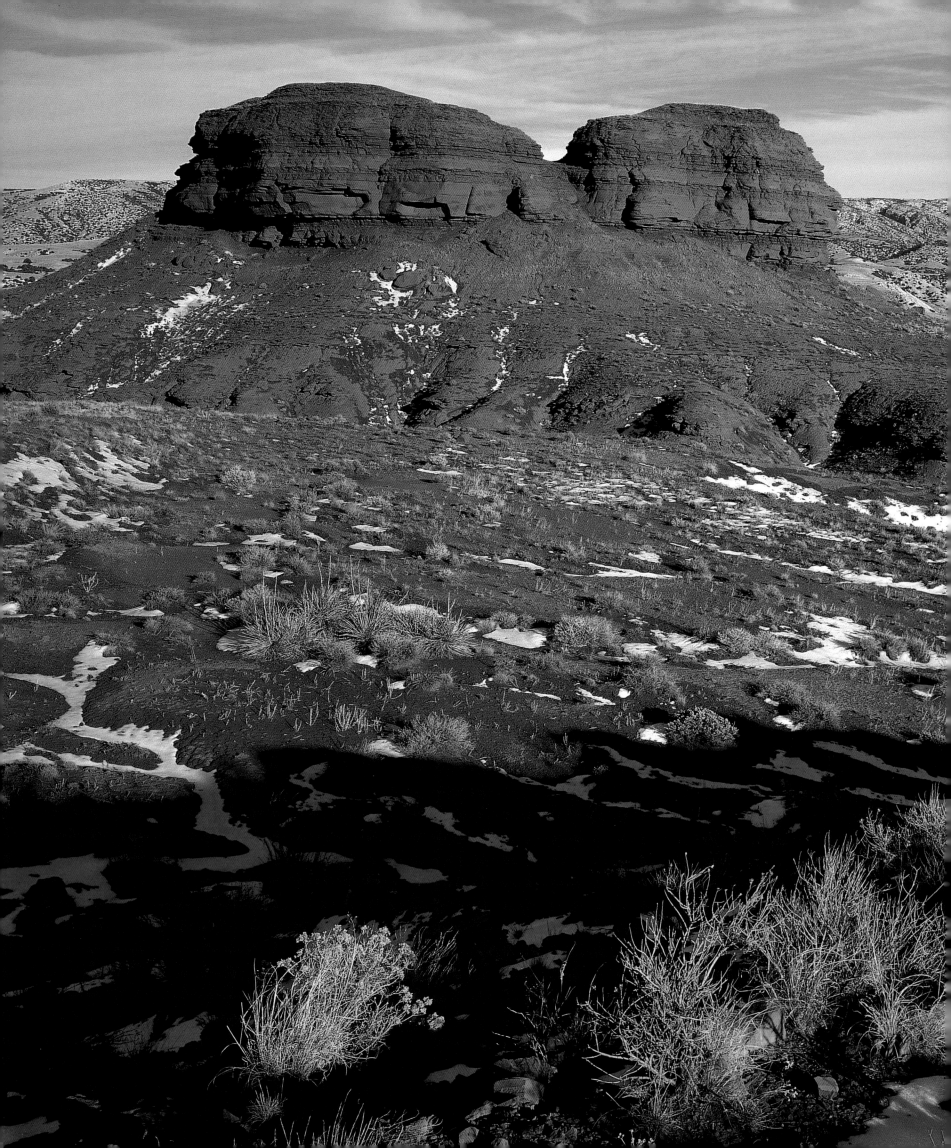

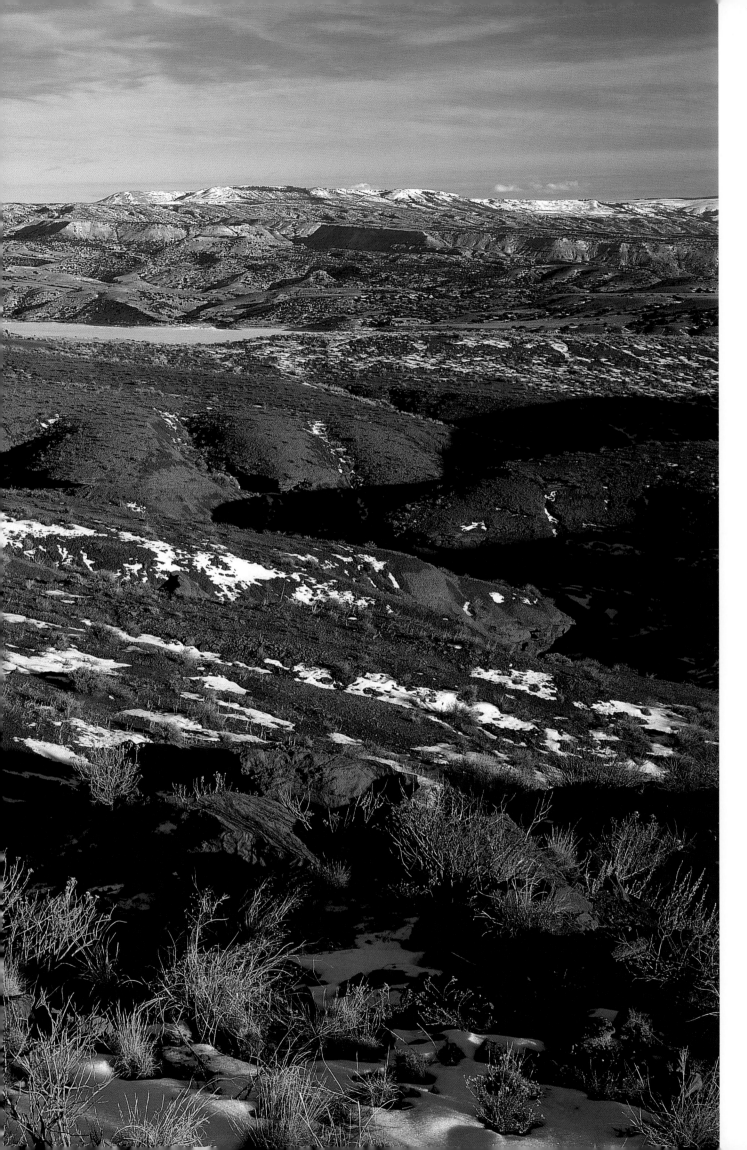

This redrock formation near Horseshoe Bend in Bighorn Canyon National Recreation Area shows the tremendous erosive power of wind and water.

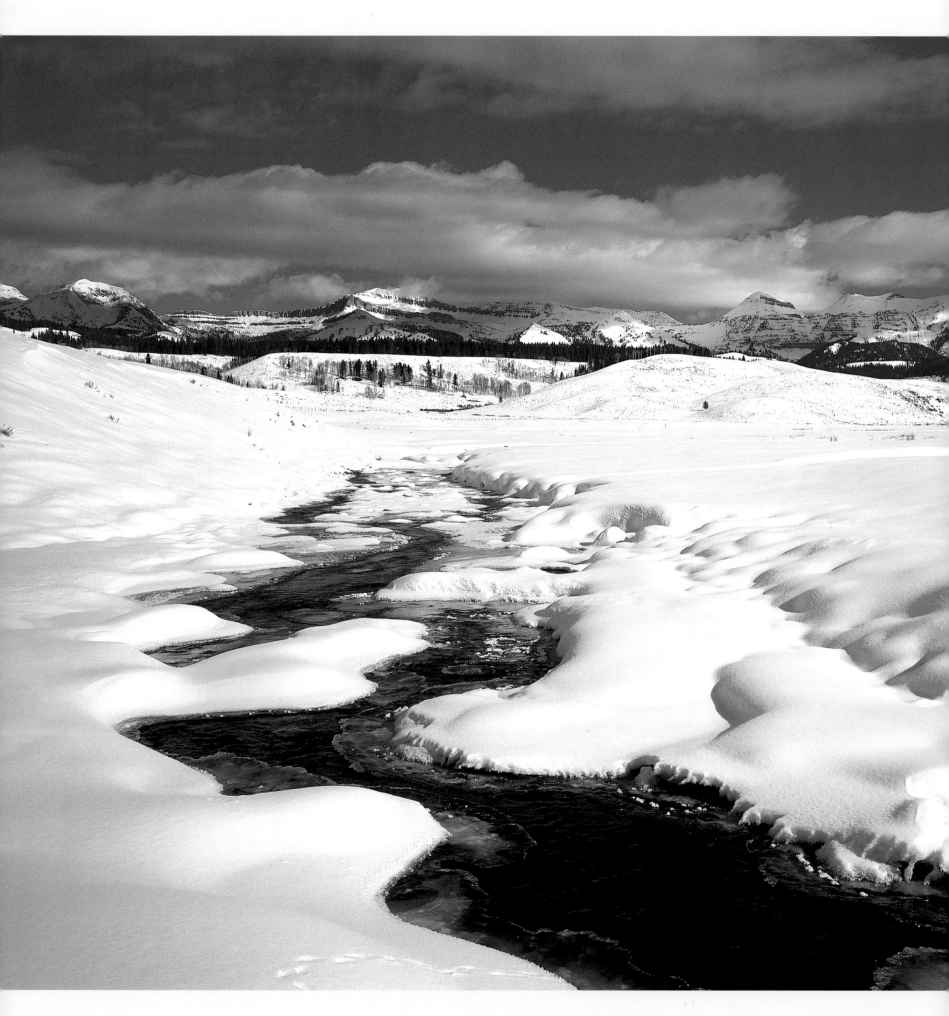

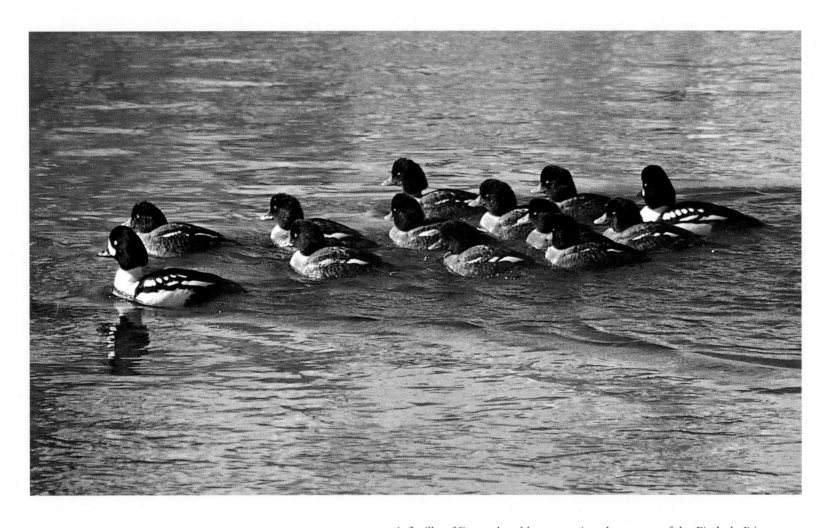

ABOVE: A flotilla of Barrow's goldeneye cruises the waters of the Firehole River in Yellowstone National Park. These hardy diving ducks are named after Sir John Barrow, secretary to the British admiralty.

FACING PAGE: Dell Creek struggles to remain free of winter's icy grip in the shadow of the Gros Ventre Range near Bondurant.

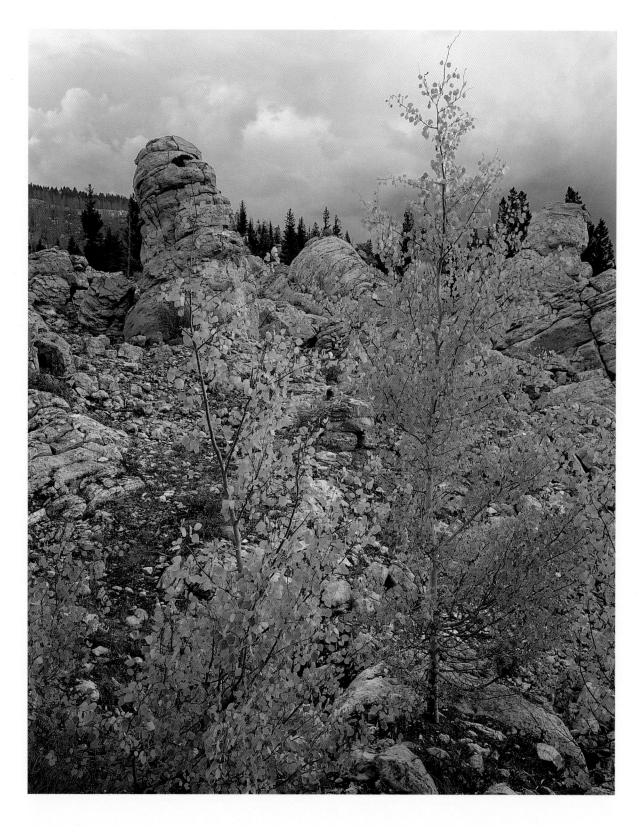

ABOVE: Storm clouds roll over the Hoodoos near Mammoth Hot Springs in Yellowstone National Park. In just a few days these golden-hewed aspens will lose almost all of their splendid autumn foliage.

FACING PAGE: A spectacular sunset is reflected on the terraces of Great Fountain Geyser in Yellowstone National Park.

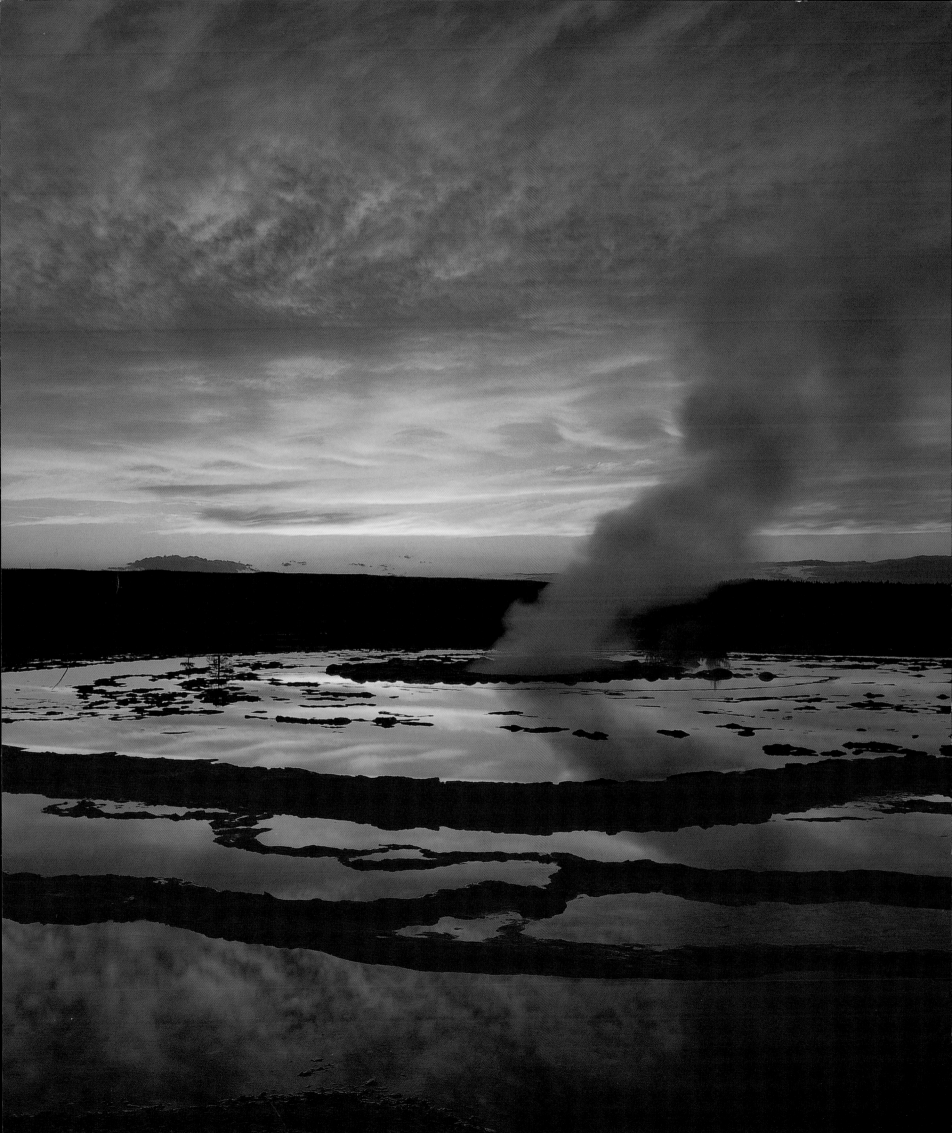

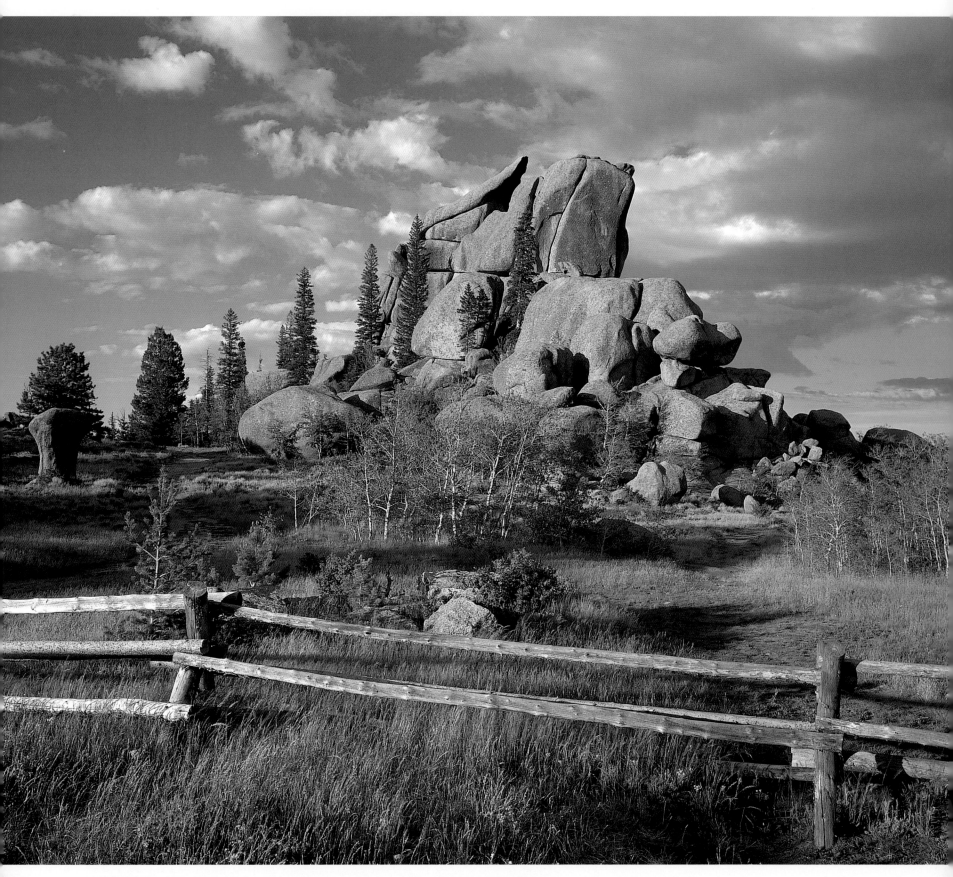

Vedauwoo Rocks in Medicine Bow National Forest looks like a giant's building blocks.
However, these blocks are made of granite and offer a playground for rock climbers from
all over the world who come here to try out one of the best climbing areas in Wyoming.

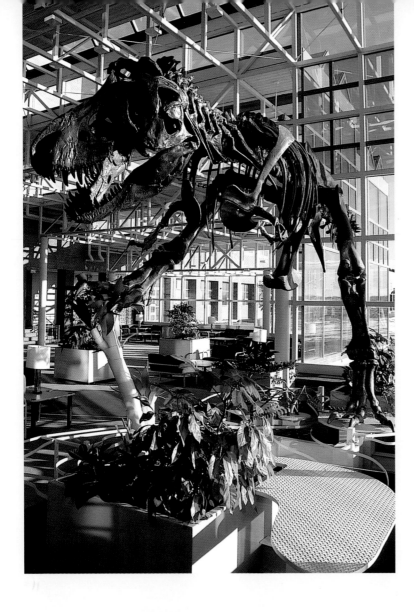

LEFT: This skeletal replica of a Tyrannosaurus Rex along with pottery artifacts, small fossils, and four other life-sized prehistoric creatures are found at the Natural History Museum on the campus of Western Wyoming Community College in Rock Springs.

BELOW: From Fort Fetterman near Douglas, General George Crook led three marches into Sioux and Cheyenne country during the Indian Wars in the late 1870s. This is the reconstructed officers' quarters, which now houses a museum.

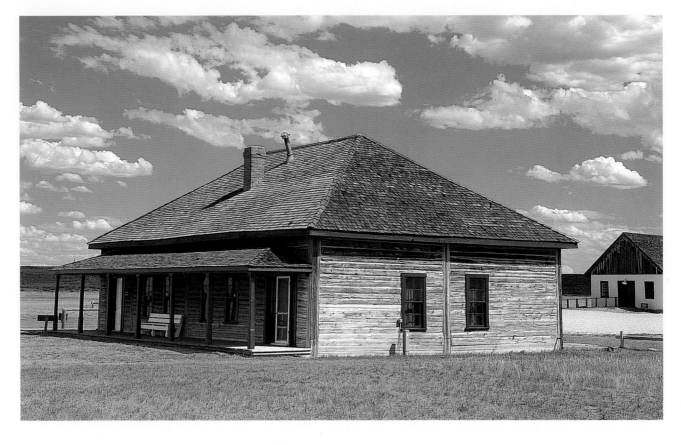

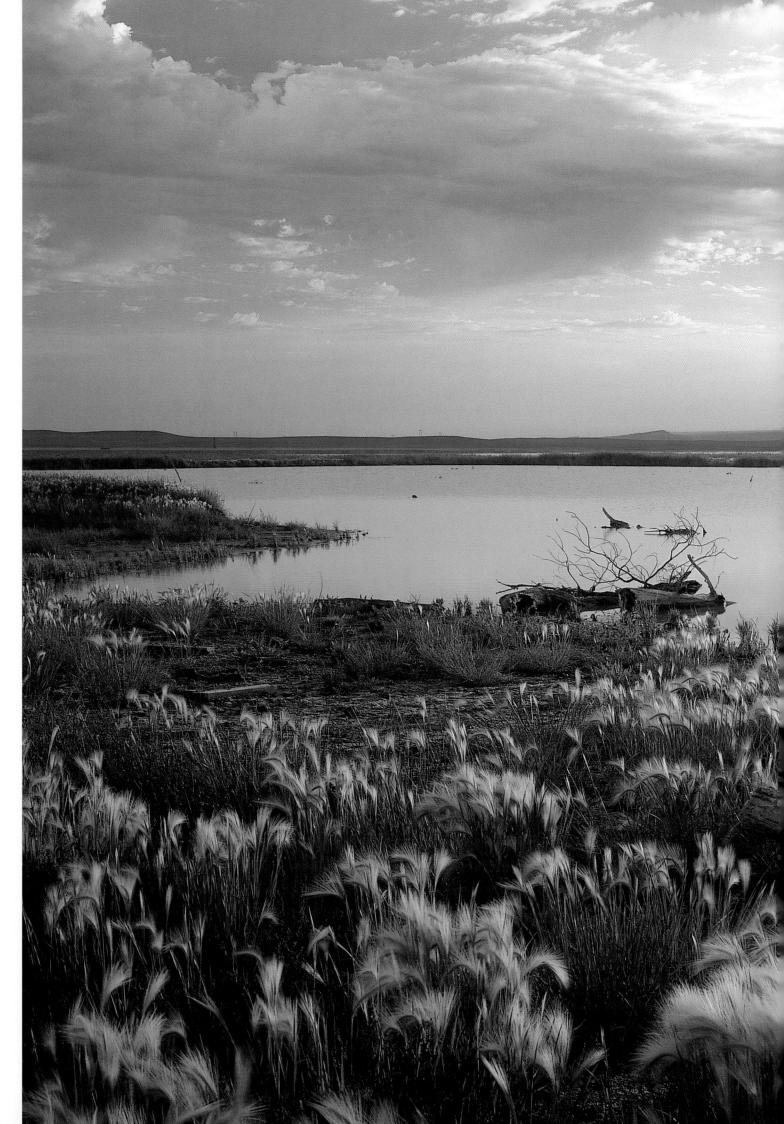

Foxtail barley blows gently in the morning breeze along Keyhole Reservoir. This reservoir, surrounded by the lands of Keyhole State Park, is a popular fishing and bird-viewing spot in the northeastern portion of the state.

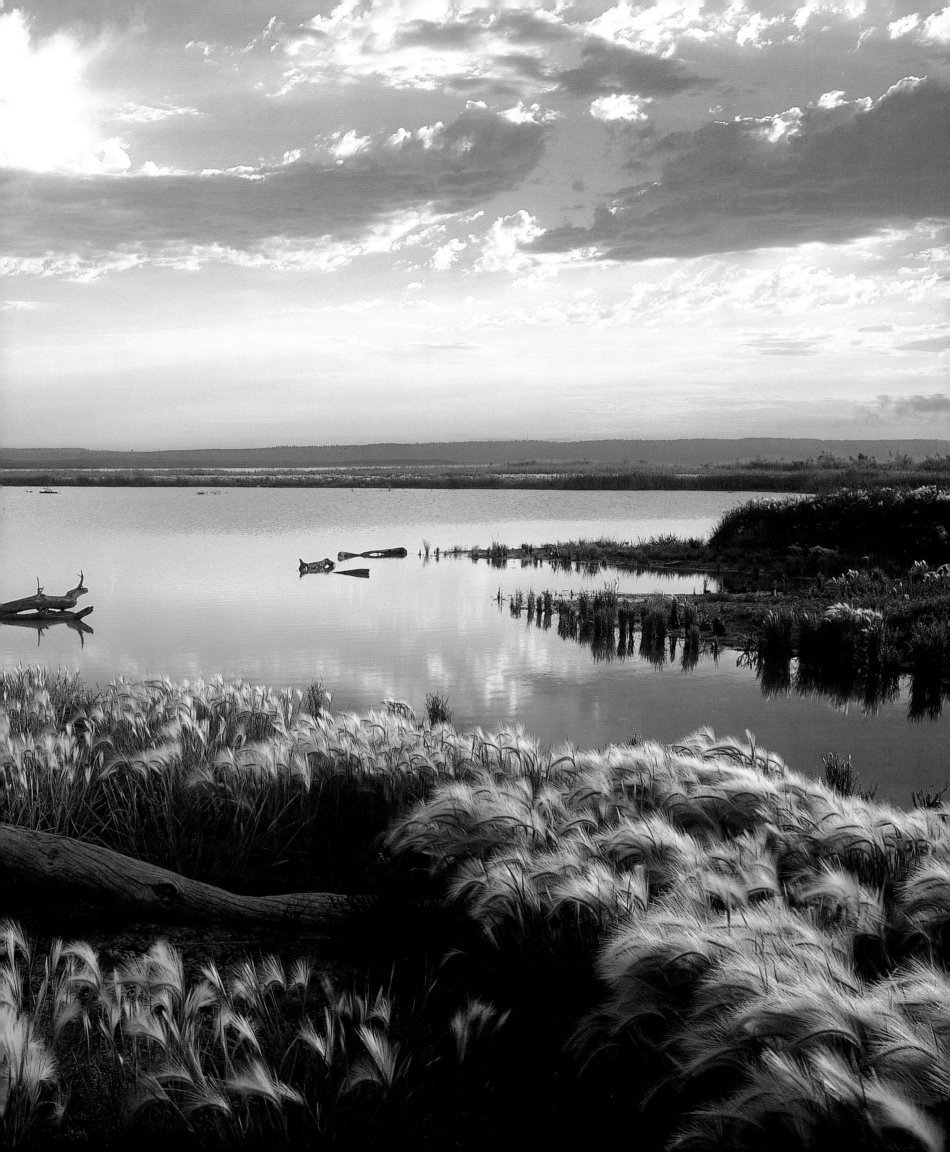

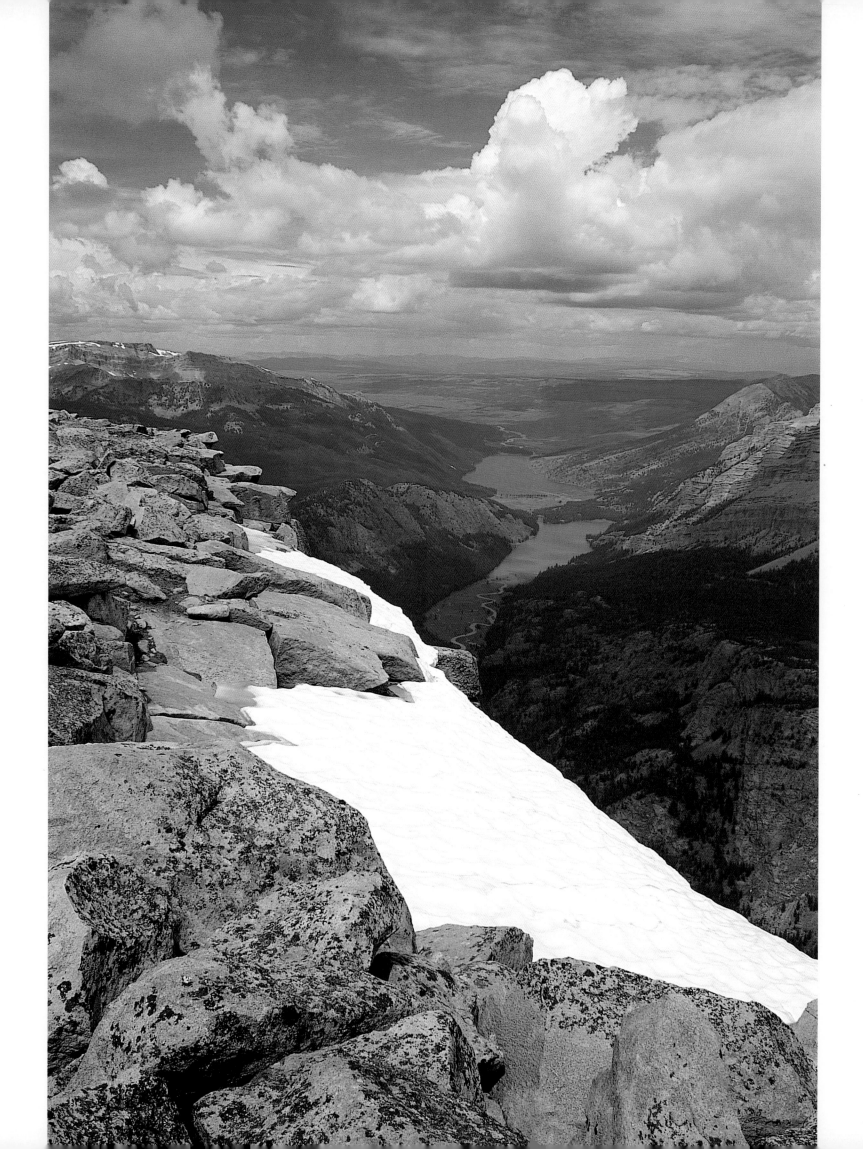

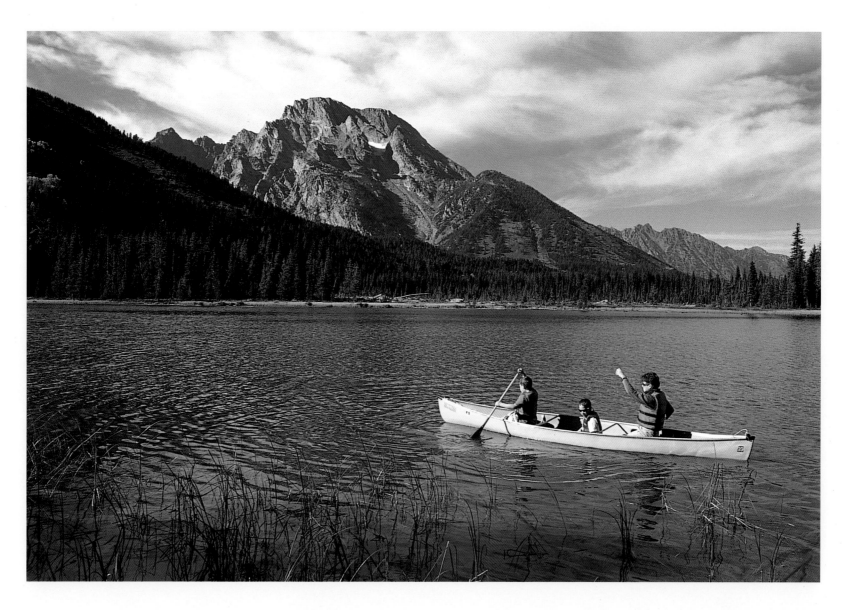

ABOVE: The massive form of Mount Moran rises over String Lake in Grand Teton National Park.

FACING PAGE: This summit view comes courtesy of Squaretop Mountain, whose stumplike form dominates the skyline above the Green River Lakes. Squaretop is the most photographed peak in the Wind River area, but this is a unique vantage point, only accessible via a strenuous climb from Beaver Park 3,000 feet below.

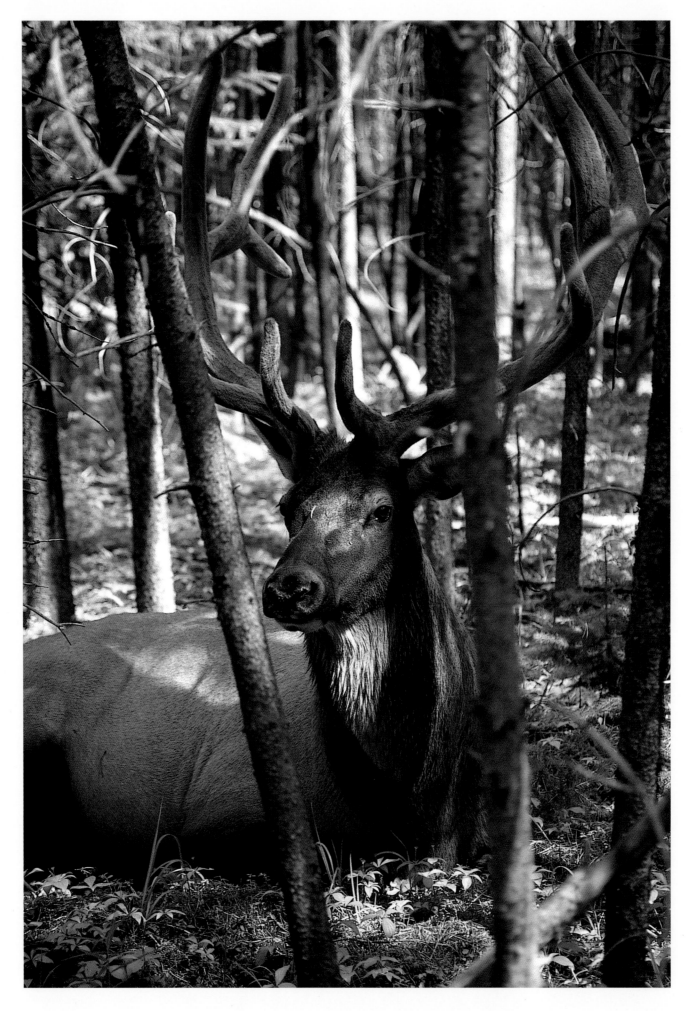

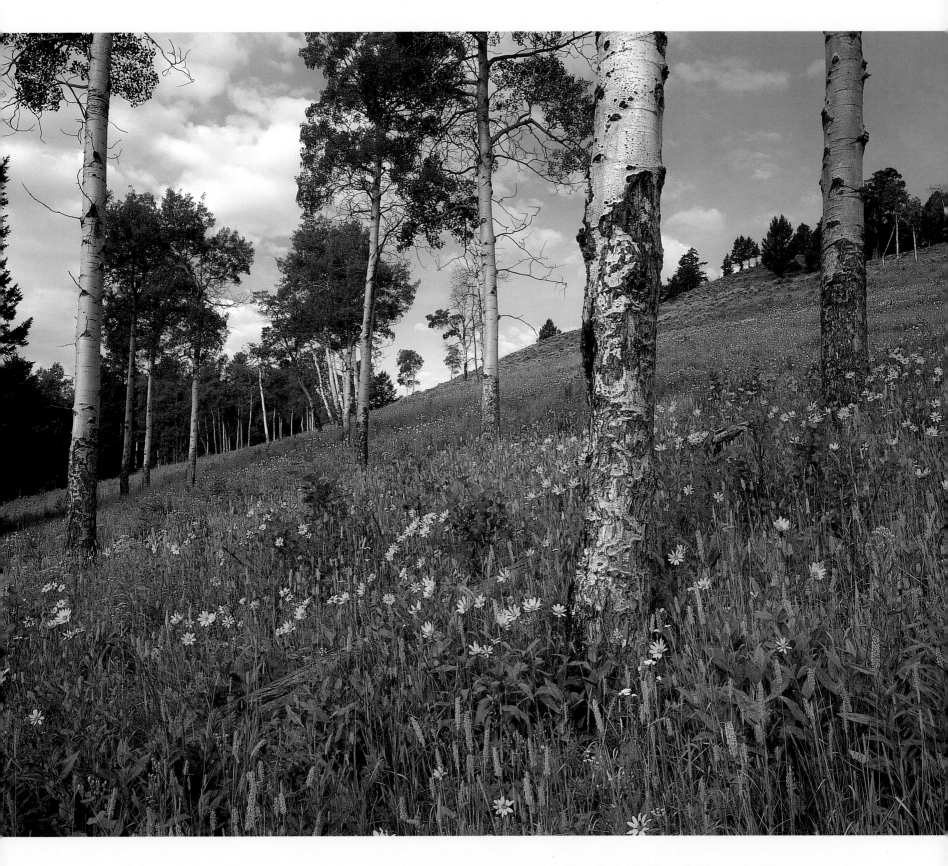

ABOVE: A sunflowered landscape on Blacktail Plateau Drive in late July. Wildflowers abound in the northern areas of Yellowstone National Park during midsummer.

FACING PAGE: This big fellow lolls away the afternoon in a thicket of lodgepole pine. Wapiti, or elk as they are more commonly known, inhabit much of western Wyoming.

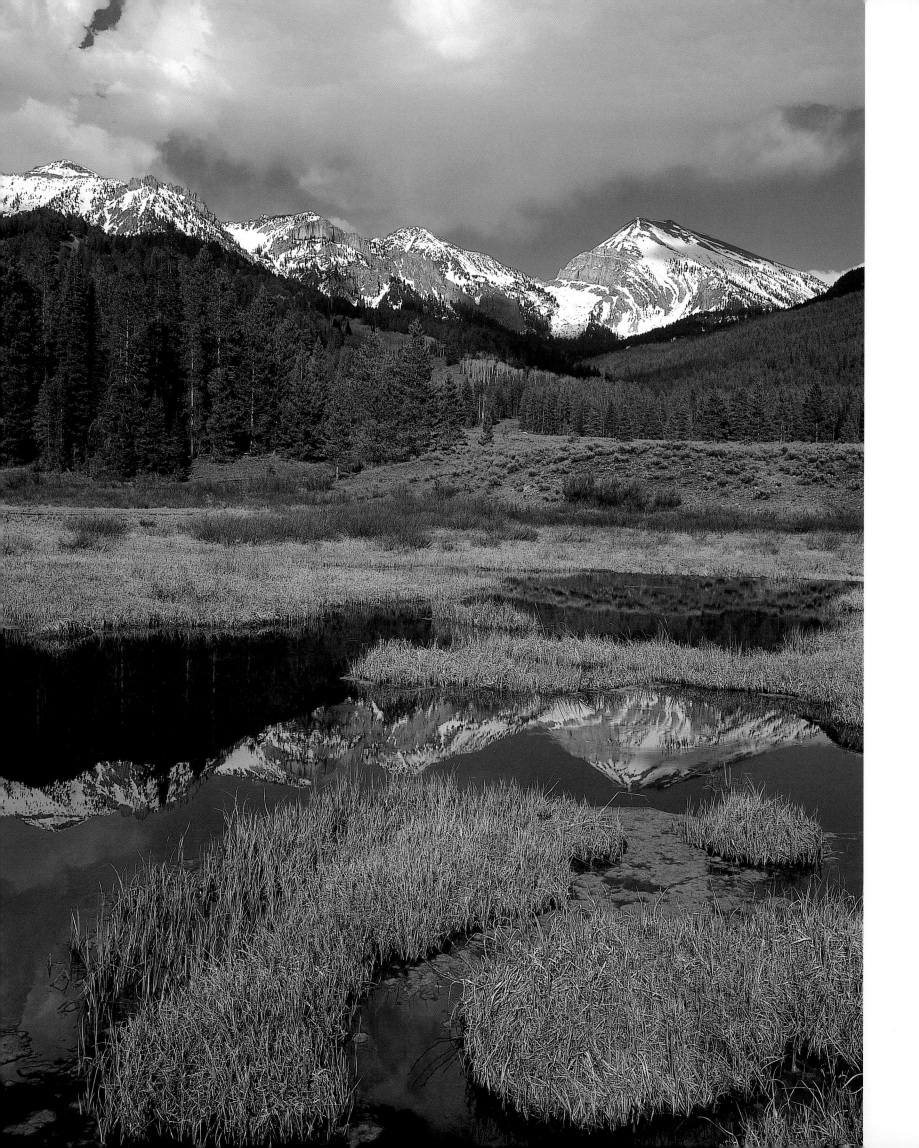

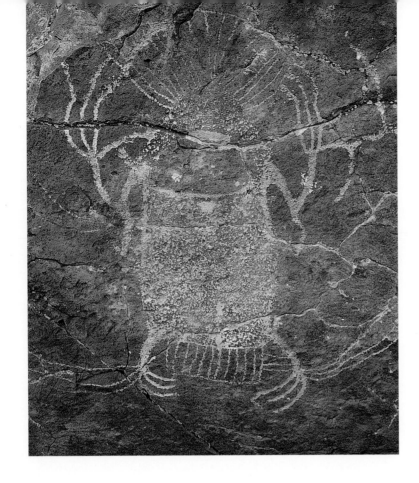

LEFT: Ancient petroglyphs dot the Wyoming landscape. Archaeologists believe these rock carvings are from a people group pre-dating the Native American tribes that inhibited this area when the first Anglo-Americans appeared.

BELOW: The Duncan Mine near Atlantic City is a proud relic of days gone by. The mining boom in the South Pass area during the 1860s helped propel the push to split Wyoming Territory from Dakota Territory. At one time the area in and around South Pass City had a population of more than two thousand people, making it the largest town in Wyoming.

FACING PAGE: The snow-covered peaks of the Gros Ventre Range offer a stark contrast to the lush green of early spring around this beaver pond along Granite Creek in the Bridger-Teton National Forest.

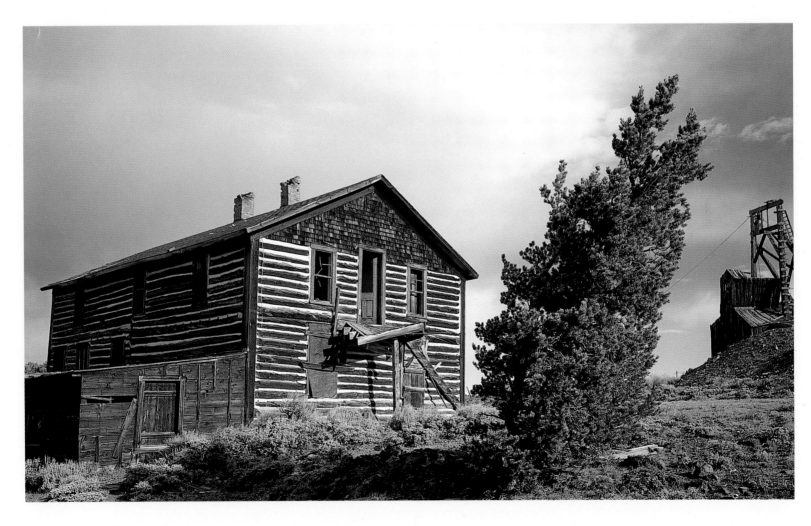

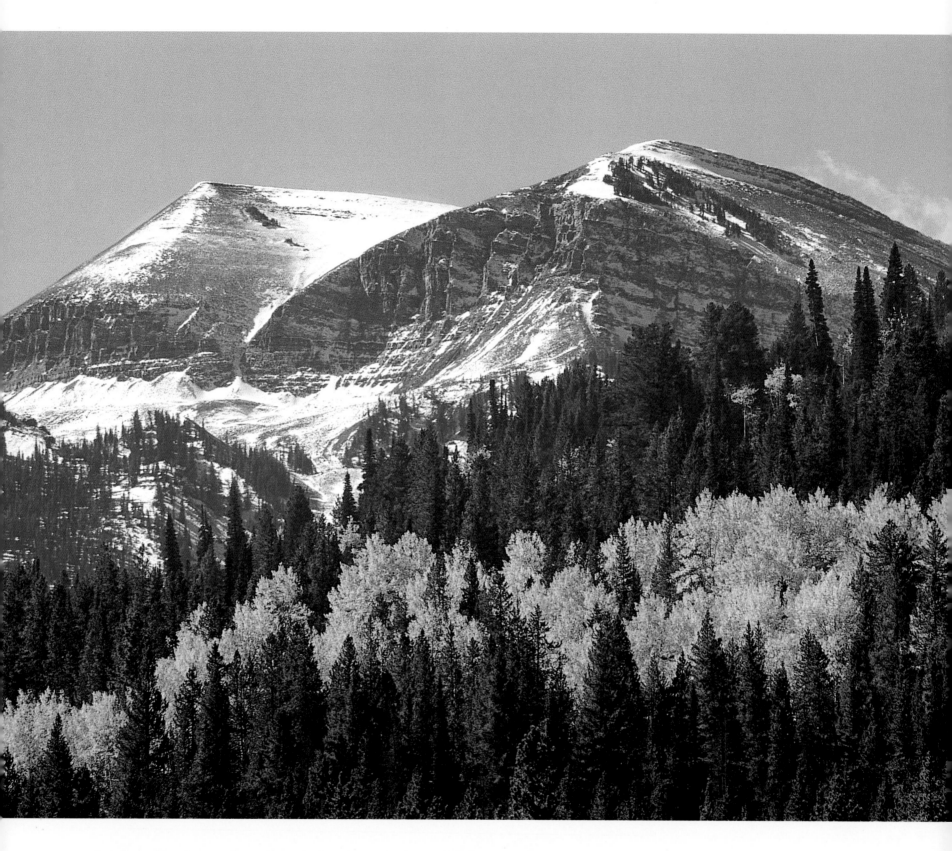

A fresh dusting of snow adorns Clause Peak at the northern end of the Wyoming Range. This snow and the fall colors indicate winter is just around the corner in this section of the Bridger-Teton National Forest.

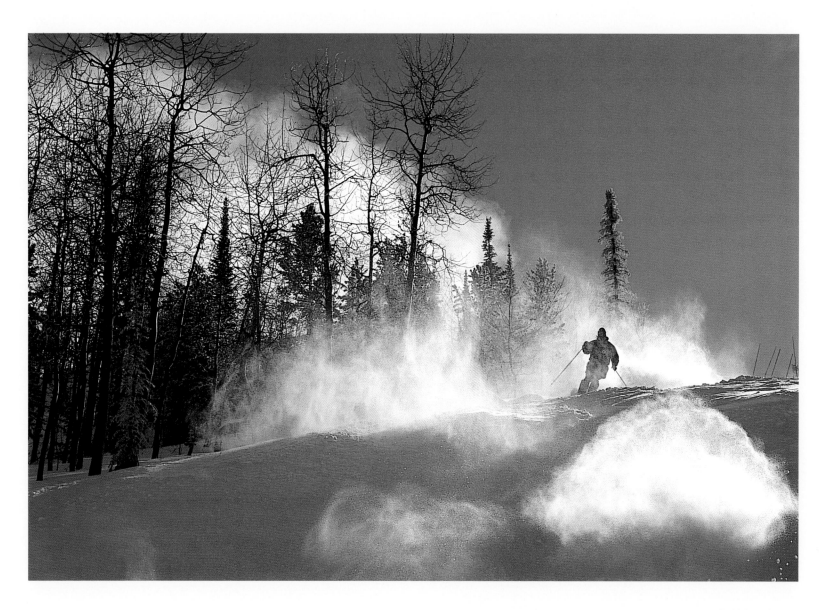

Afternoon rays highlight this skier's run down a dry powder slope at Wyoming's newest ski resort, White Pine Ski Area and Resort.

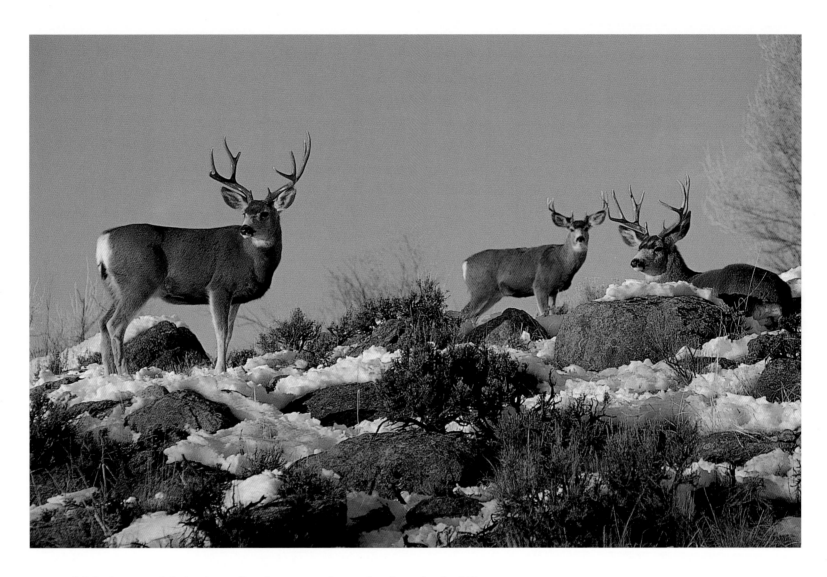

ABOVE: Mule deer spend their winters foraging among the sagebrush on the foothills, mesas, and desert plateaus surrounding most of the mountain ranges in Wyoming. This group of bucks was photographed near Pinedale.

FACING PAGE: Frozen North Cottonwood Creek winds its way out of the Wyoming Range. This seldom-photographed range of high peaks is one of Wyoming's favorite winter playgrounds.

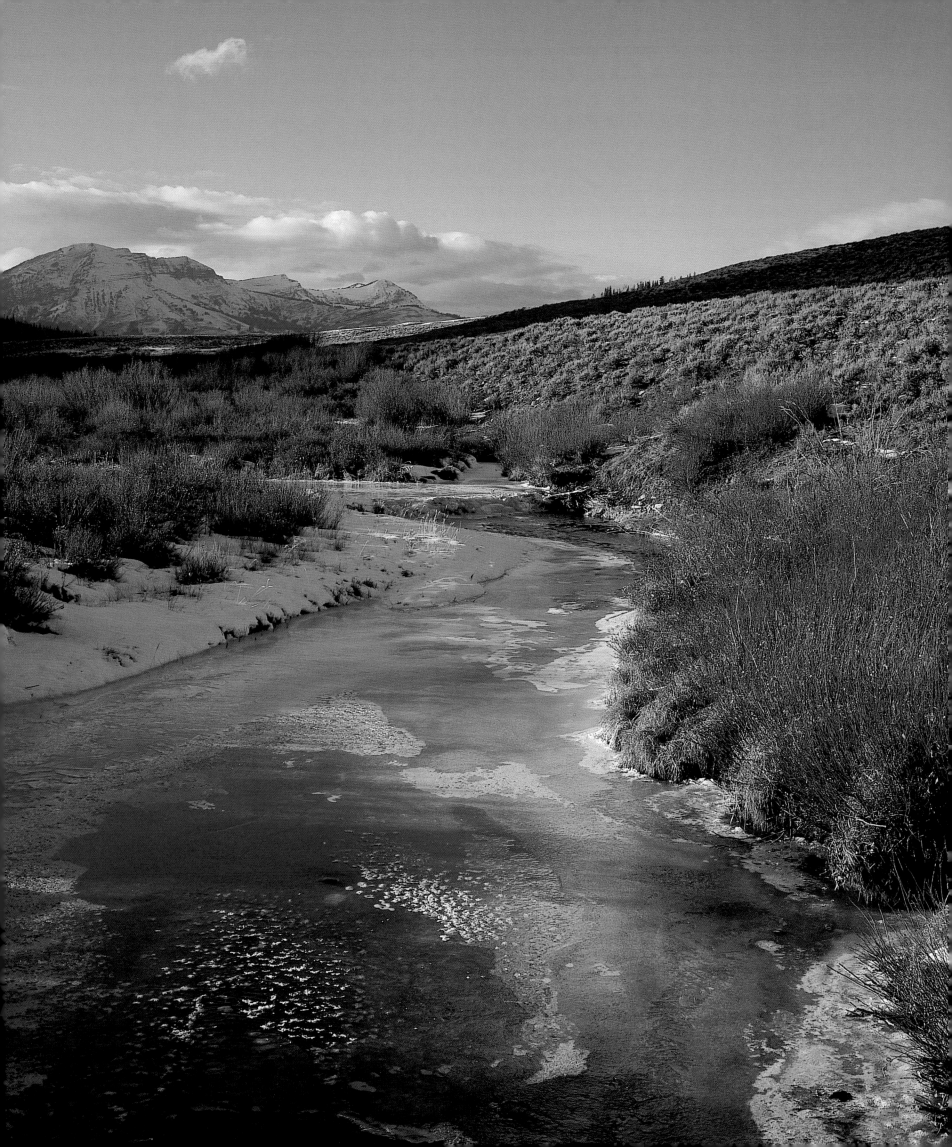

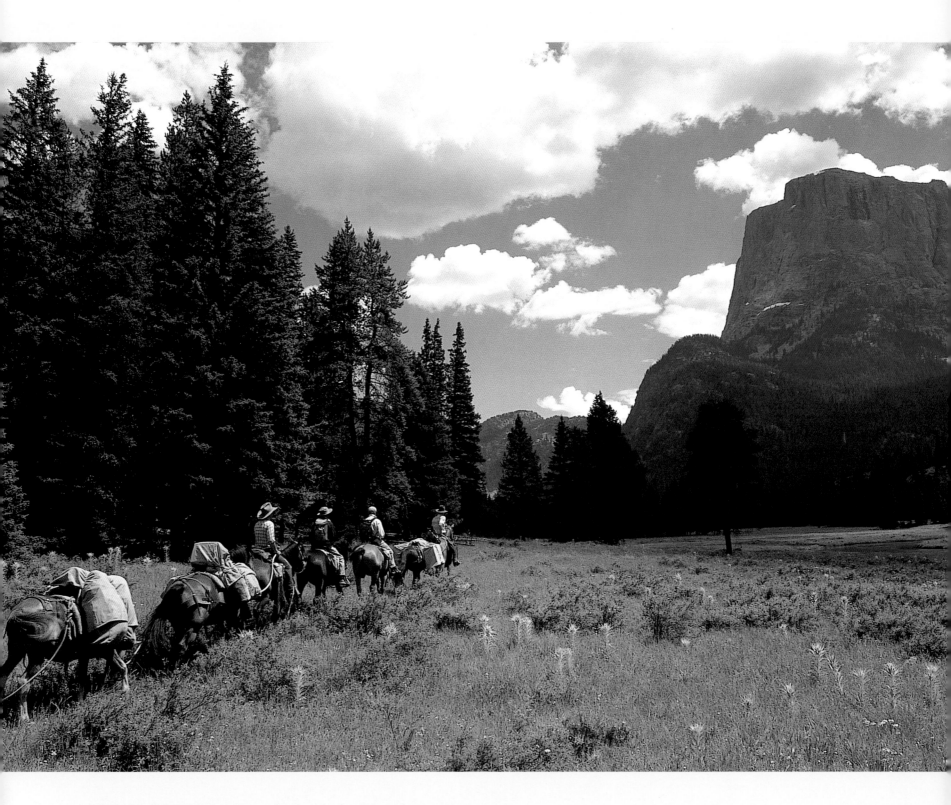

Many city slickers hire guides to take them by horse into the mountains to enjoy the solitude of wilderness. Here an outfitter leads his clients into the Bridger Wilderness beneath the towering hulk of Squaretop Mountain.

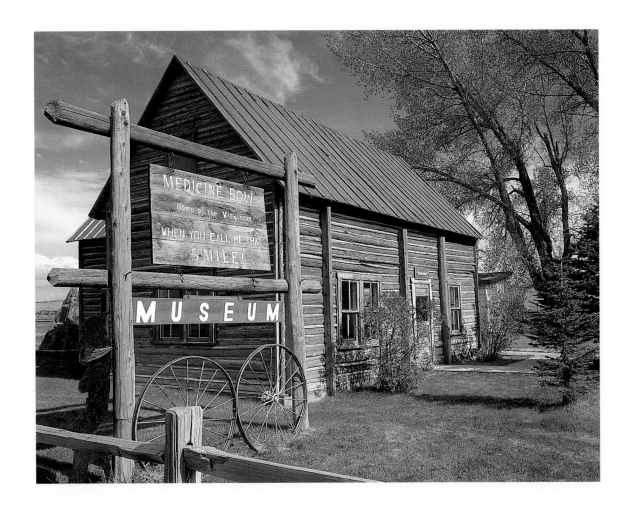

LEFT: This cabin, located in the town of Medicine Bow, was once the home of author Owen Wister, who penned the classic western *The Virginian*. The building is now a museum, and the sign outside reminds folks of the Virginian's ties to this place that Wister described as "Strewn there by the wind."

BELOW: Arrowleaf balsam-root can be found through-out most of the foothills of the Wyoming Rockies toward the end of May. This stately arrangement stands tall along the banks of Middle Popo Agie River (pronounced po-PO-zha) in Sinks Canyon State Park near Lander.

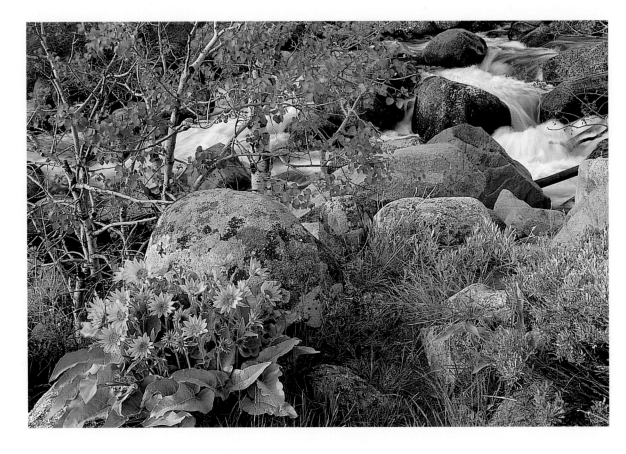

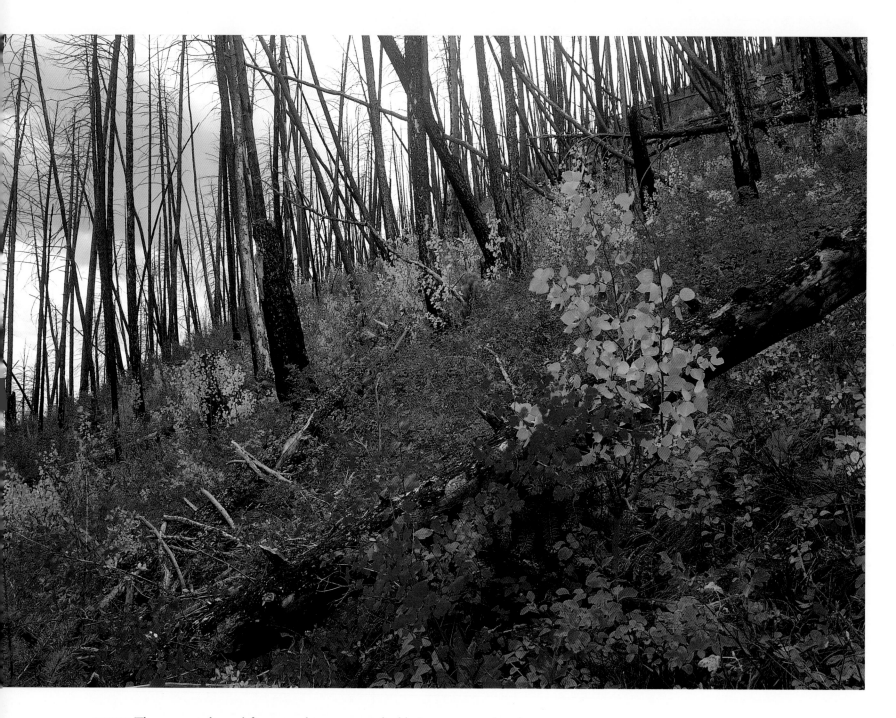

ABOVE: The overcast sky and fire-scarred trees accent the blazing orange, red, and yellow hues near Elk Creek in Yellowstone National Park.

FACING PAGE: Water from Deep Lake flows over solid rock as it starts its journey out of the Wind River Mountains. Steeple and East Temple peaks rise abruptly from the far shore of the lake.

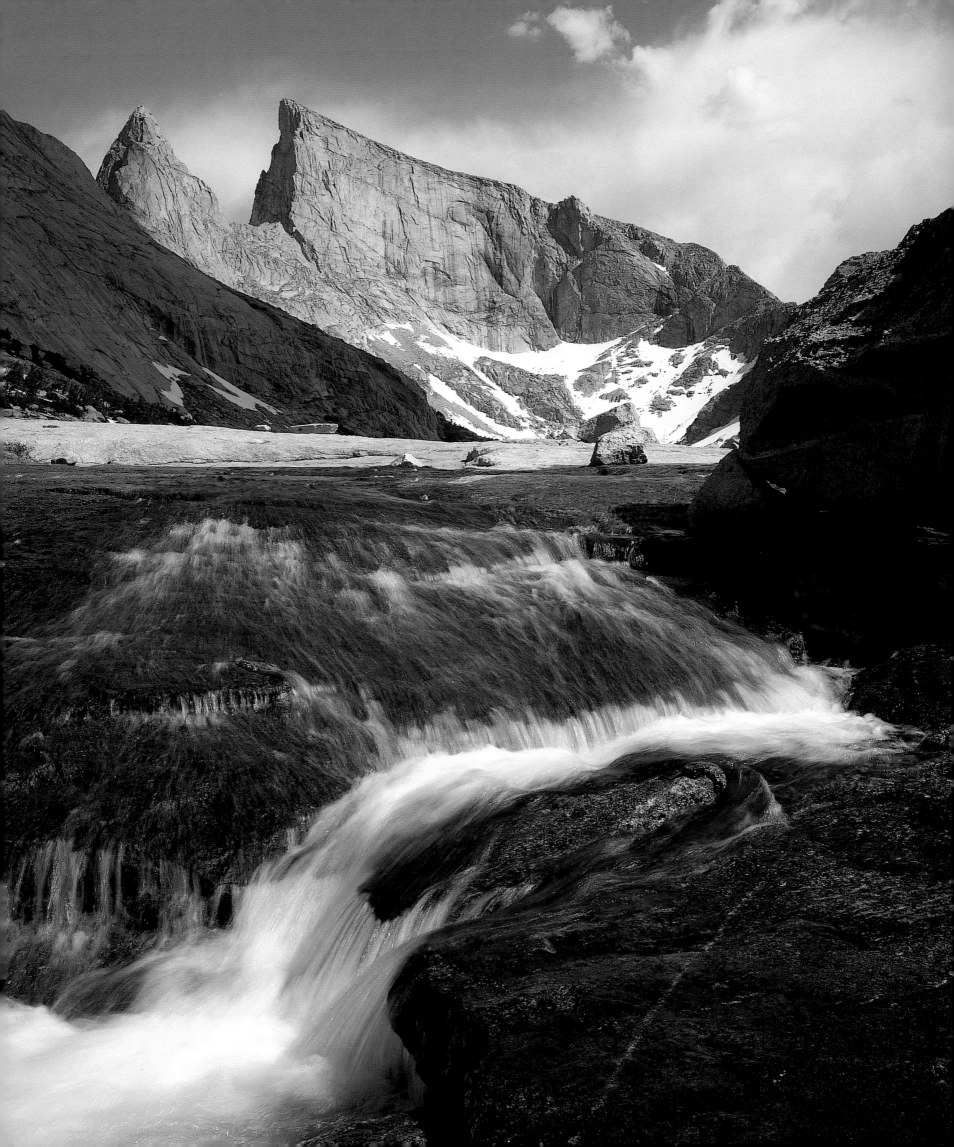

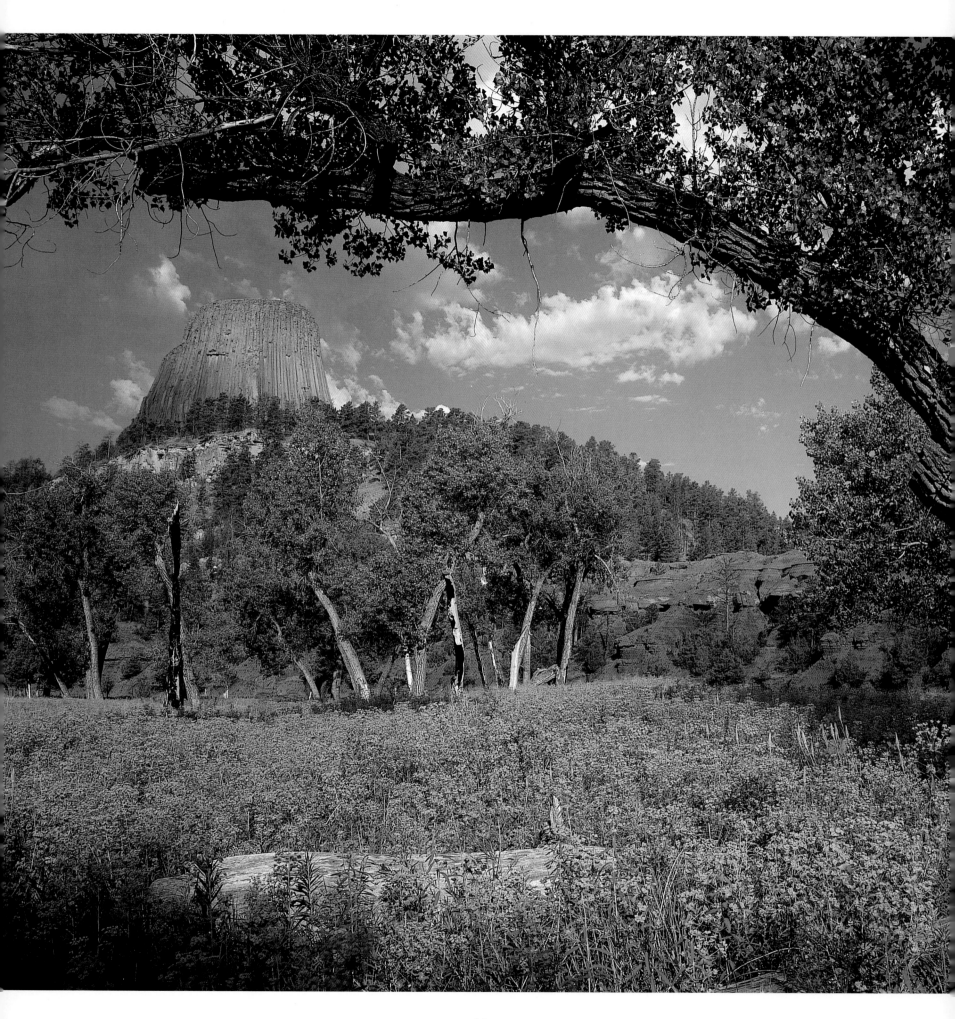

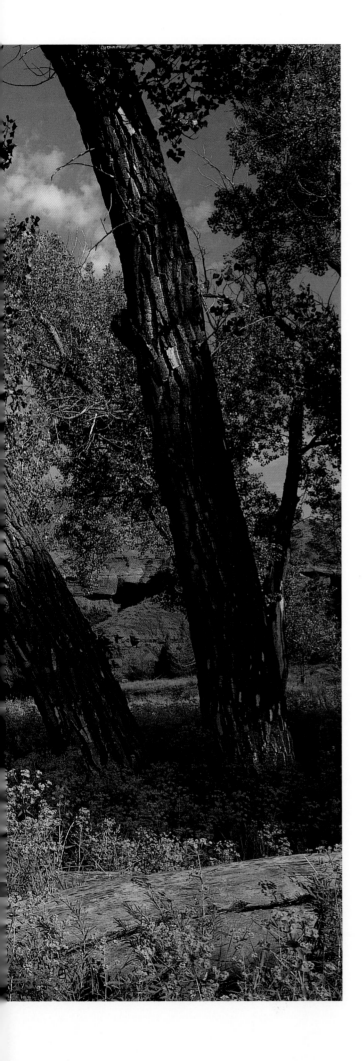

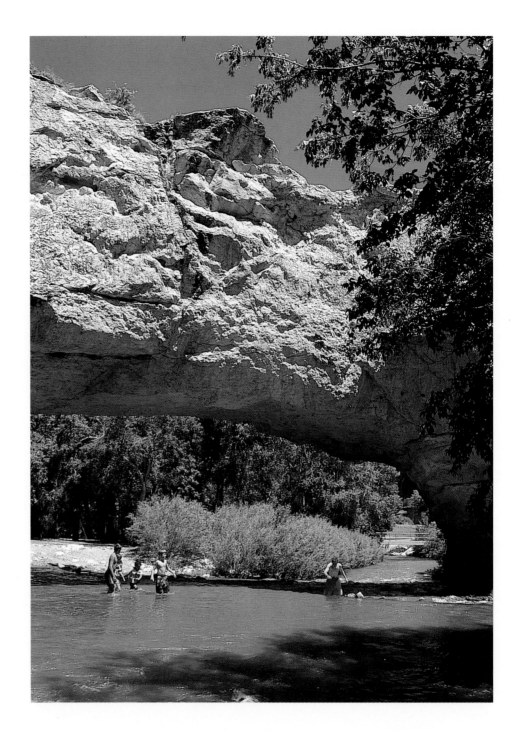

ABOVE: Ayres Natural Bridge spans La Prele Creek at Converse County Park. The youngsters playing beneath it probably don't know that it is one of the few natural bridges in the world with water flowing under it.

LEFT: A sweeping cottonwood limb frames Devils Tower. The tower is the remnant of an ancient volcano. In 1906, the tower and land surrounding it were declared the nation's first national monument by President Theodore Roosevelt. The 1977 movie *Close Encounters of the Third Kind* popularized this already well-known landmark.

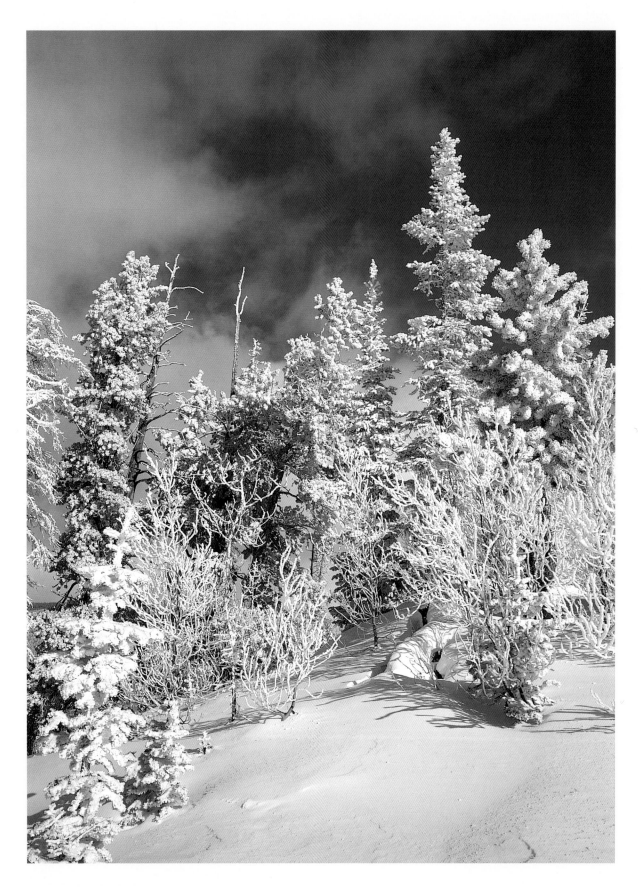

Snow-plastered trees spread their frames into wintry skies over western Wyoming. Struggling to survive at an elevation of over 9,000 feet, these hardy trees have seen many a fierce storm blast through the Bridger-Teton National Forest.

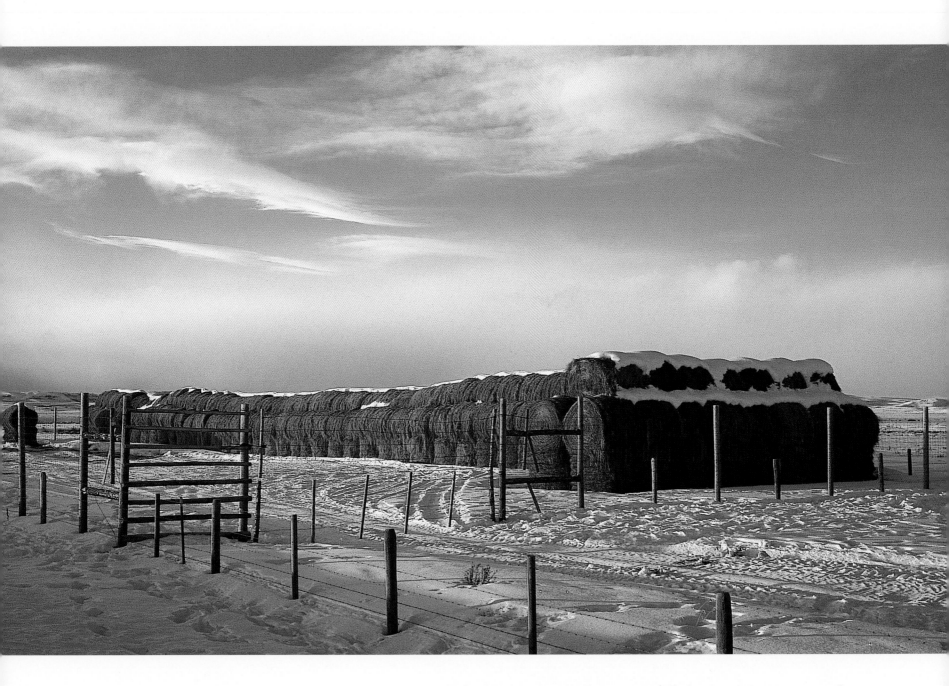

With more cows than people per square mile, hay is an important commodity in Wyoming. This ranch near Merna is well stocked with its winter supply.

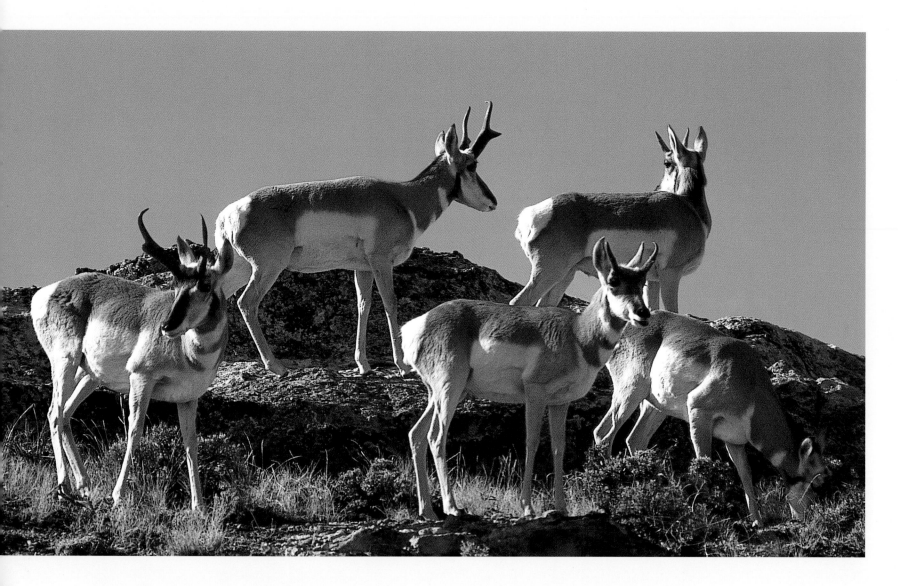

ABOVE: More than 40 million pronghorn once roamed the North American plains. They can still be seen in large herds running the mesas and desert plateaus in many parts of Wyoming. These graceful creatures can easily reach speeds of 45 miles per hour or more, making them the fastest land mammal on the continent. PHOTO BY MARCO RUBEK

FACING PAGE: Steamboat Lake, which is part of the Pathfinder National Wildlife Refuge southwest of Casper, is an important habitat for shorebirds and waterfowl.

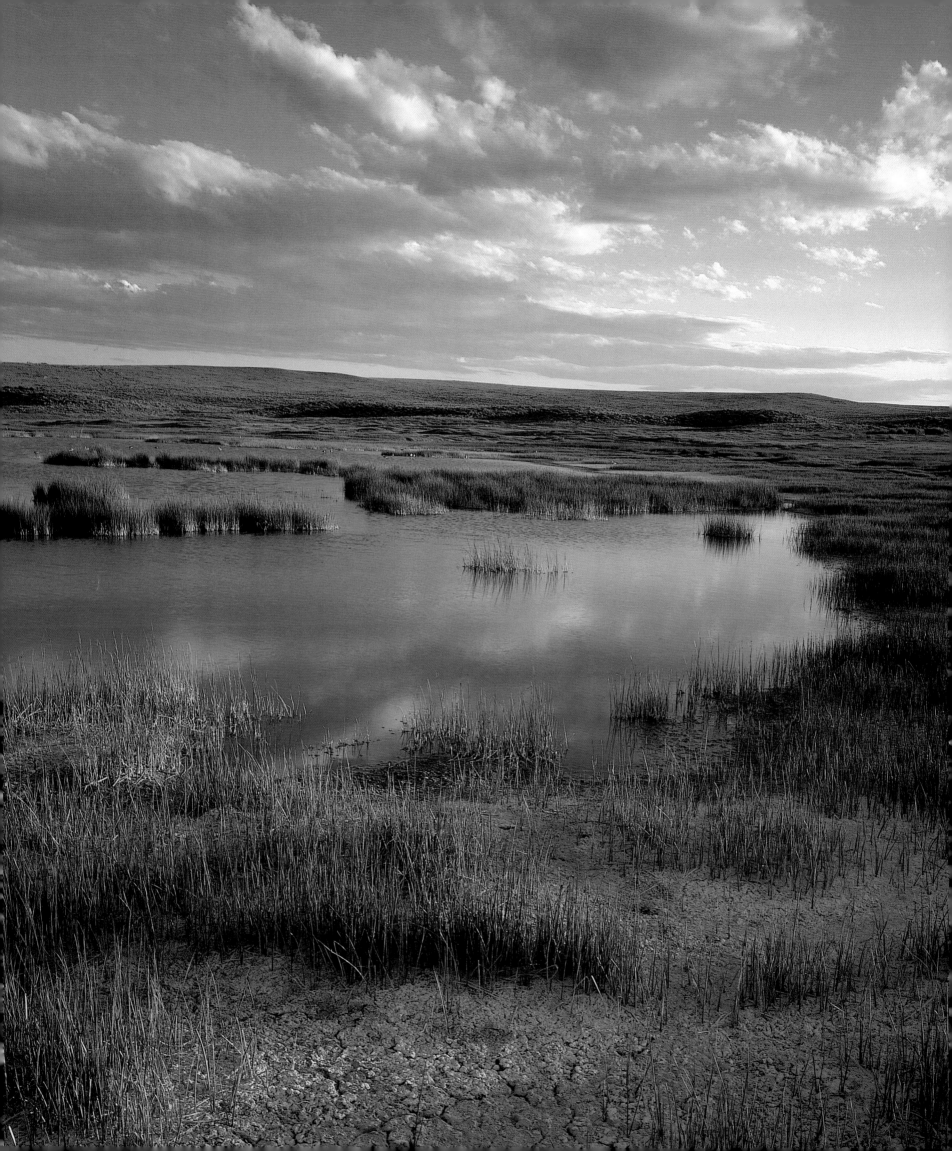

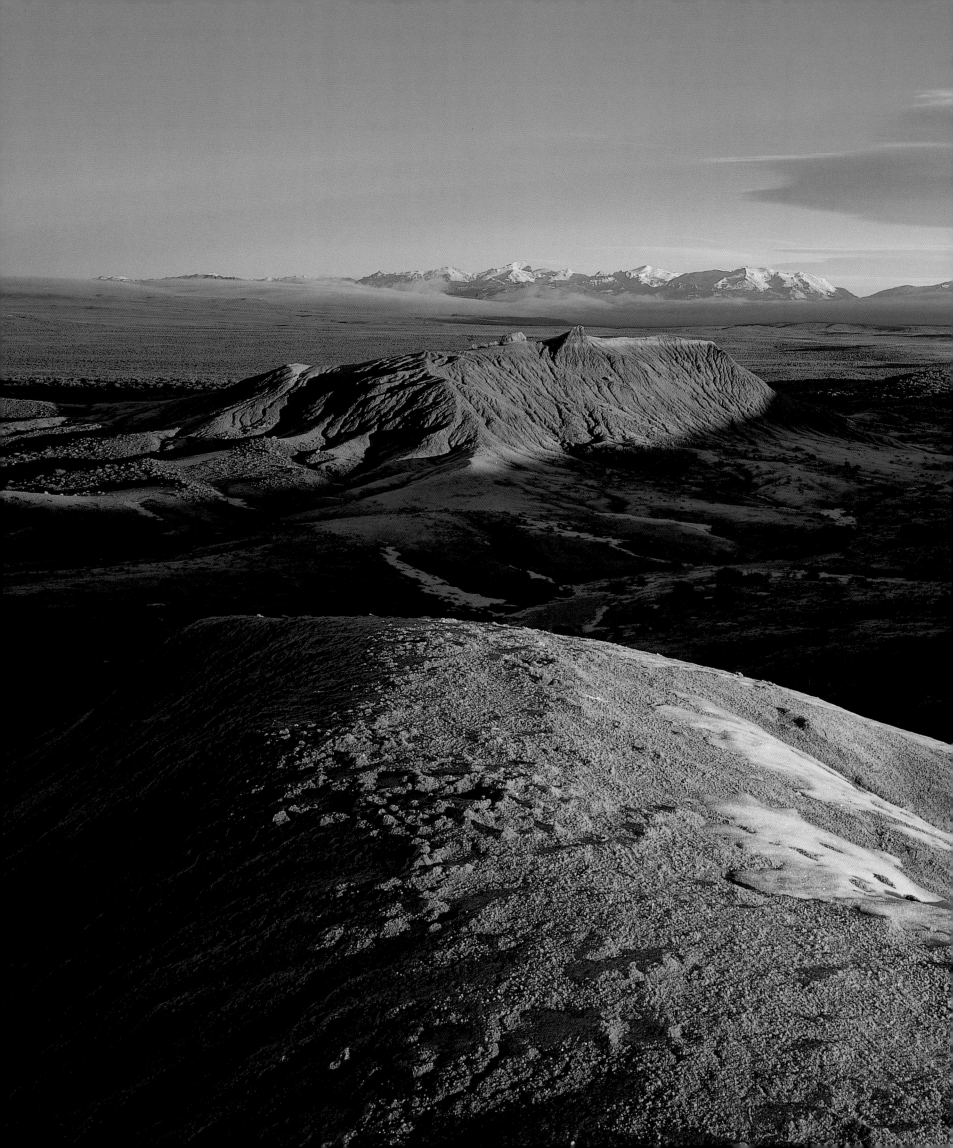

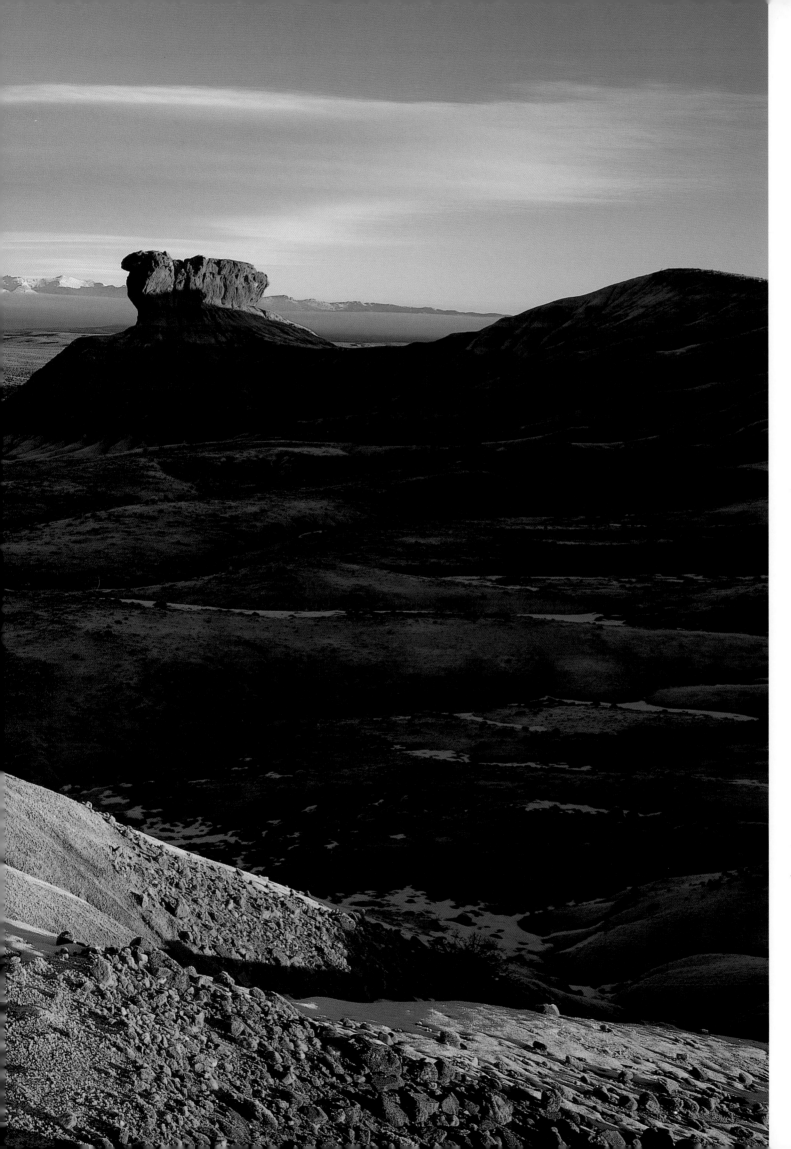

Plume Rock was one of the smaller and lesser known landmarks used by travelers on the Oregon Trail. It is located in Sweetwater County just off a dirt road northeast of Farson.

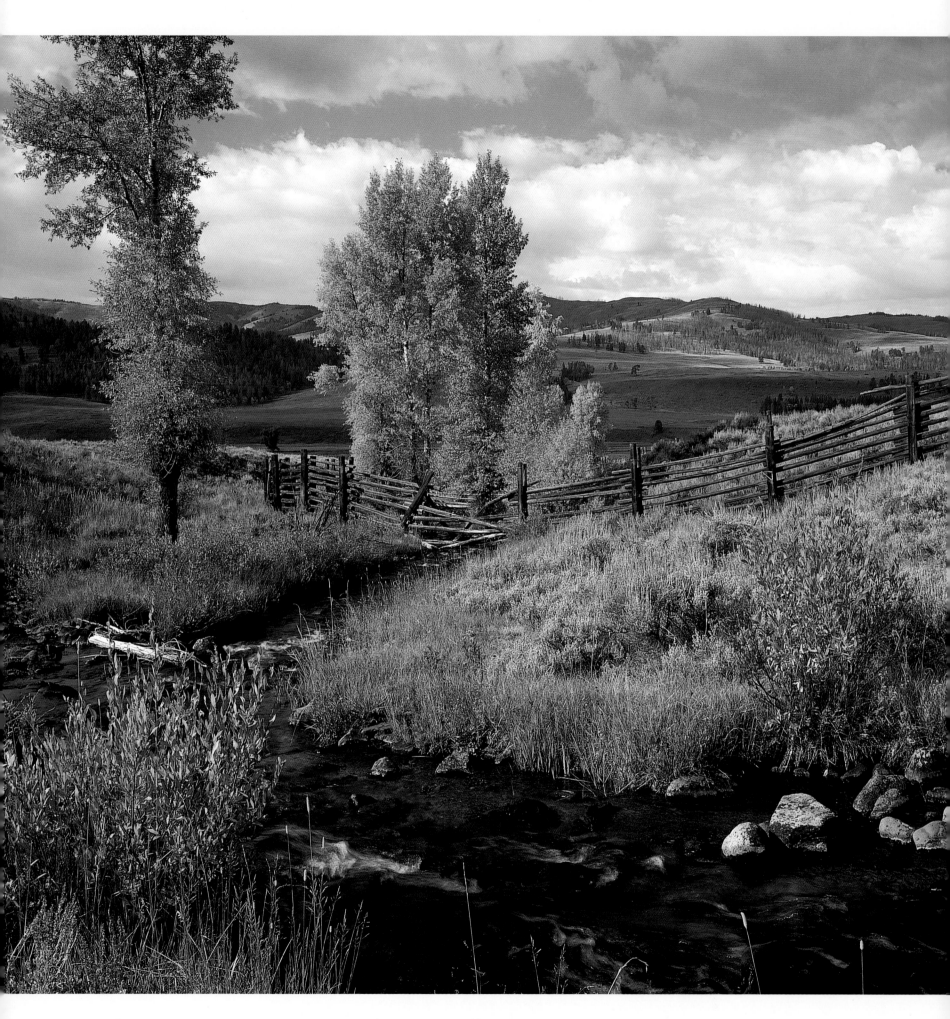

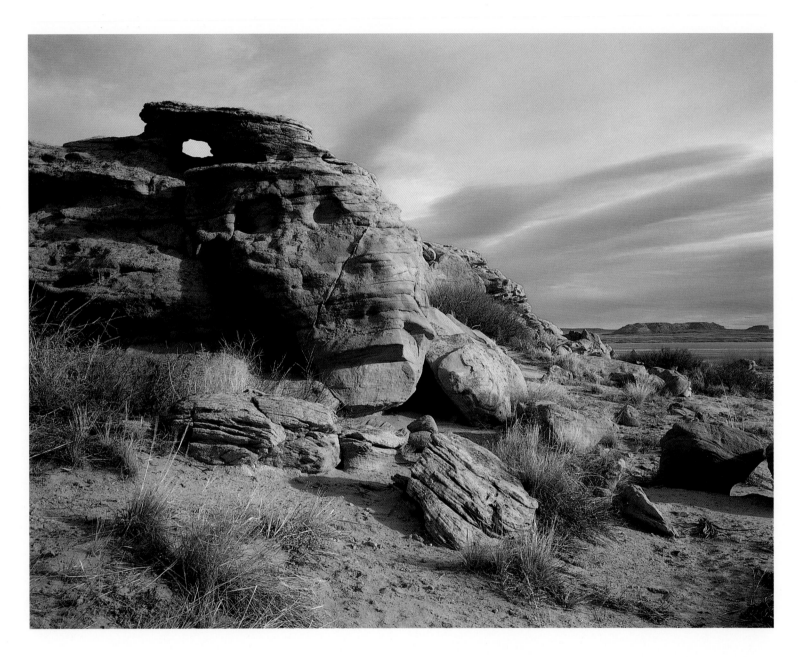

ABOVE: Sandstone formations adorn the ridges and hillsides in Boysen State Park. Boysen Reservoir can be seen in the distance.

FACING PAGE: Rose Creek runs through the Lamar Buffalo Ranch, which was built in the early twentieth century to increase the herd size of the remaining bison in Yellowstone. The ranch is now used as headquarters for the Yellowstone Institute, which offers educational seminars and field trips on the ecology and geology of Yellowstone National Park. Participants get to stay at this historic ranch in the heart of the Lamar Valley.

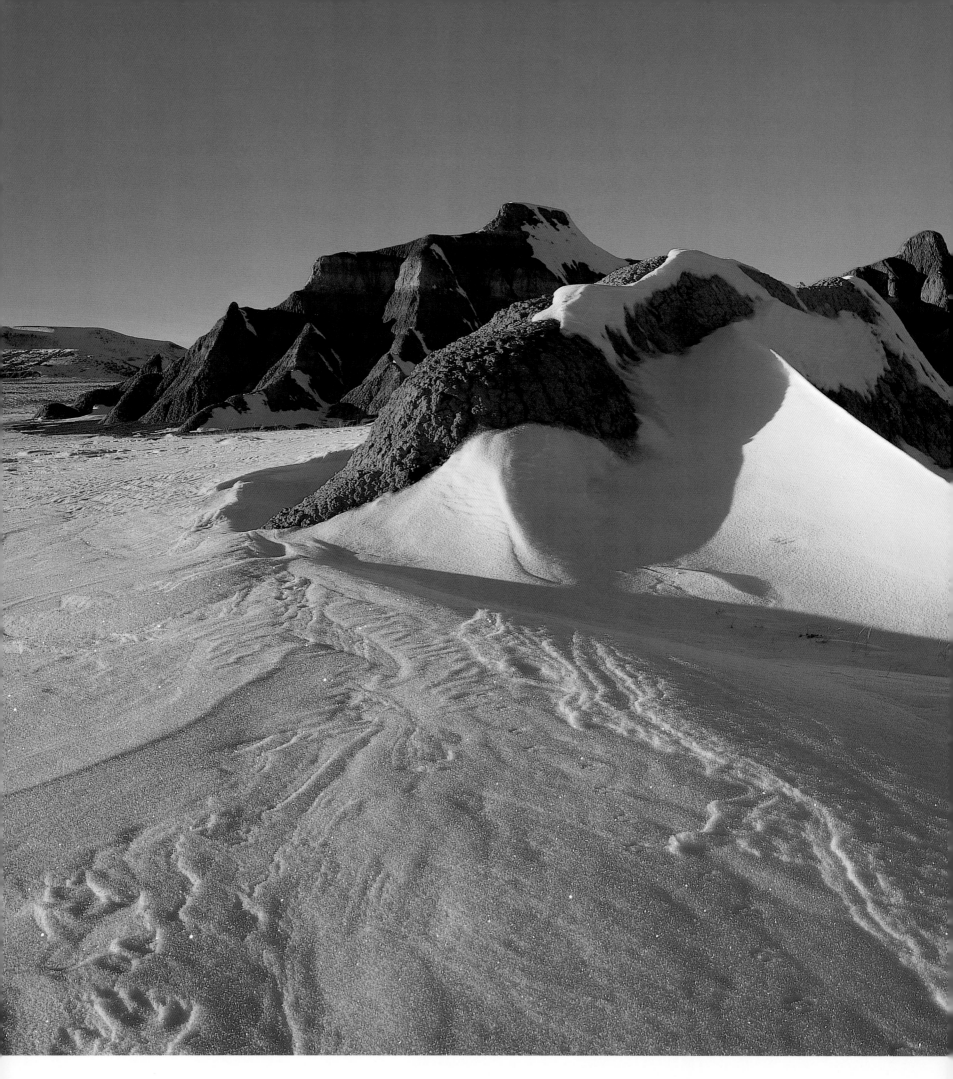

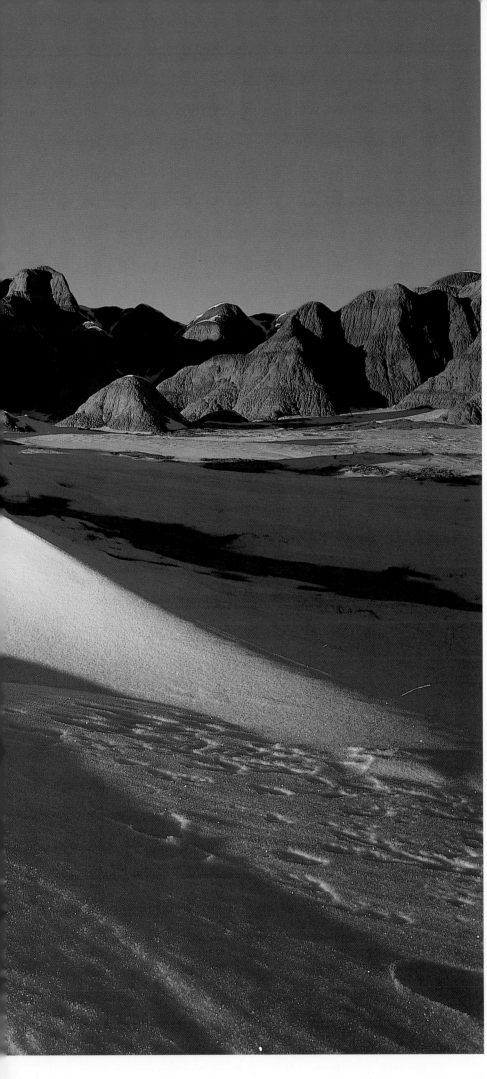

There are many geological formations in Wyoming called "badlands." This one lies just north of the town of Marbleton off Highway 189.

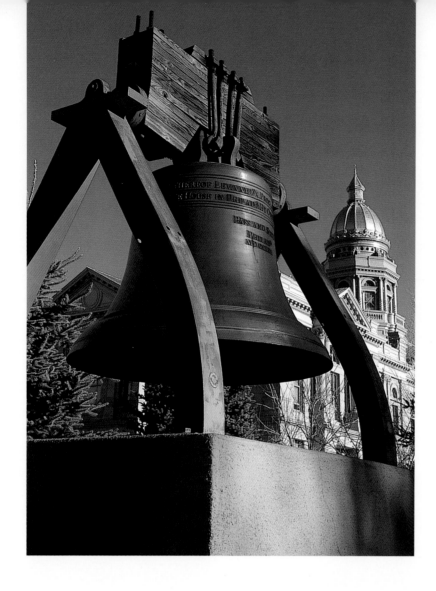

LEFT: The Equality State's gold-domed capitol rises behind a replica of the Liberty Bell in Cheyenne.

BELOW: This seldom-seen bird is a harlequin duck, so named because of the male's striking plumage—a "harlequin" is an actor who wears a mask or has colorful makeup. Harlequins can sometimes be seen at LeHardy Rapids on the Yellowstone River.

FACING PAGE: A Yellowstone Lake sunrise illuminates the steam emitted by the many hot springs, mud pots, and fumaroles of the West Thumb Geyser Basin in Yellowstone National Park.

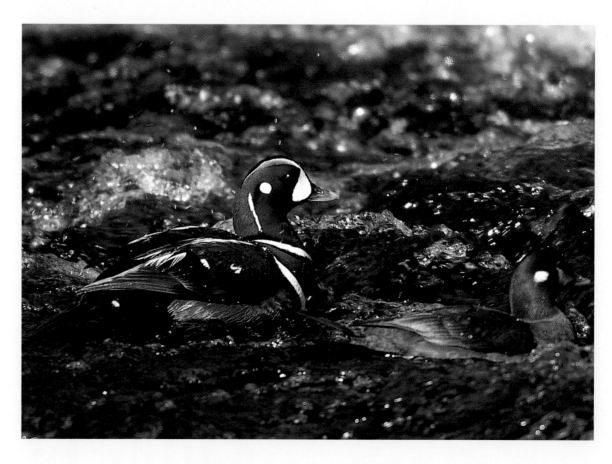

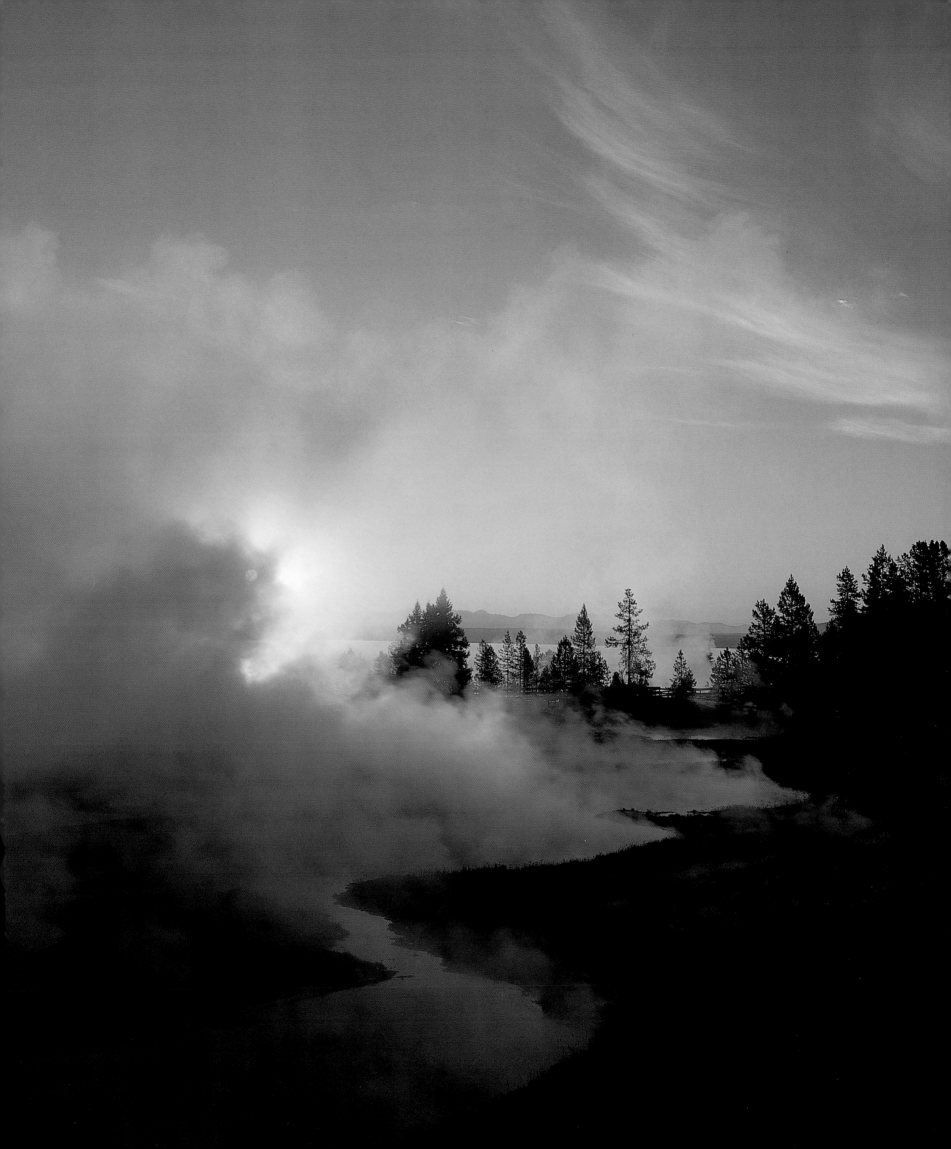

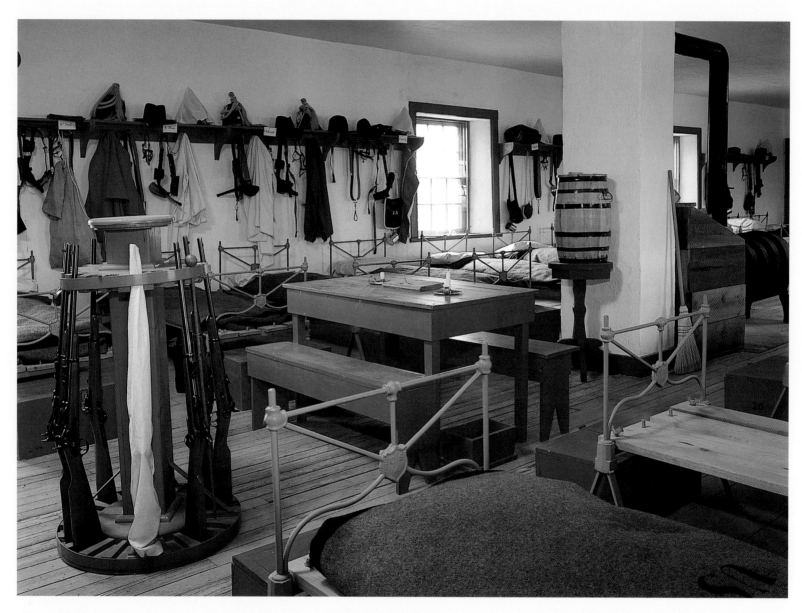

The enlisted men's barracks at Fort Laramie were spartan compared to the offi-cers' quarters. Both can be viewed at Fort Laramie National Historic Site, which preserves the heritage of this stopping place along the Oregon Trail.

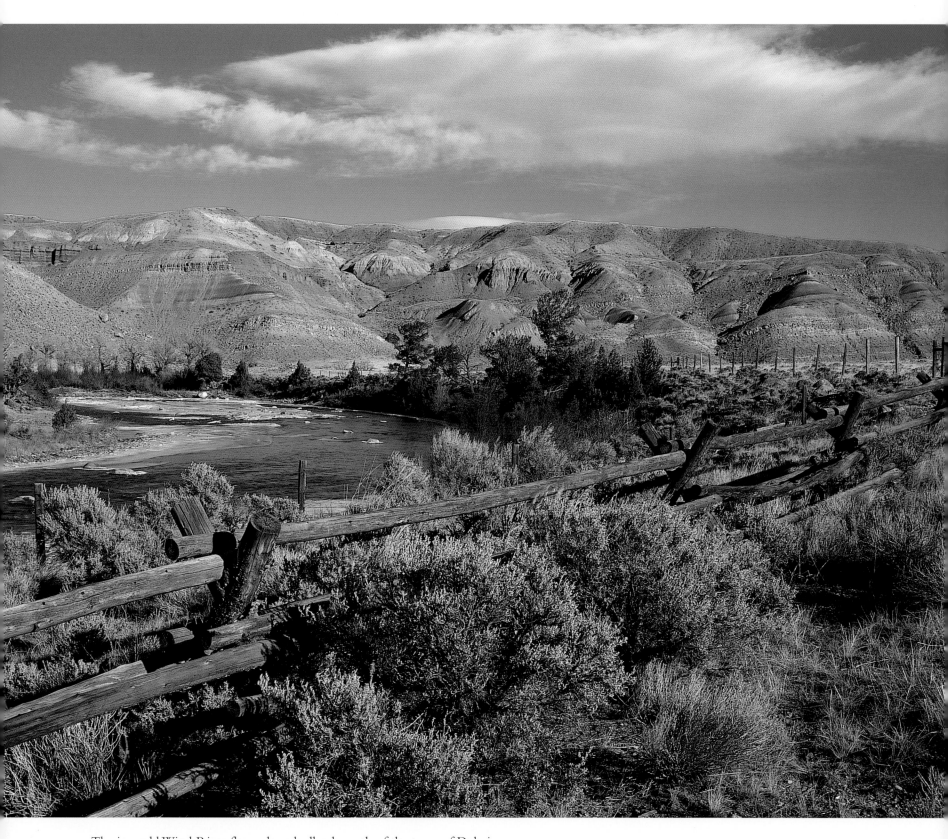

The icy cold Wind River flows along badlands south of the town of Dubois.

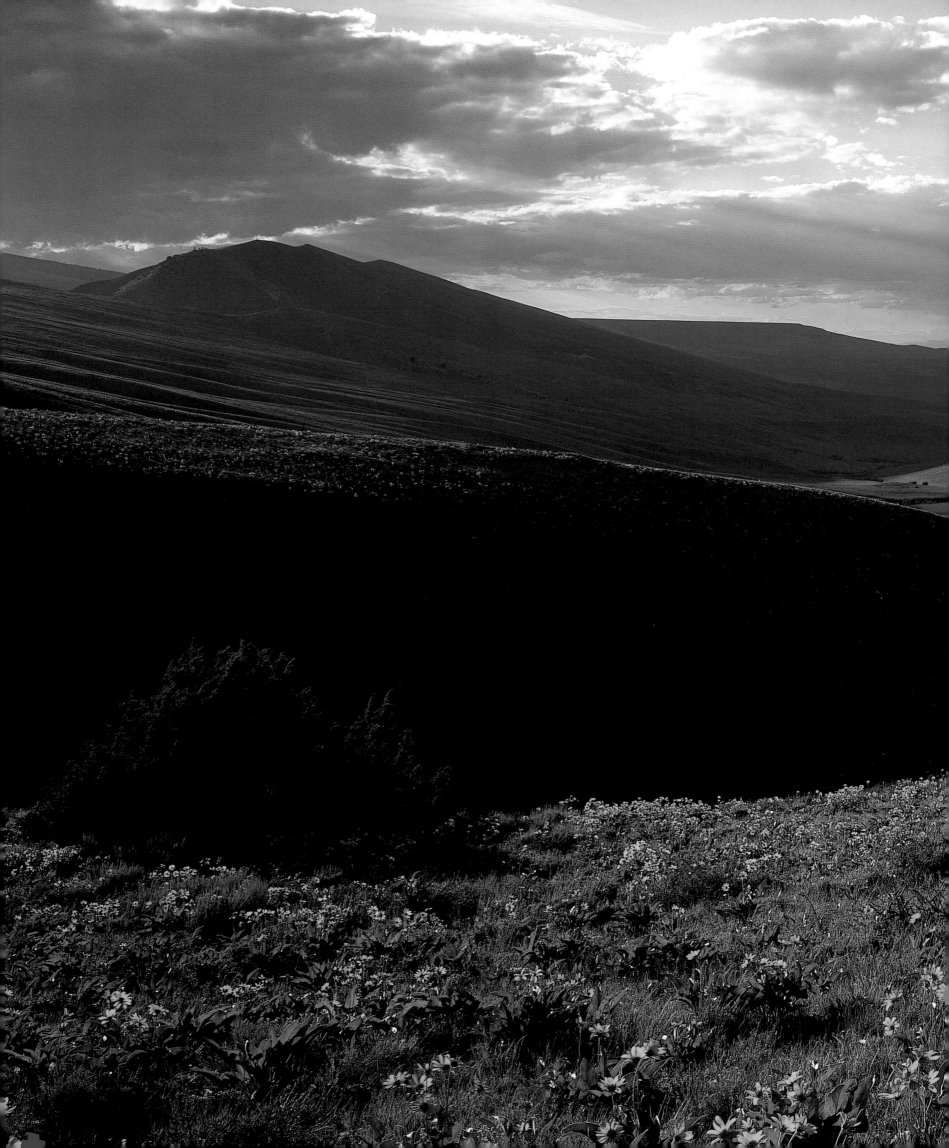

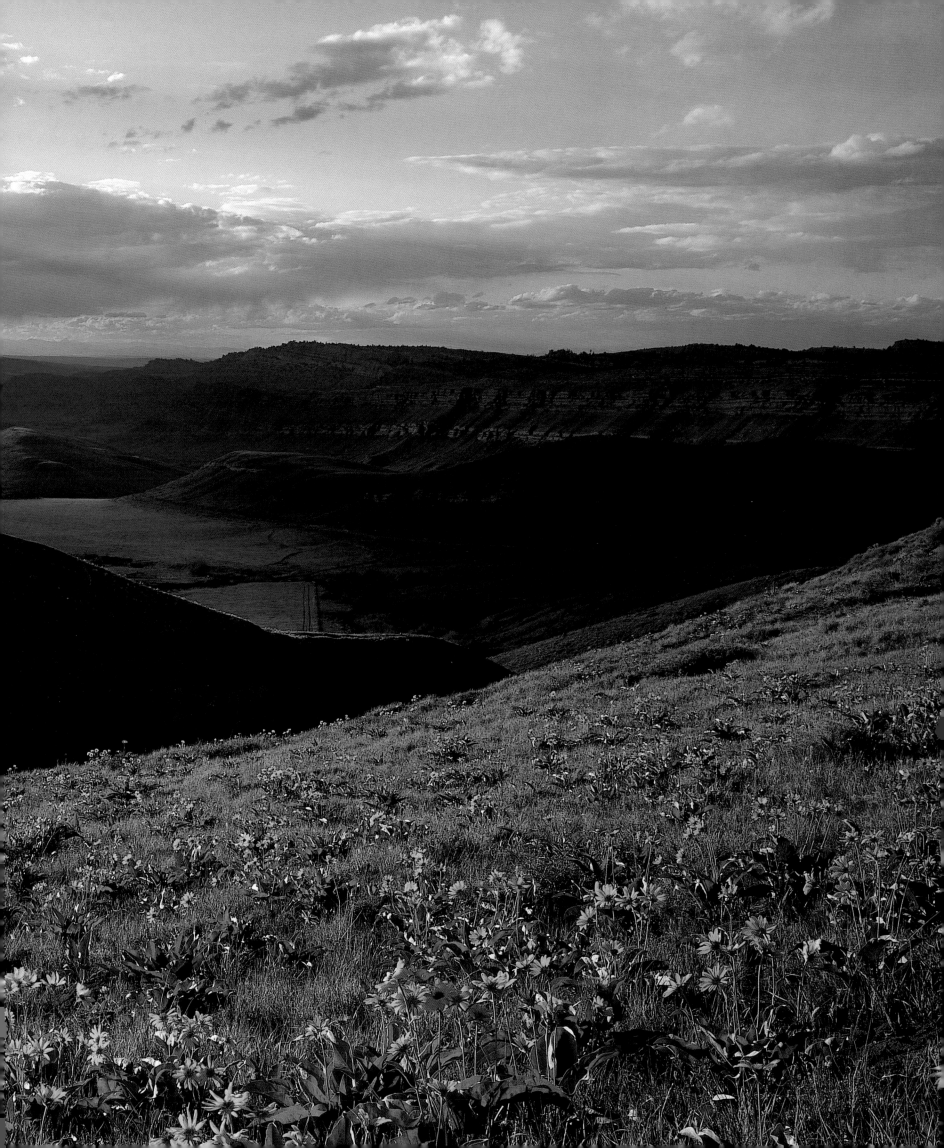

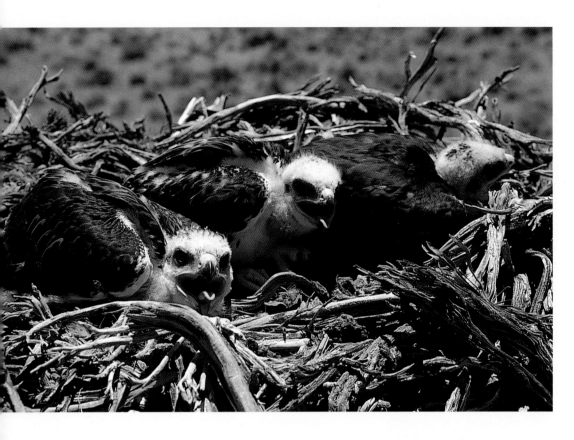

PRECEDING PAGES: Balsamroot dots the hillside above Red Canyon. This beautiful region south of Lander contains a wildlife management area that is closed for parts of the year to protect critical wildlife habitat.

LEFT: Swainson's hawk fledglings wait for their parents to bring them their next meal. This raptor bears the name of an early nineteenth-century natural history illustrator, Englishman William Swainson.

BELOW: Trail Town's historic buildings and exhibits were reassembled on the first site of the frontier town of Old Cody. Among the artifacts found here are the grave of John "Jeremiah" Johnson and a log cabin used by Butch Cassidy, the Sundance Kid, and other members of the Wild Bunch.

FACING PAGE: The cascading waters of Shell Creek have carved this magnificent gorge on the west side of the Bighorn Mountains out of ancient Precambrian granite, some of the oldest rock on earth.

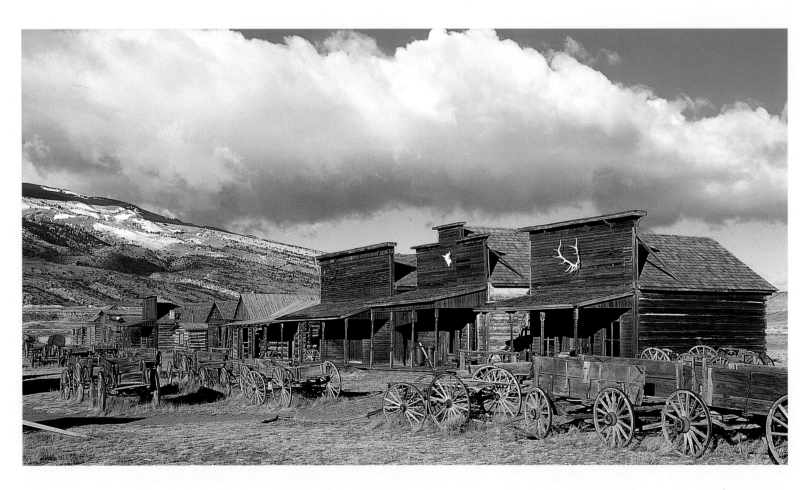

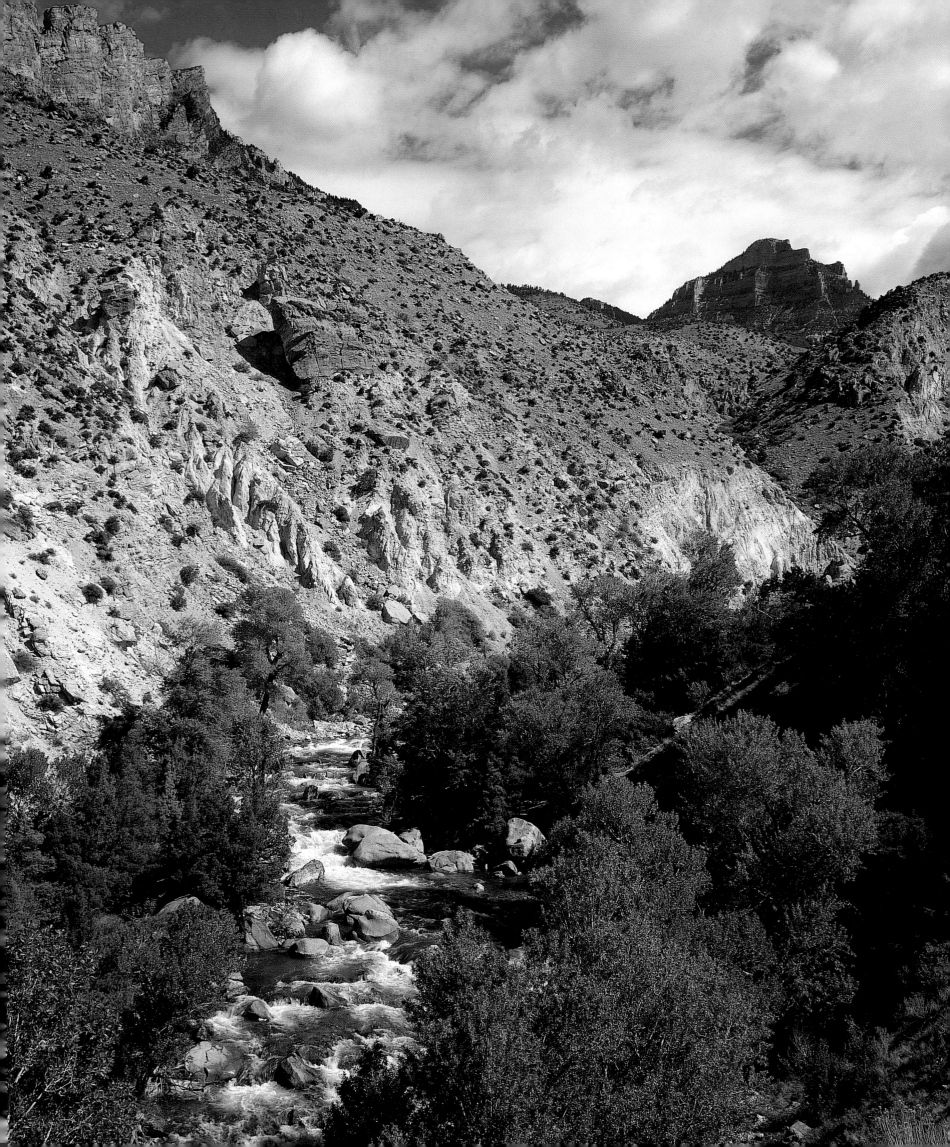

RIGHT: Early morning light creates a dazzling display of autumn color in the Teton section of the Bridger-Teton National Forest. This shot was taken just south of the Triangle X Ranch on a back road paralleling Grand Teton National Park.

BELOW: The courtship display of the male blue grouse is one of the earliest signs of spring in the high mountain forests. This swain seeks a female near the top of Signal Mountain in Grand Teton National Park.

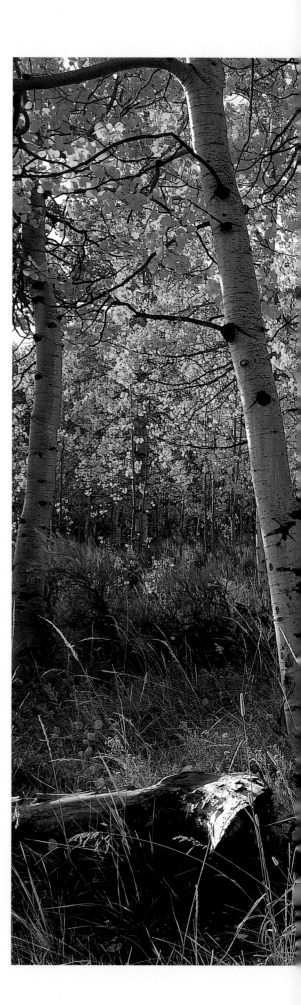

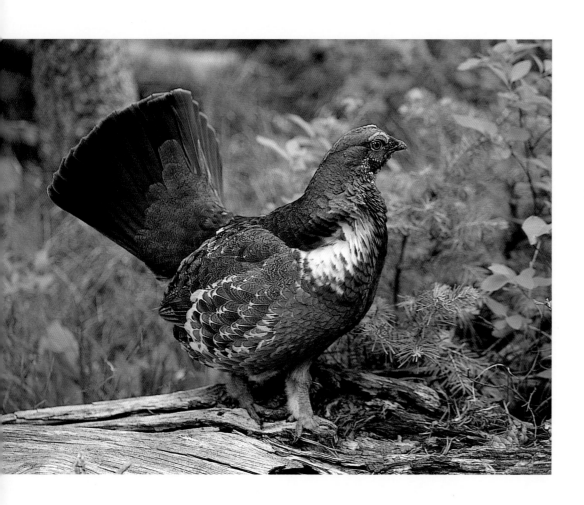

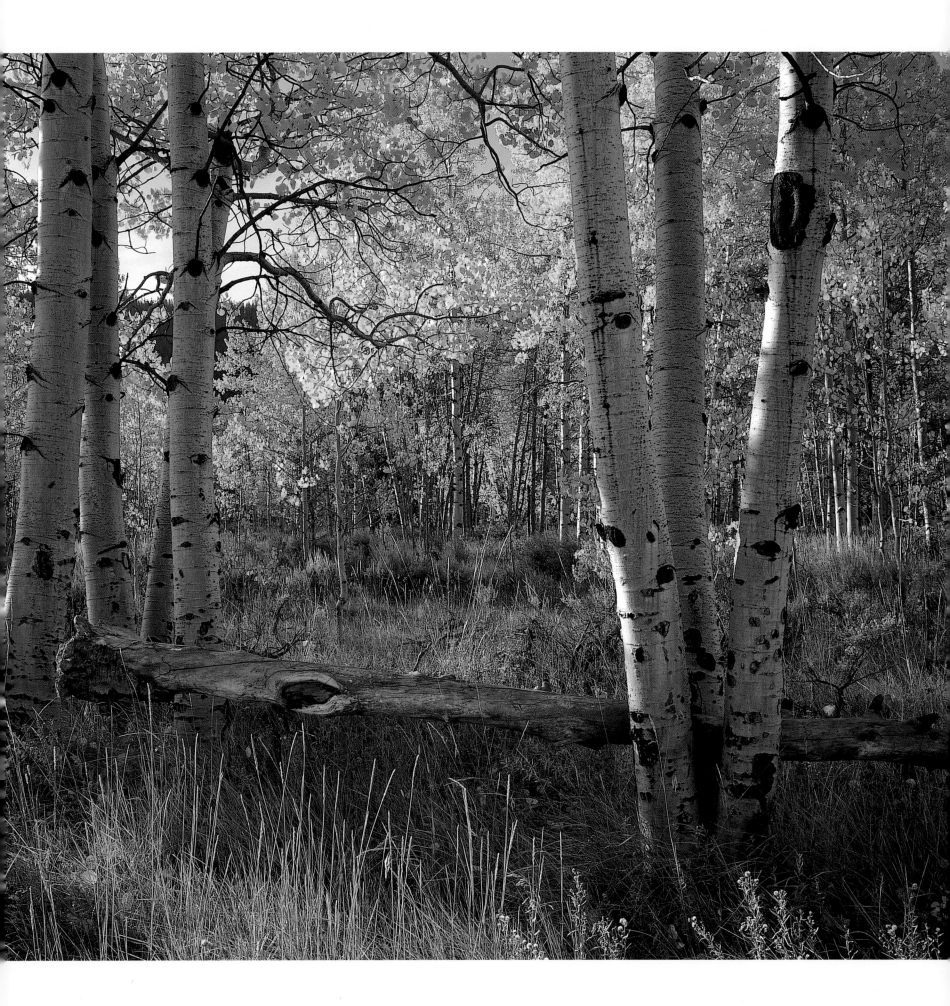

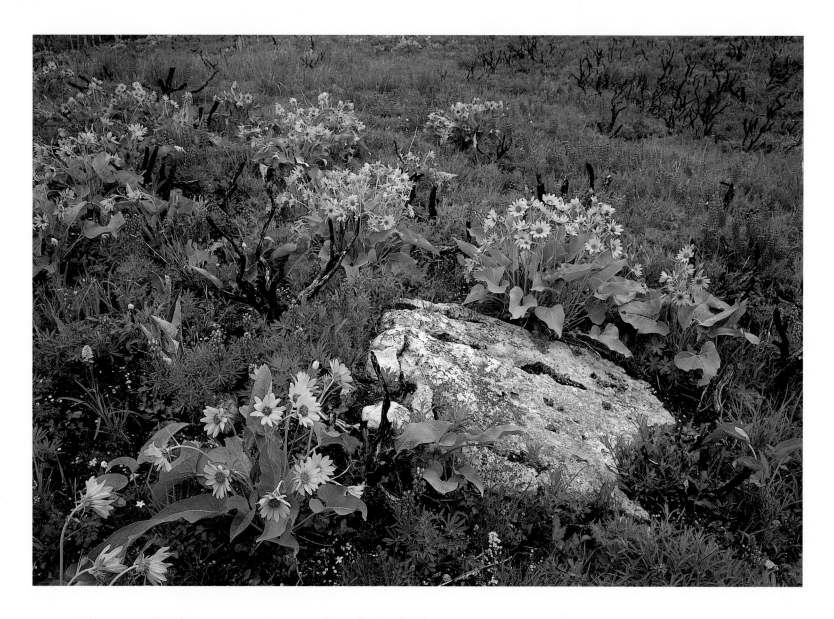

ABOVE: Wherever you find balsamroot growing you will usually also find lupine. Notice the signs of a recent fire that scorched the sagebrush and fertilized the soil for this tandem of species high on the western slopes of the Bighorn Mountains.

FACING PAGE: Cumulus clouds float slowly over Beartooth Butte and Beartooth Lake in the Shoshone National Forest. This peak on the Beartooth Plateau lies near the southern terminus of the Beartooth Mountains along the Wyoming–Montana border.

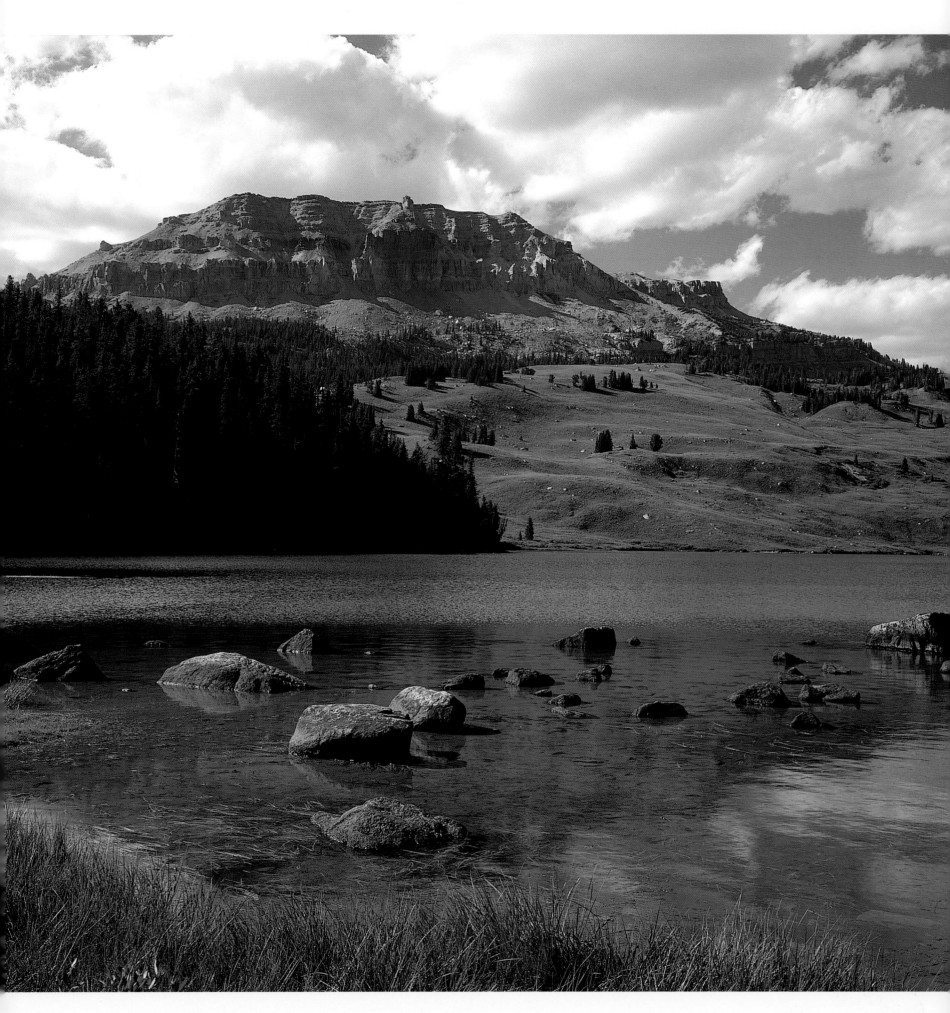

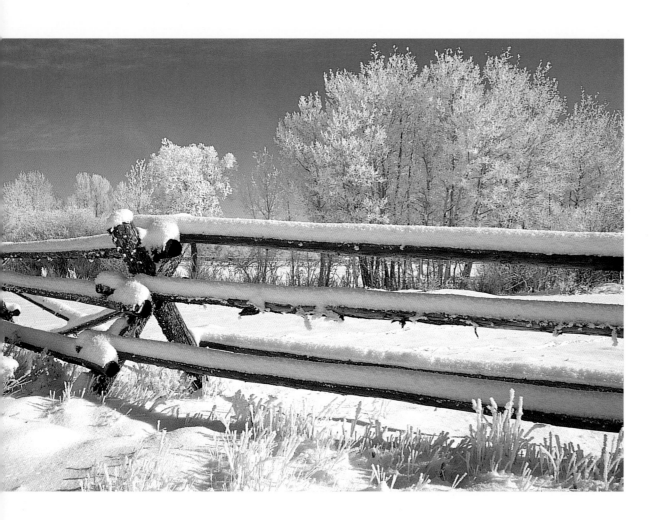

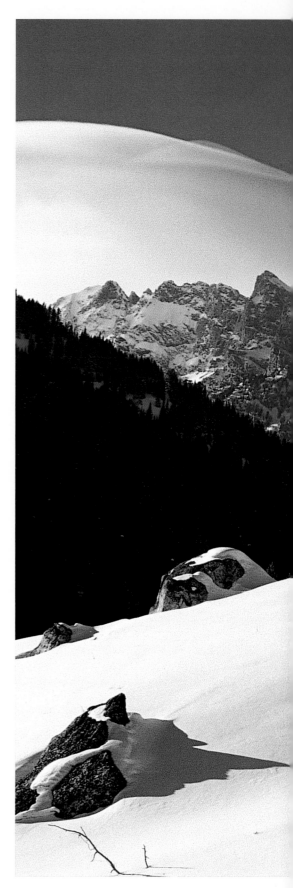

ABOVE: Fresh snow and hoarfrost turn this Sublette County landscape into a winter wonderland.

RIGHT: Cross-country skiers make their way to the frozen shores of Taggart Lake beneath the gaze of the Tetons.

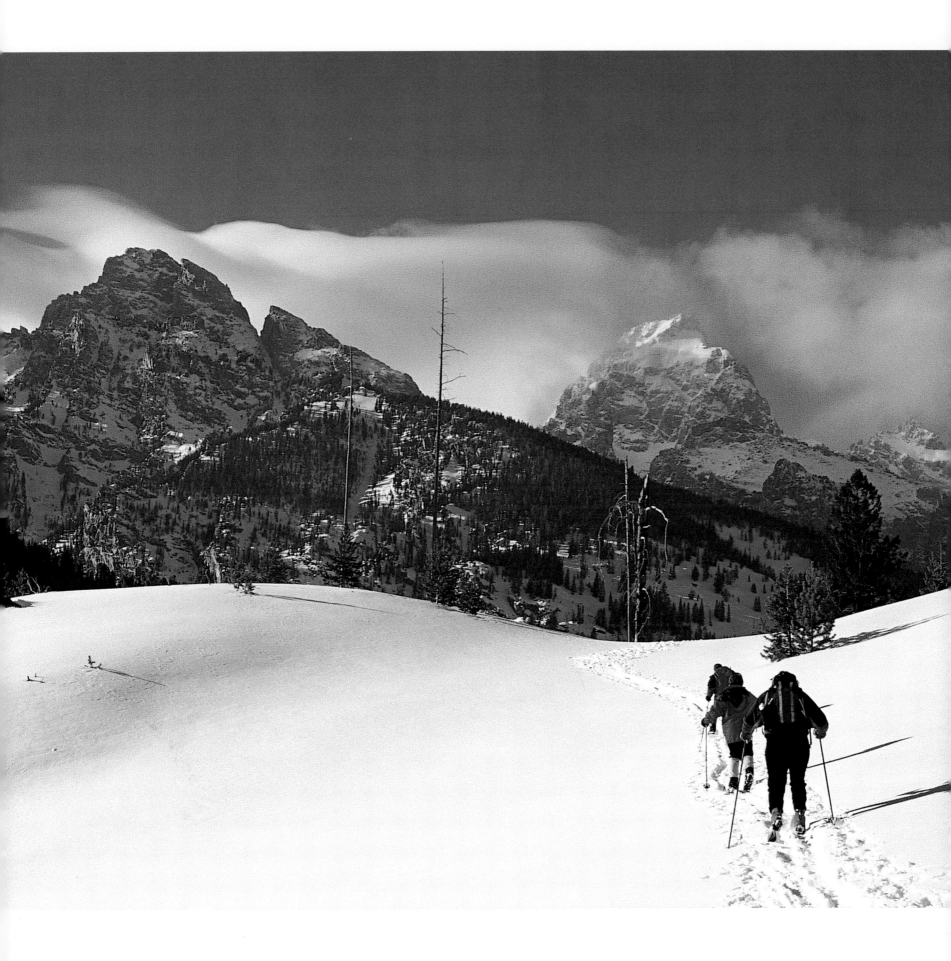

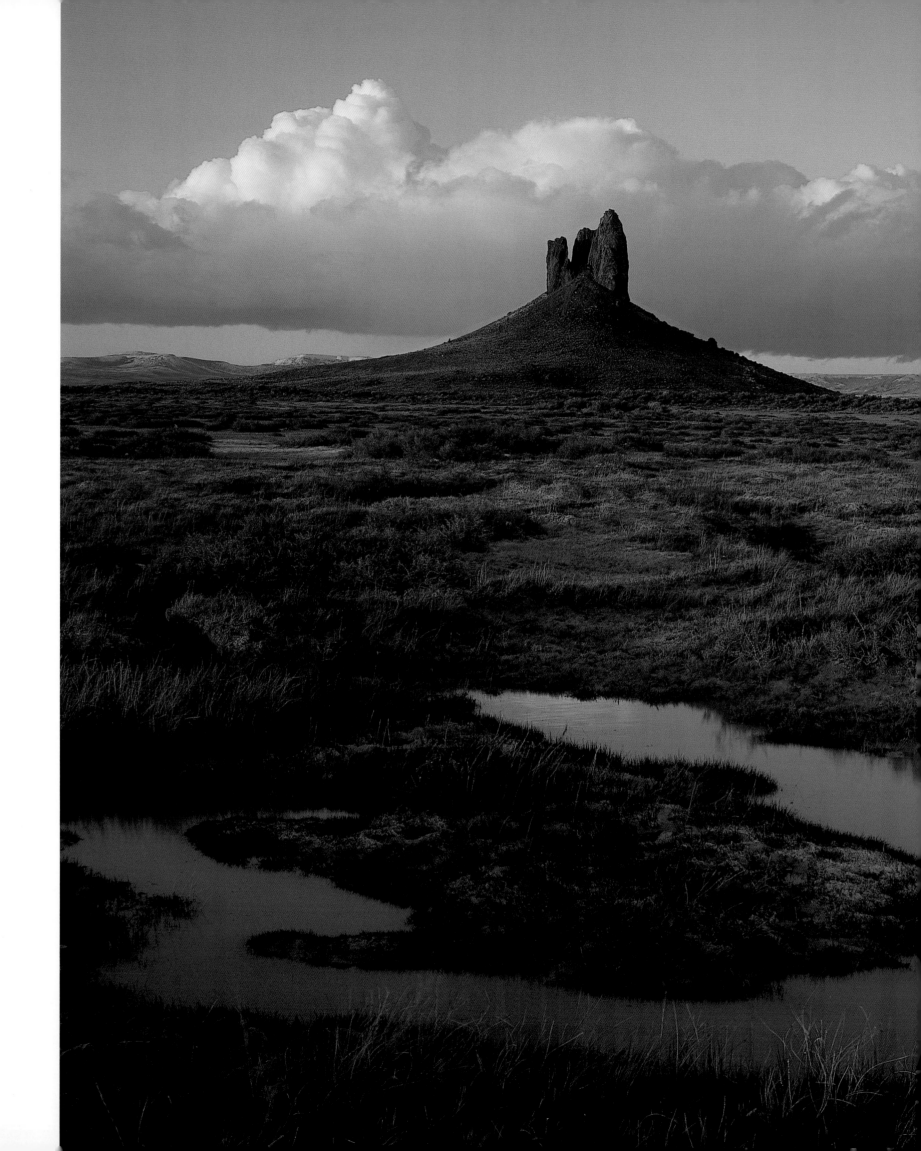

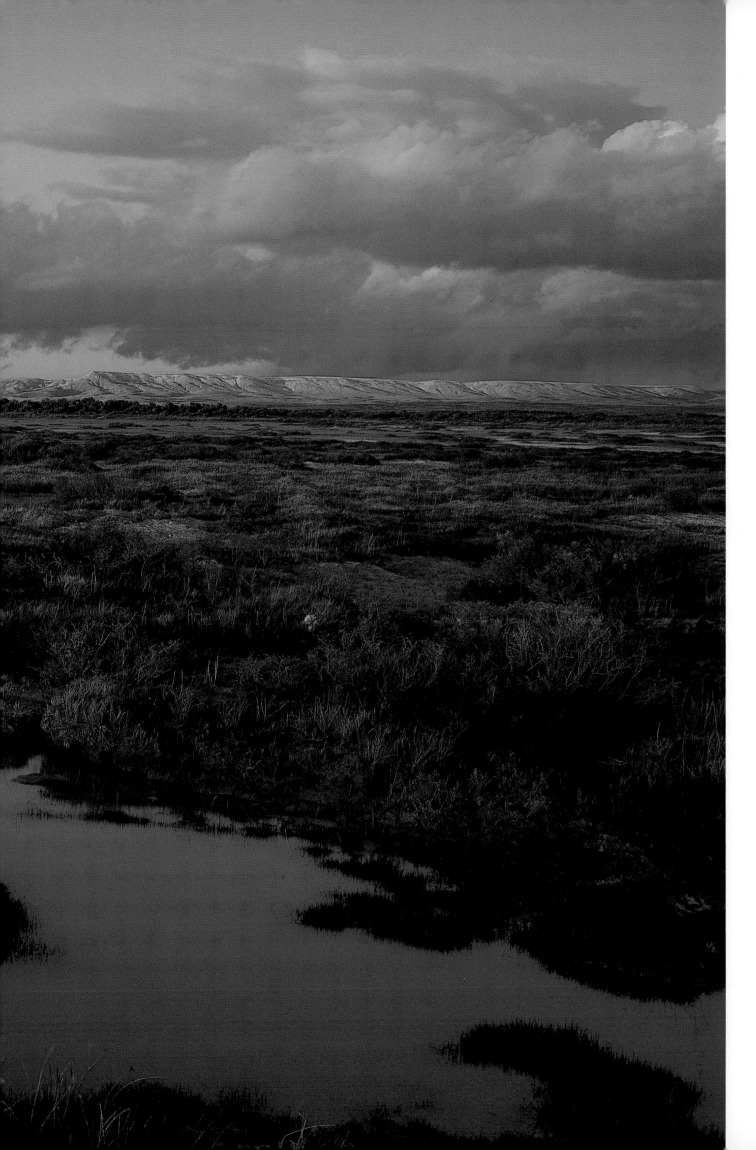

Boars Tusk is at the center of controversy as environmentalists wrestle with the oil and gas industry over just how much of this beautiful area located on Bureau of Land Management land should be drilled.

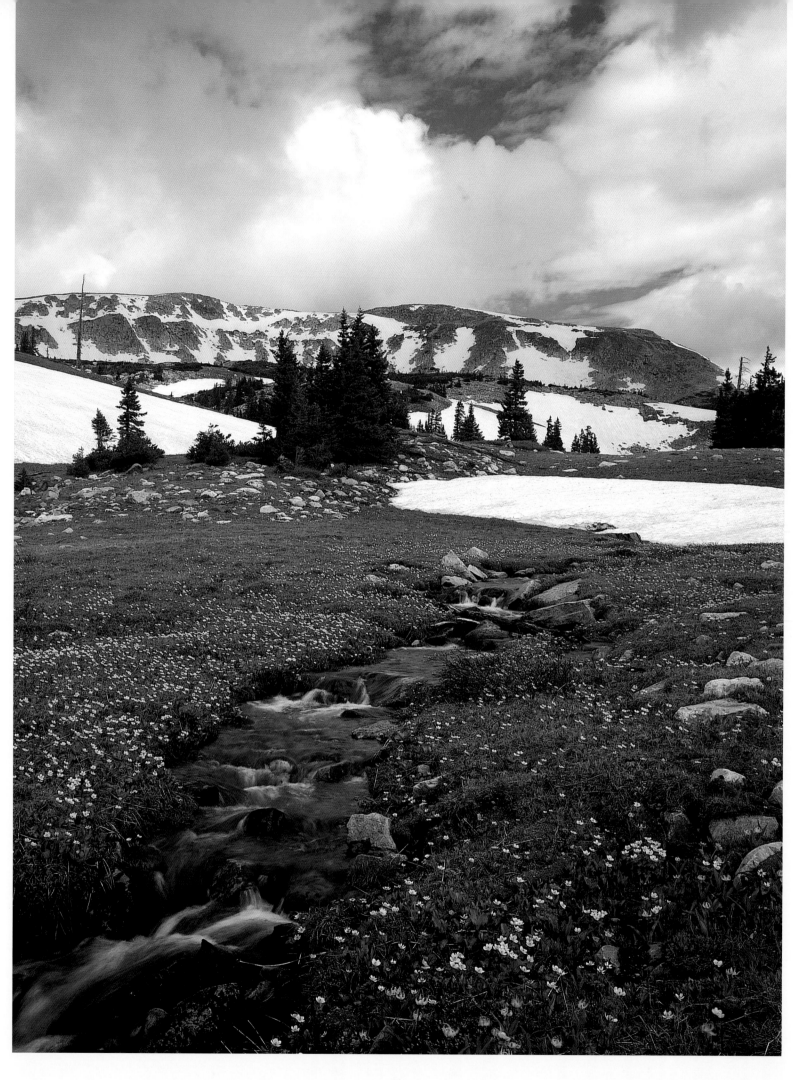

RIGHT: The waters of the New Fork River in the upper reaches of New Fork Canyon turn emerald green as the last light of the day ascends the canyon walls.

BELOW: A cow moose grazes undisturbed in a meadow high in the Beartooth Mountains of the Shoshone National Forest.

FACING PAGE: Snowmelt sloshes through a meadow beneath the peaks of the Snowy Range. Located in the Medicine Bow National Forest, the Snowy Range Scenic Byway passes through an area of extreme natural beauty punctuated by crystal-clear alpine lakes, wind-sculpted stands of trees, and glacier-carved rock.

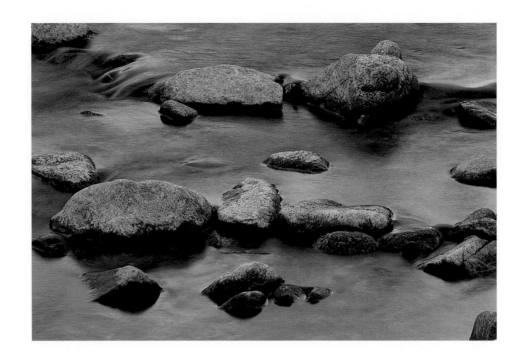

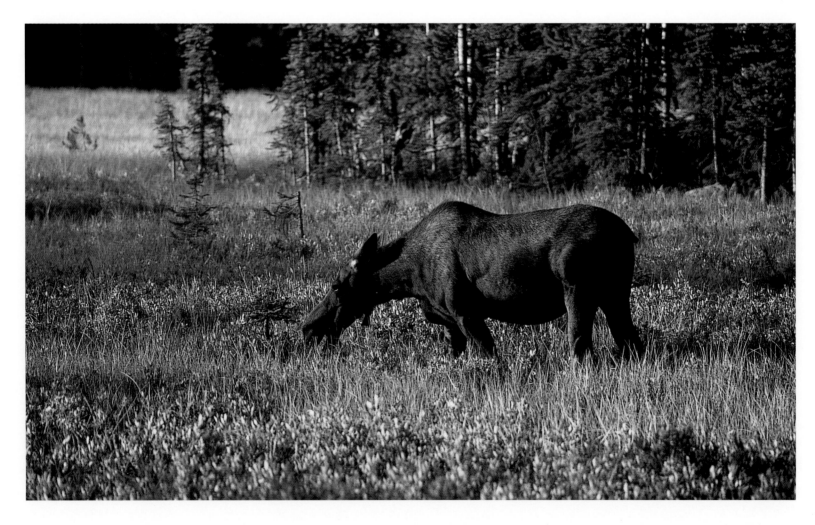

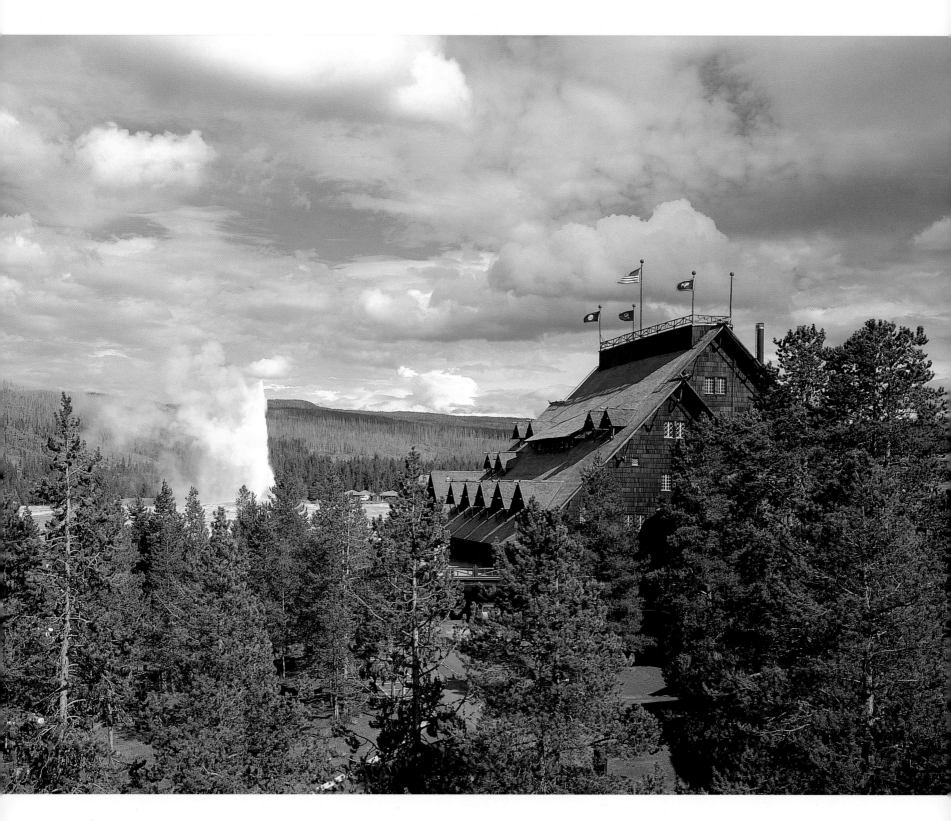

ABOVE: Old Faithful Inn is as much of a landmark in Yellowstone National Park as the geyser for which it was named.

FACING PAGE: Volcanic rock at Storm Point on the shores of Yellowstone Lake gives evidence of the area's geological past. This point of land jutting out on the north edge of Yellowstone Lake's 110 miles of shoreline is often pounded by violent storms.

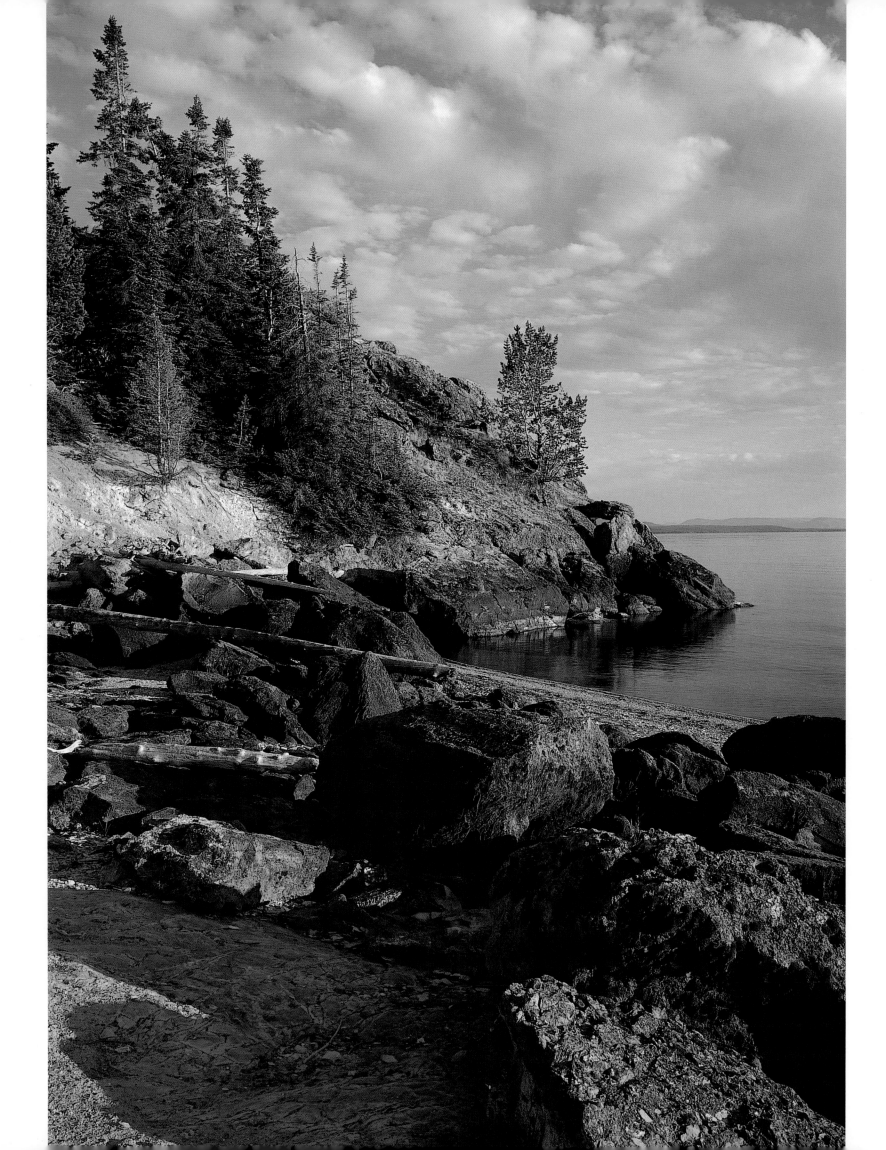

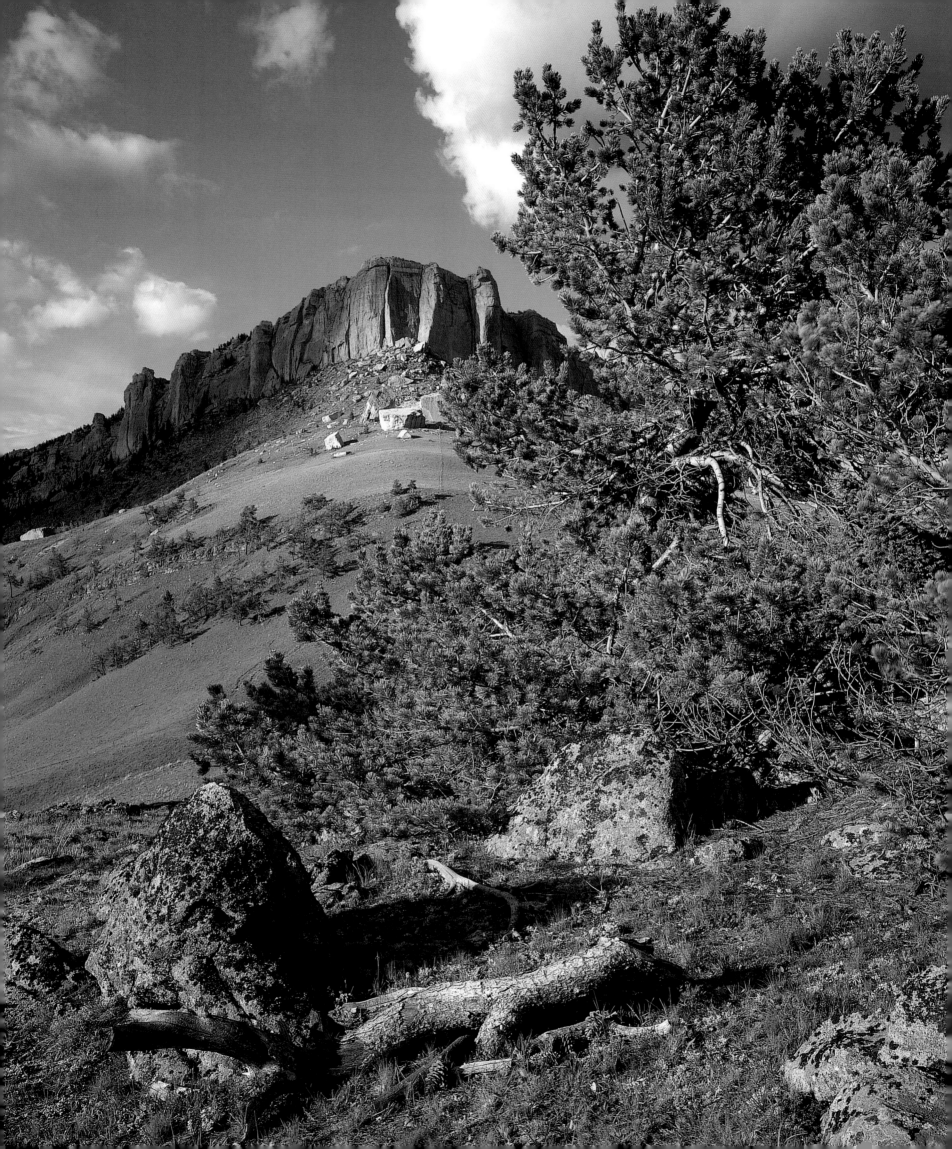

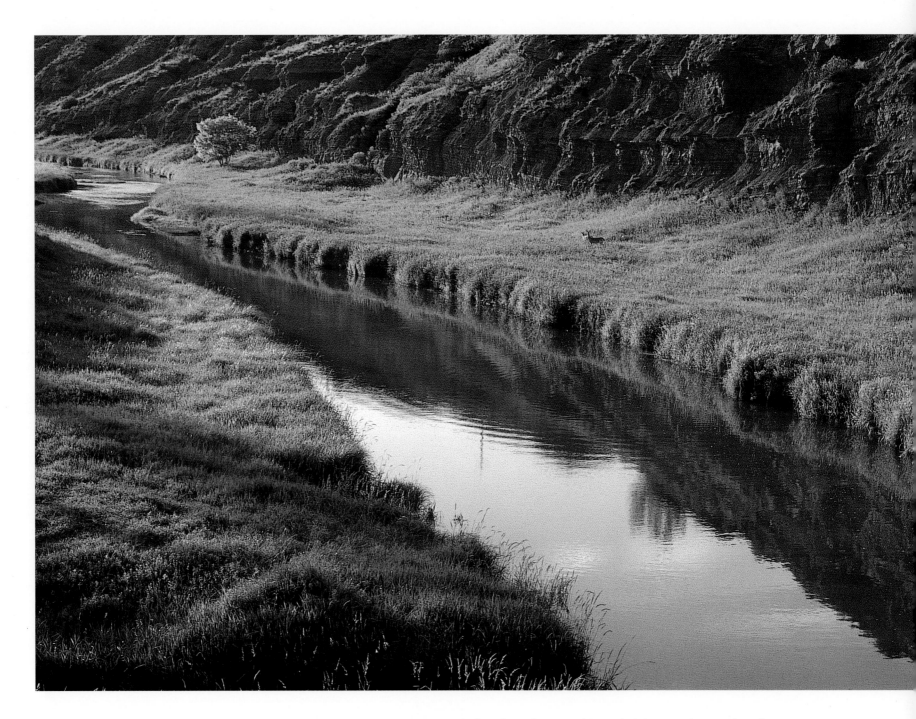

ABOVE: Search this photo for two white-tailed deer standing in the tall grasses along the Belle Fourche River near the town of Hulett in the northeastern part of the state.

FACING PAGE: Steamboat Rock points skyward along the Bighorn Scenic Byway. This prominent bluff of Bighorn dolomite is part of the Bighorn Mountains and is within the confines of Bighorn National Forest.

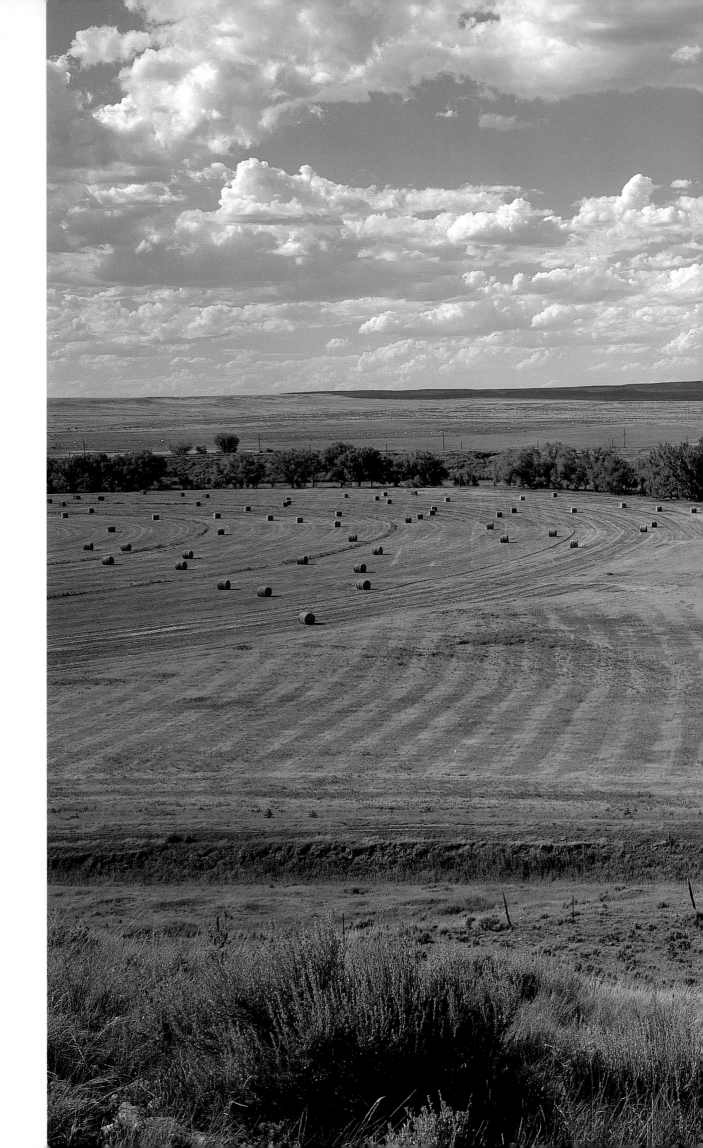

The North Platte River
meanders its way across
the ranch country west
of Douglas. During the
great westward migra-
tion in the mid-1800s
this waterway served as
an important corridor
for the many wagon
trains following what
became known as the
Oregon Trail.

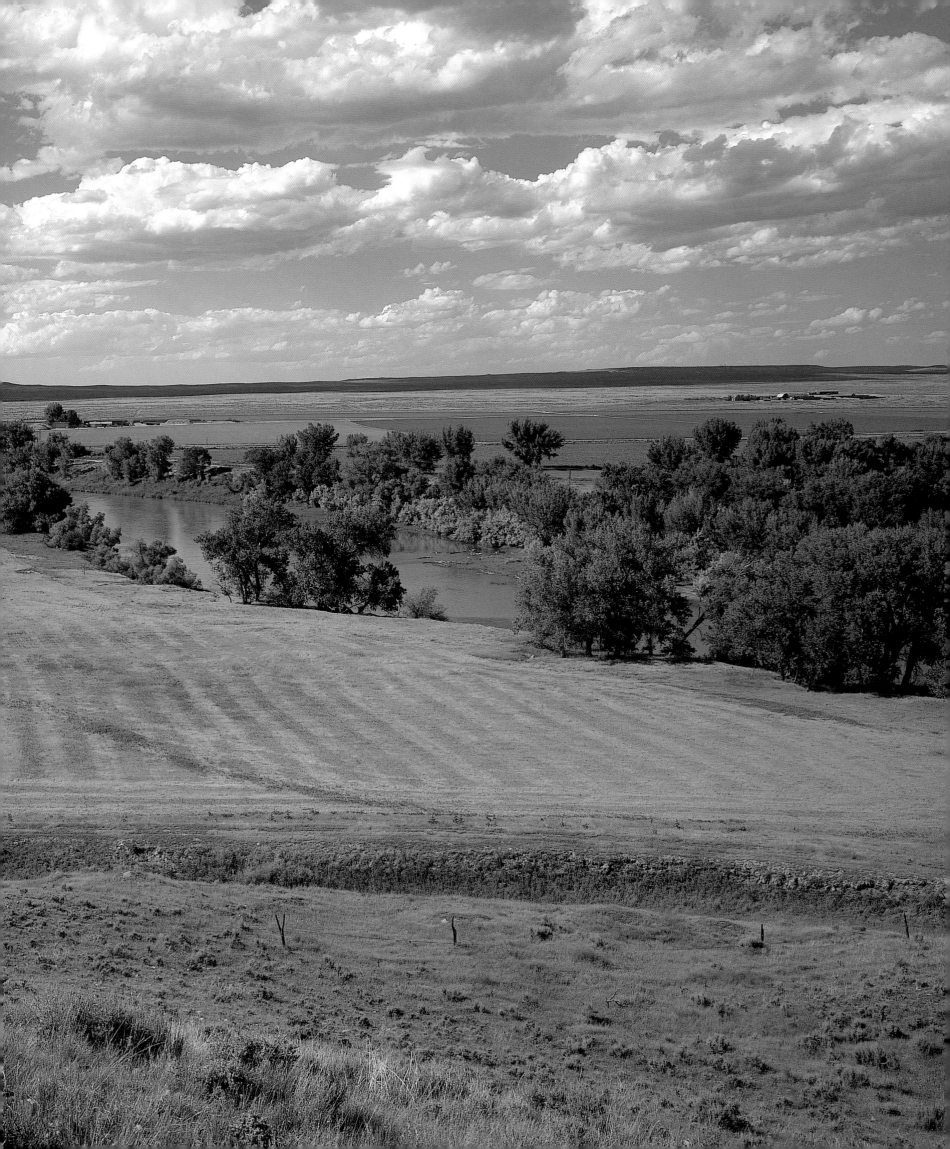

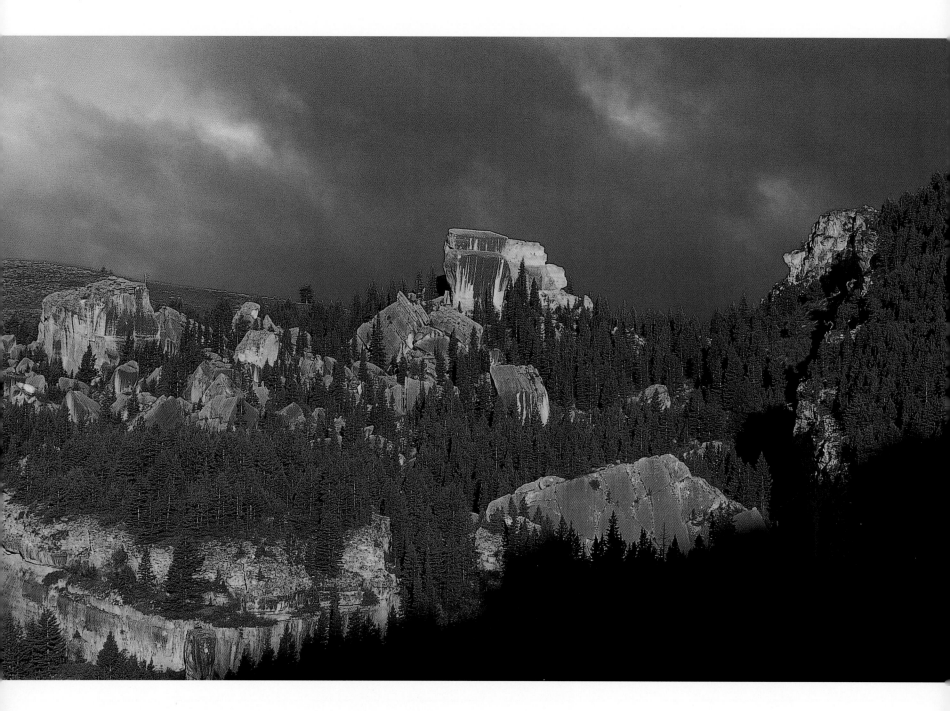

An overlook about 11 miles west of the town of Dayton on the Bighorn Scenic Byway offers a view of Fallen City. This interesting piece of geology is a field of huge blocks of Madison limestone that have broken off the rocks above and slid down the slope, creating the appearance of a city fallen over.

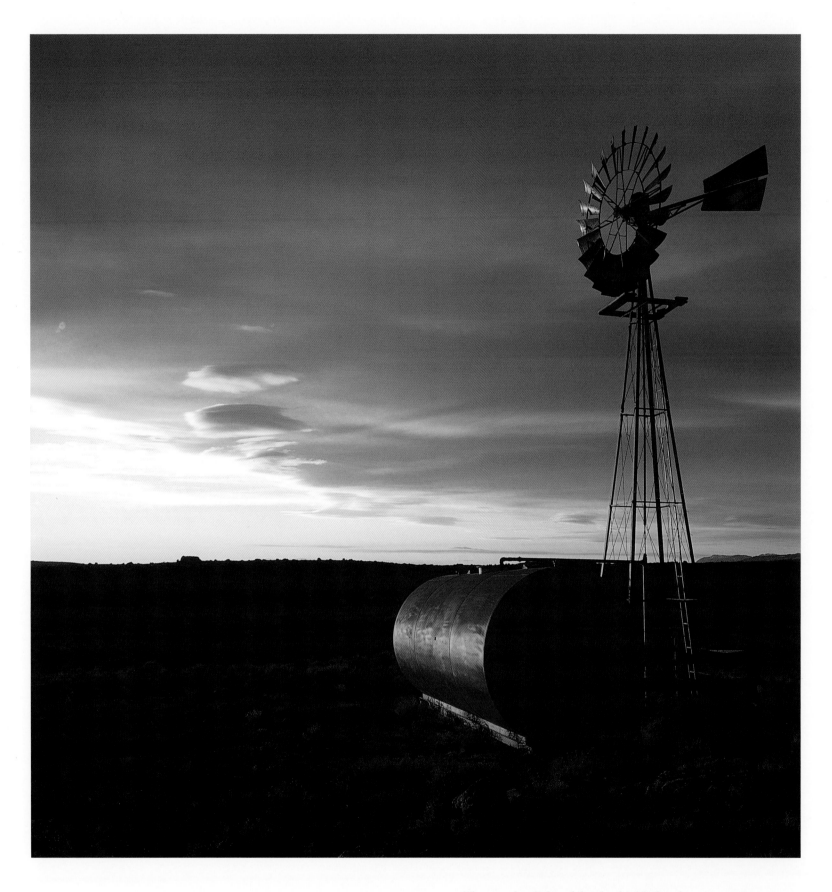

The very last light of the day highlights the vanes and water tank of this windmill north of Pinedale.

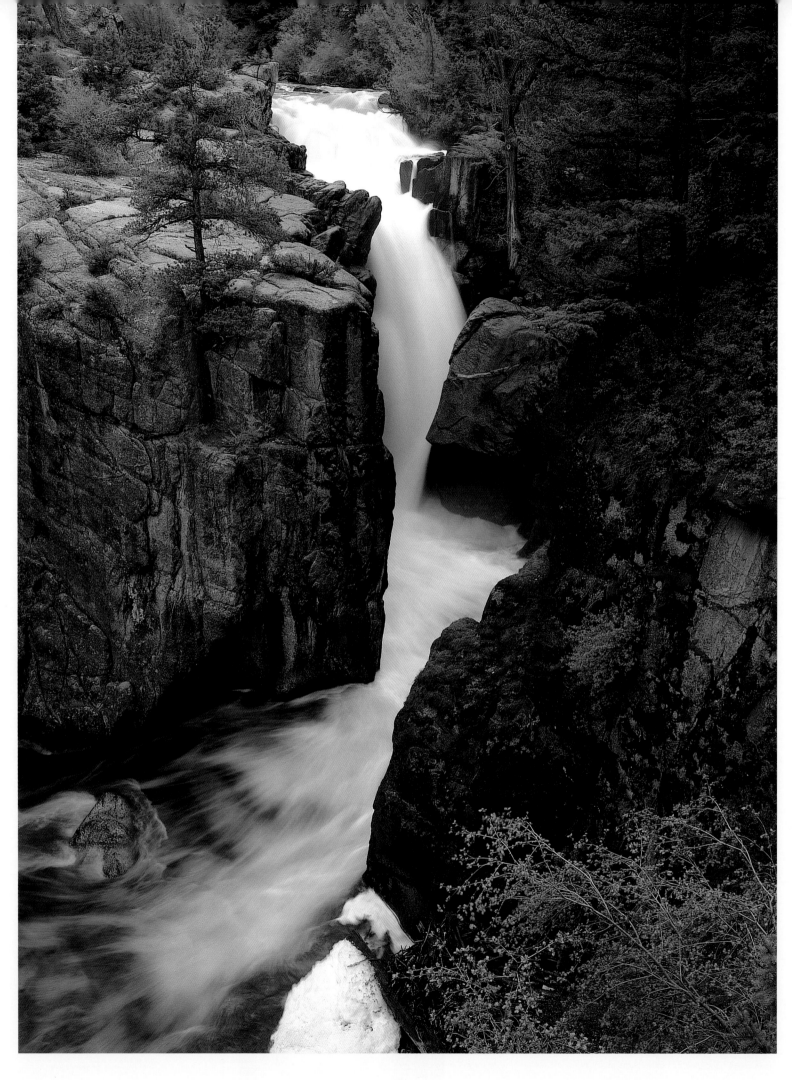

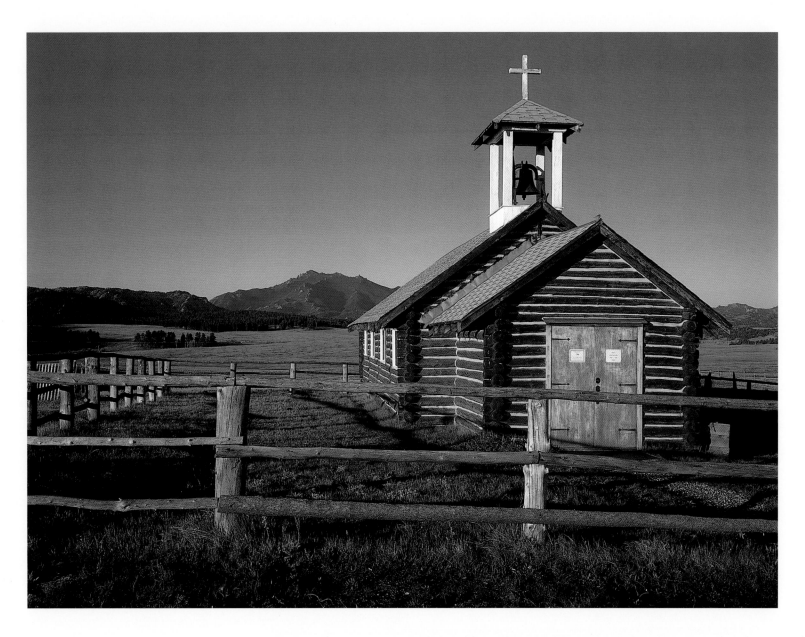

ABOVE: This quaint Episcopal chapel located in a grassy meadow below Laramie Peak is the site of many summer weddings. At 10,274 feet, Laramie Peak is the highest summit in the Laramie Mountains and also the highest peak in this part of Wyoming. A well-maintained trail leads to its top; from there a person can see much of eastern Wyoming and parts of Nebraska, Colorado, and South Dakota. For the early pioneers coming west on the Oregon Trail, this peak was one of the first visible signs that they were approaching the Rocky Mountains.

FACING PAGE: The turbulent waters of Shell Creek roar 120 feet over Shell Falls. A stop-off along Shell Canyon on the Bighorn Scenic Byway has an information center, restrooms, and a paved nature trail that leads visitors to this viewpoint.

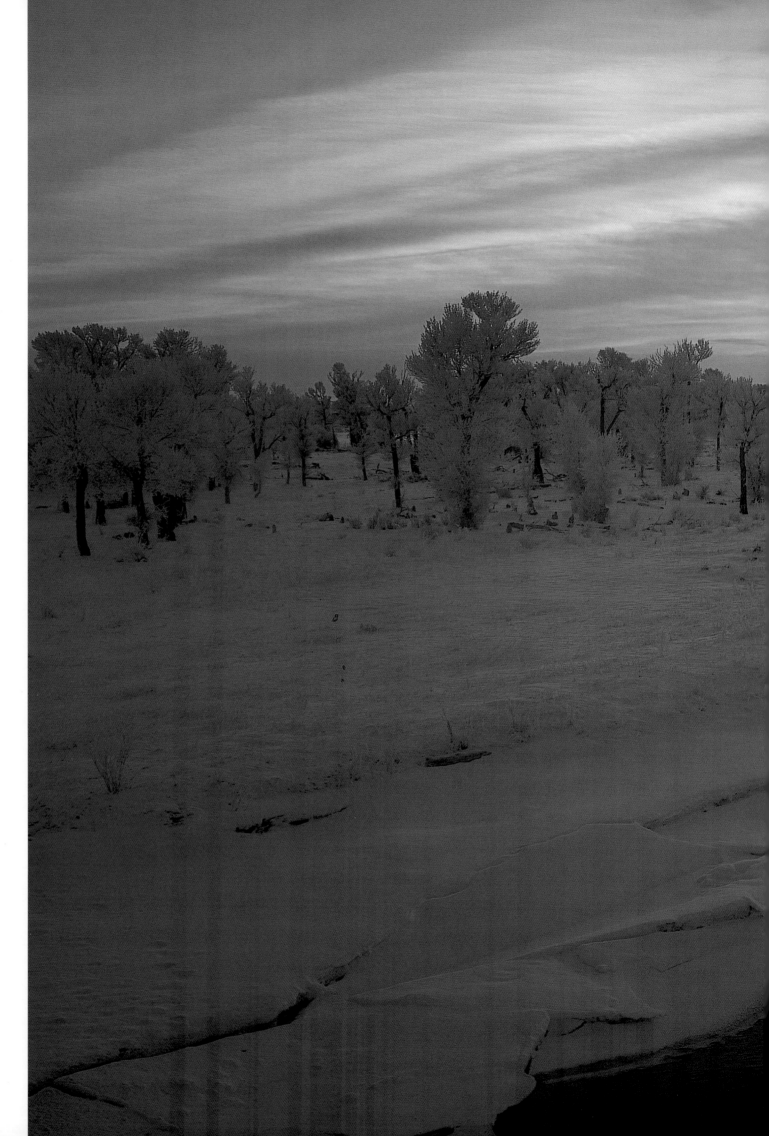

A chilly winter morn greets the Green River as it makes its way through the Seedskadee National Wildlife Refuge in Sweetwater County. Seedskadee derives its name from a Shoshone word meaning "Prairie Chicken River."

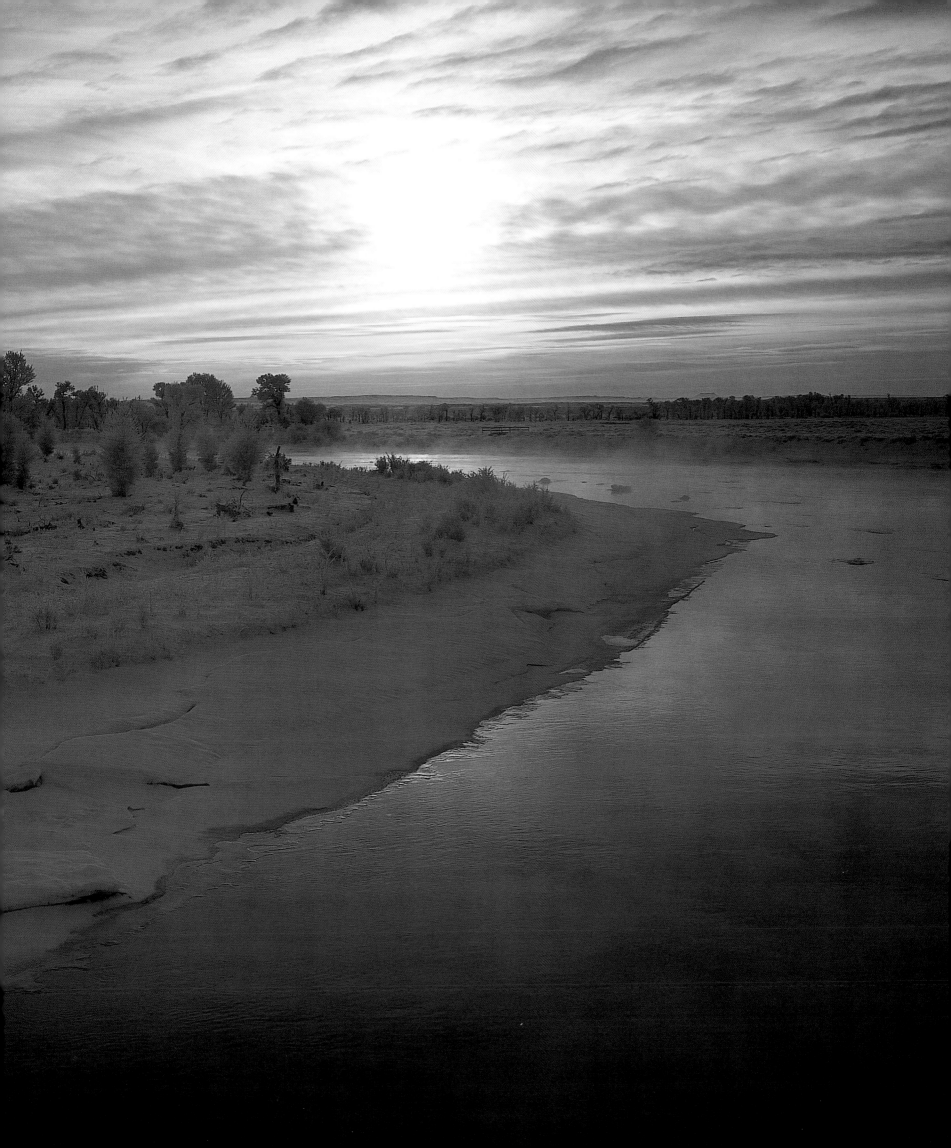

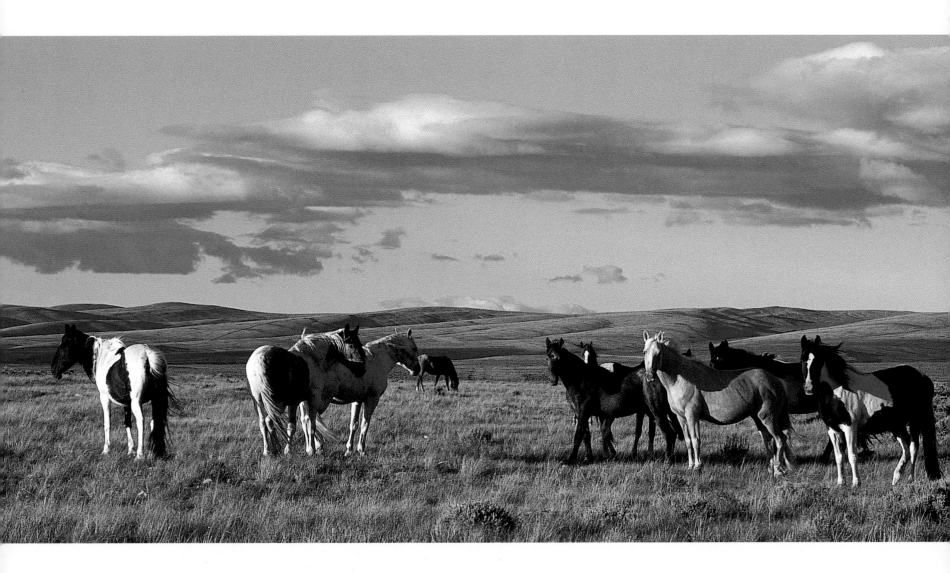

ABOVE: Wild horses remain a symbol of the Wild West. The origins of these animals date back to the days of Christopher Columbus and Hernando Cortez. Many of their descendants escaped or were abandoned between the late 1800s and 1930s. This band is part of a group of about 1,500 head that roam BLM land around Rock Springs. Periodically they are rounded up and put up for adoption. PHOTO BY MARCO RUBEK

FACING PAGE: The Killpecker Dunes east of Eden are part of a dune field that extends for nearly 100 miles, making it one of the largest in North America.

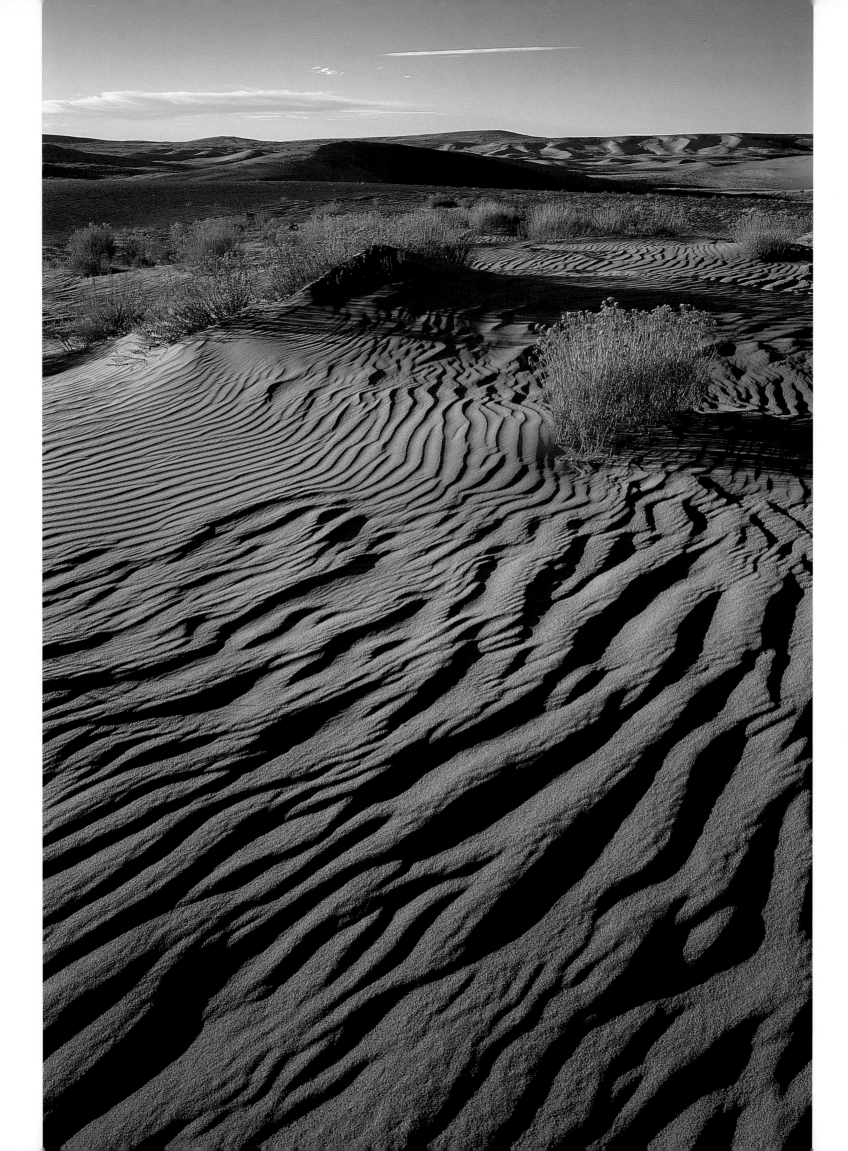

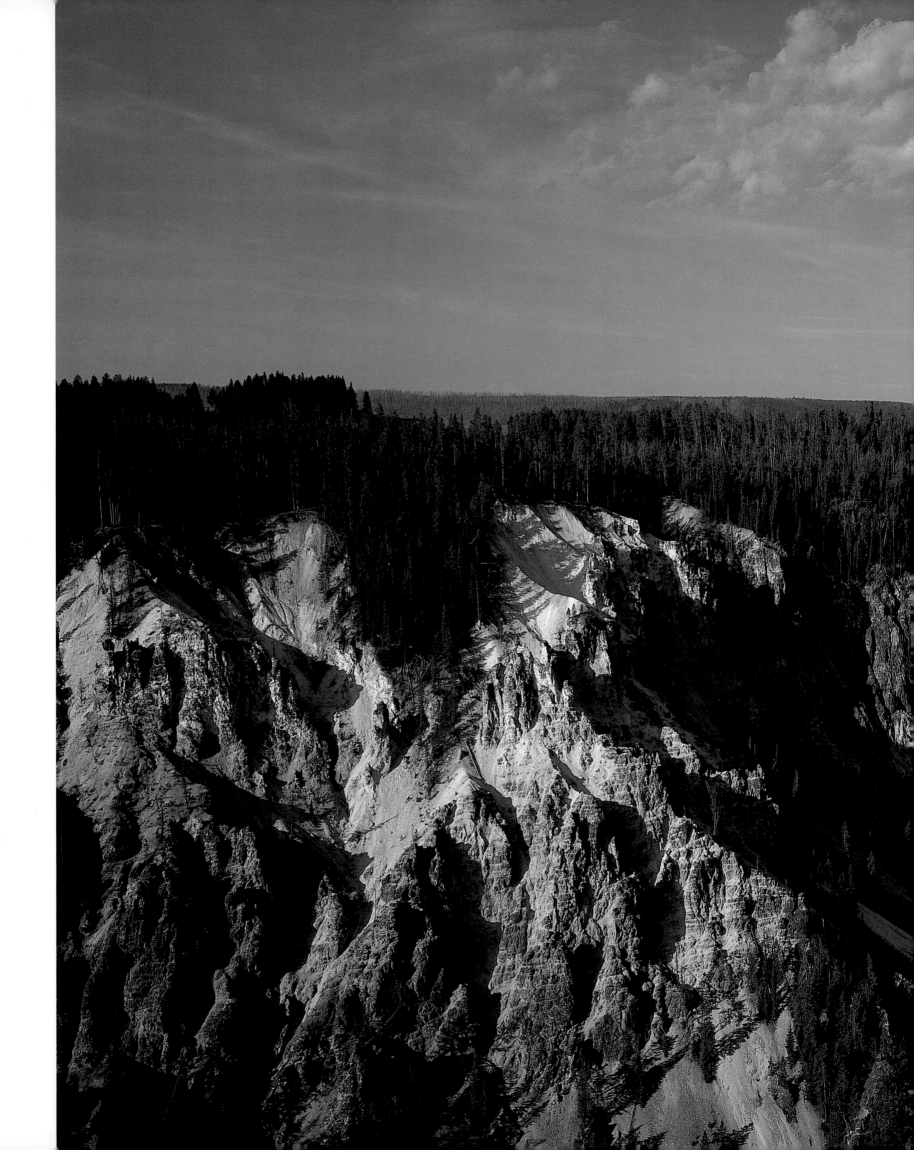

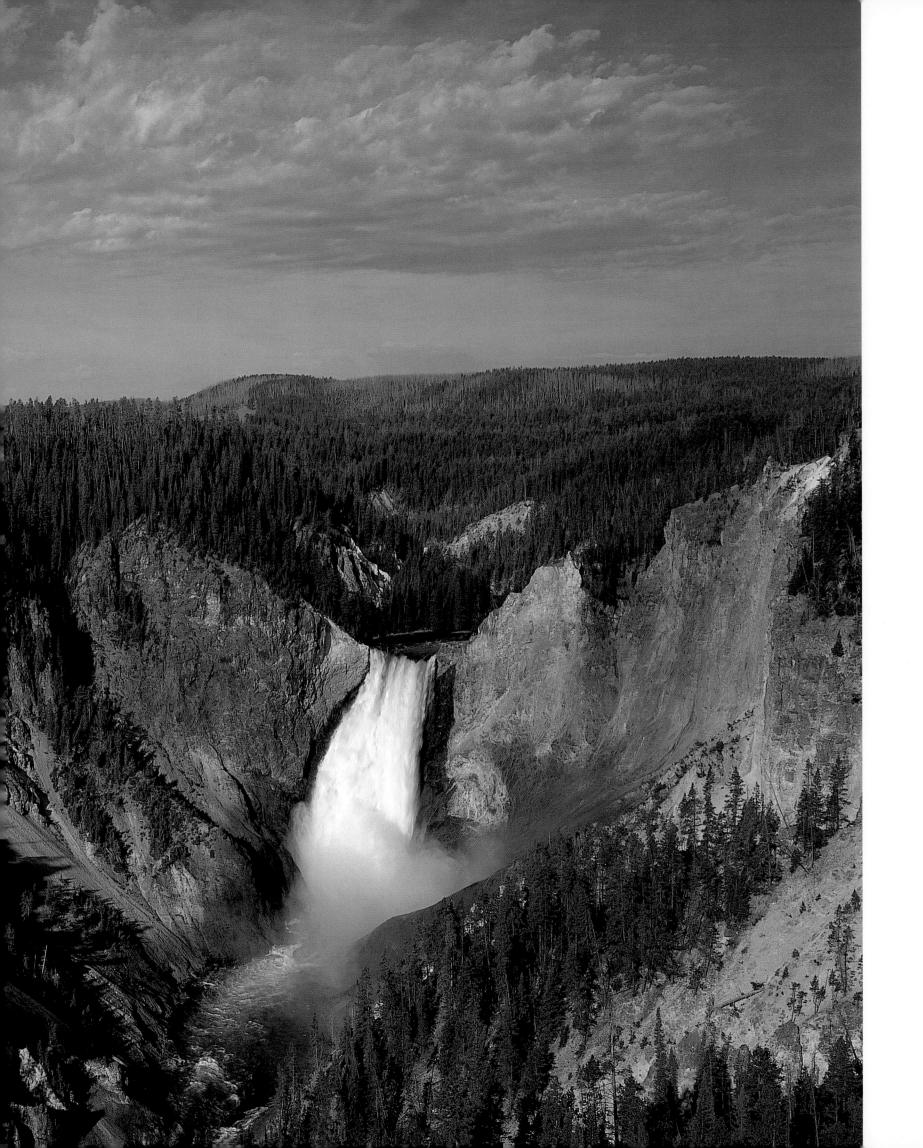

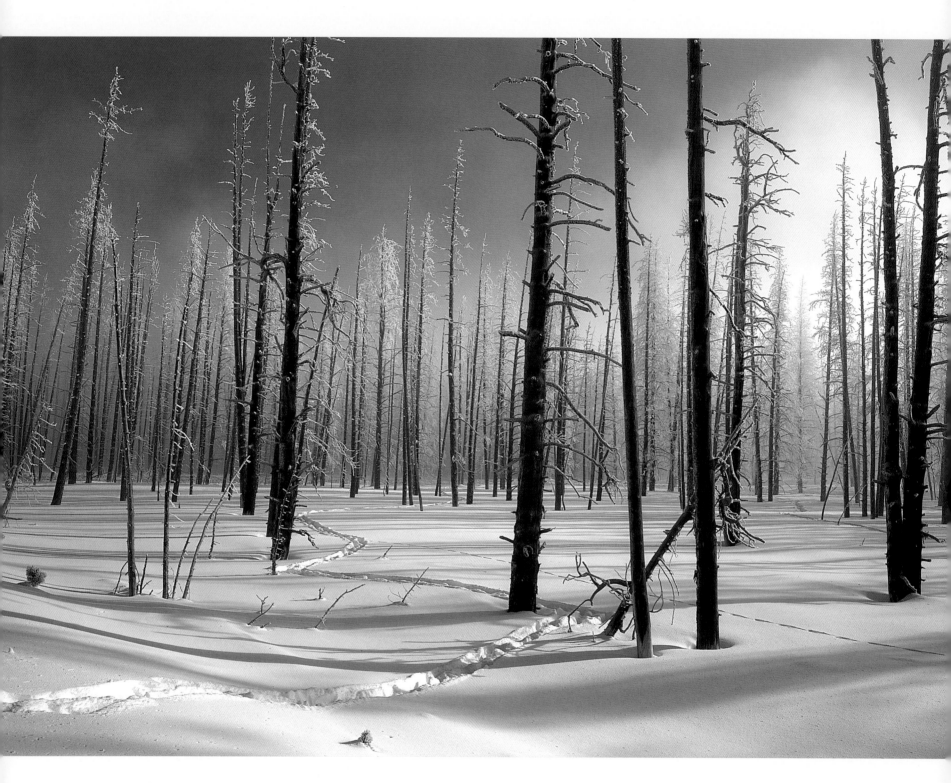

ABOVE: Winter fog lifts to reveal the ambling tracks left by one of Yellowstone's inhabitants as it made its way through a forest of dead conifers near the Lower Geyser Basin.

PRECEDING PAGES: Lower Falls crashes 308 feet into the Grand Canyon of the Yellowstone River. This view is from Lookout Point.

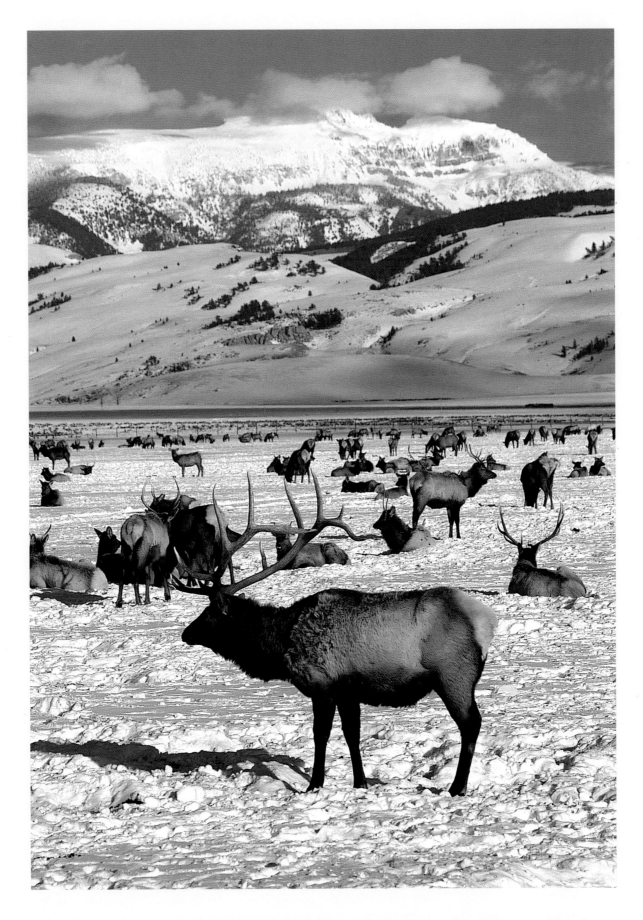

Elk congregate on the National Elk Refuge outside Jackson. This 39-square-mile reserve was established in 1912 after the development of Jackson and the surrounding country disrupted the traditional migration routes of these large mammals. When snow covers the pasture, the sometimes more than 8,000 elk are fed alfalfa hay pellets.

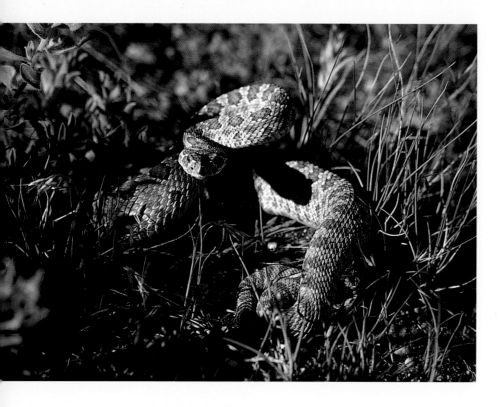

LEFT: This prairie rattlesnake living in the North Platte River Valley isn't happy about being disturbed.

BELOW: Despite being quite arid, the land within the Bighorn National Recreation Area north of Lovell is still able to support an interesting plant community.

FACING PAGE: Whiterock and Squaretop Mountain are reflected in the Green River near Green River Lakes. This is a classic view of this much-photographed area in the Wind River Mountains.

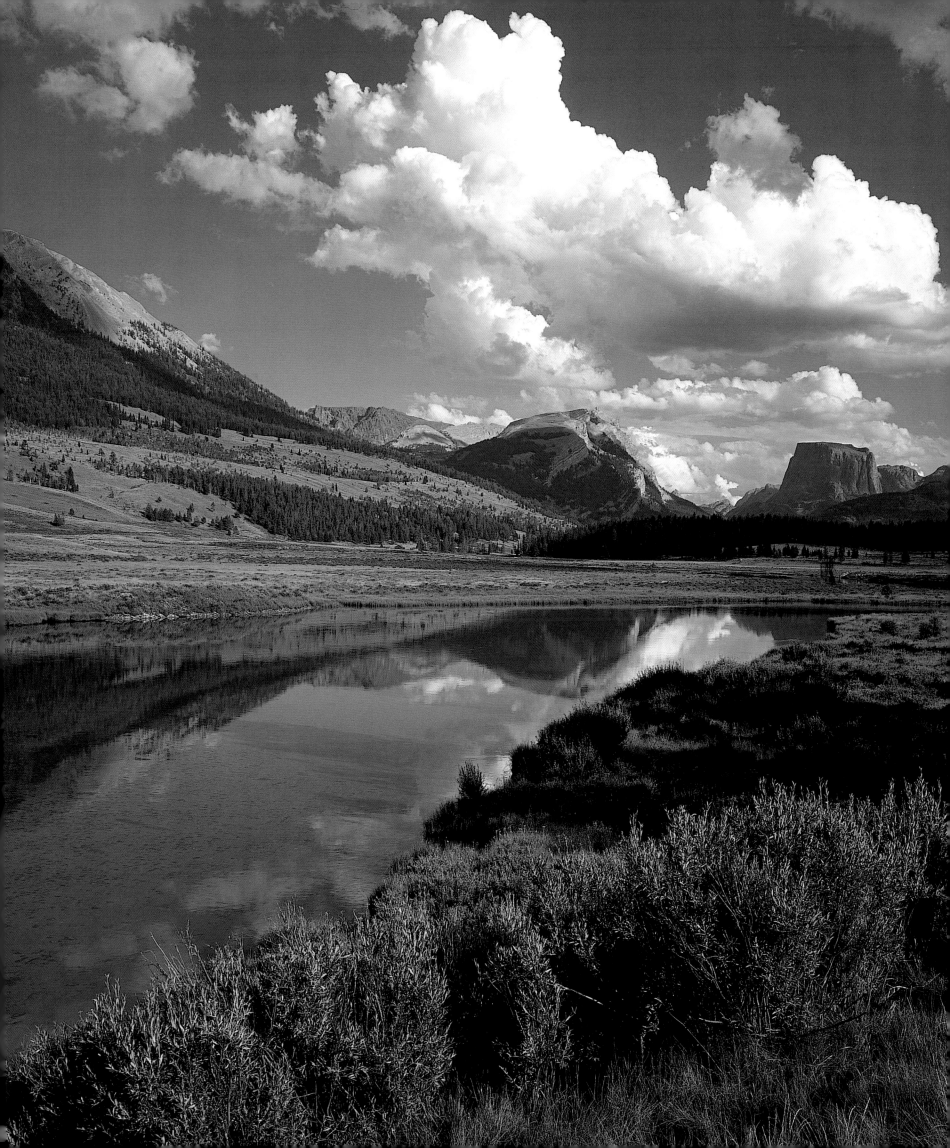

RIGHT: Sunset transforms Elbow Lake into a sea of tranquillity. Campers and photographers often relax on the shores of this wild and beautiful lake.

BELOW: Christmas lights decorate one of the four immense elk antler arches located in the Town Square in Jackson. Known around the world as Jackson Hole, this tourist community has a vigorous cultural life.

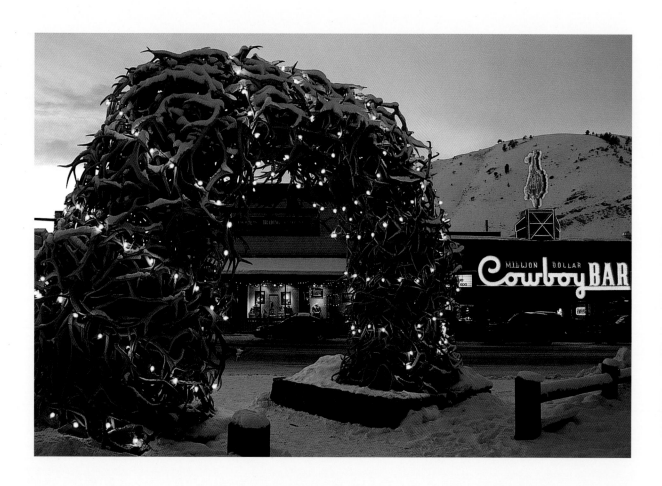

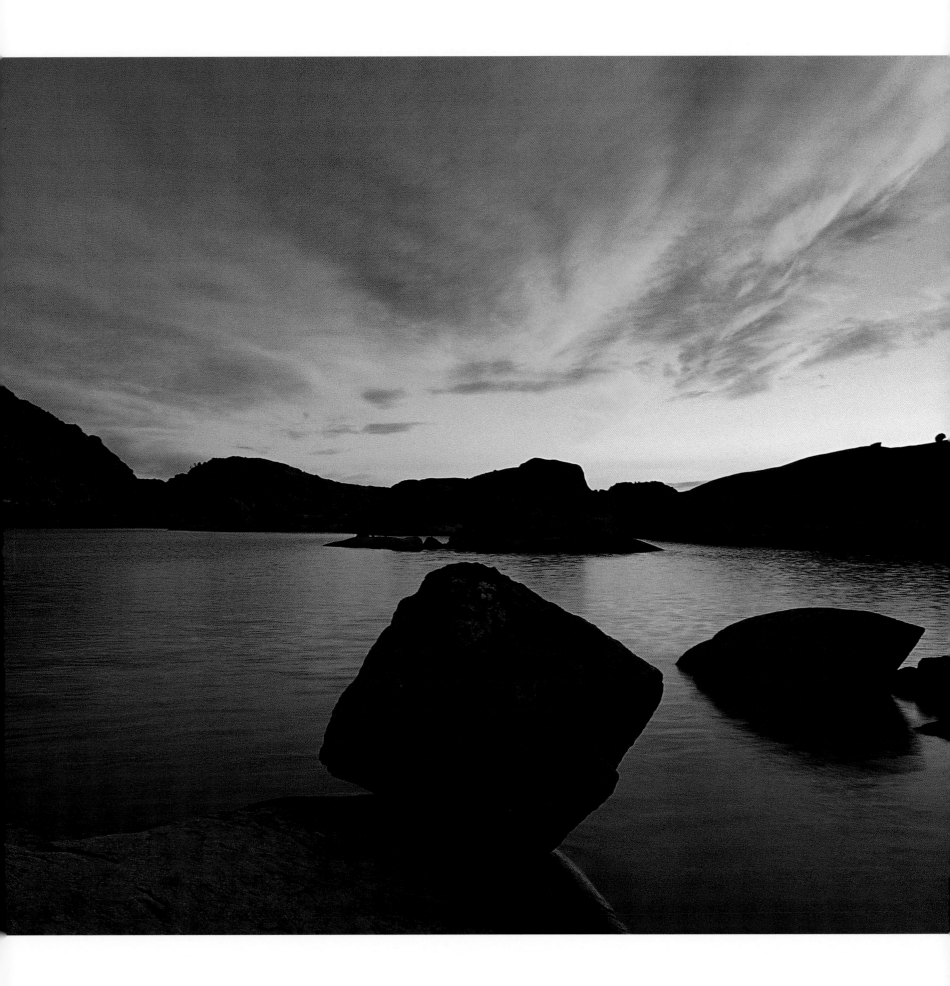

The lines of this barn juxtapose with the spires of the Tetons. The barn is part of what is known as "Mormon Row" off Antelope Flats Road in Grand Teton National Park.

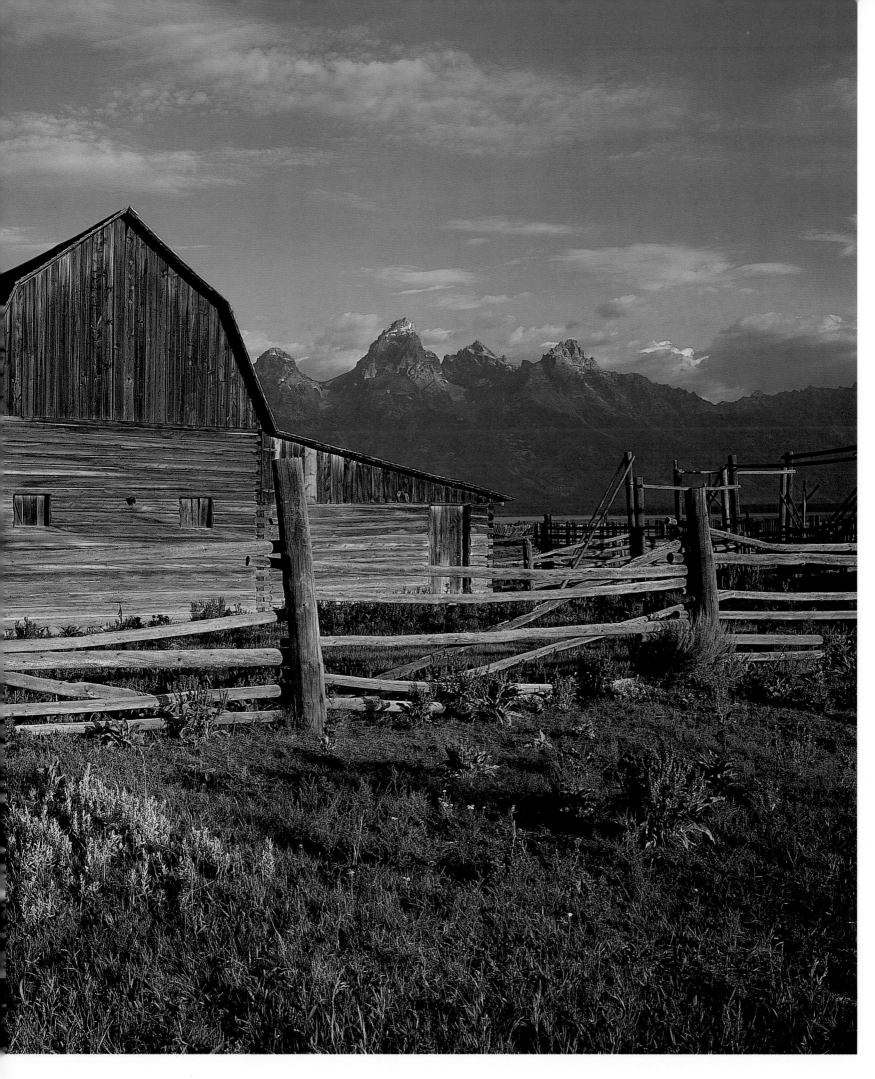

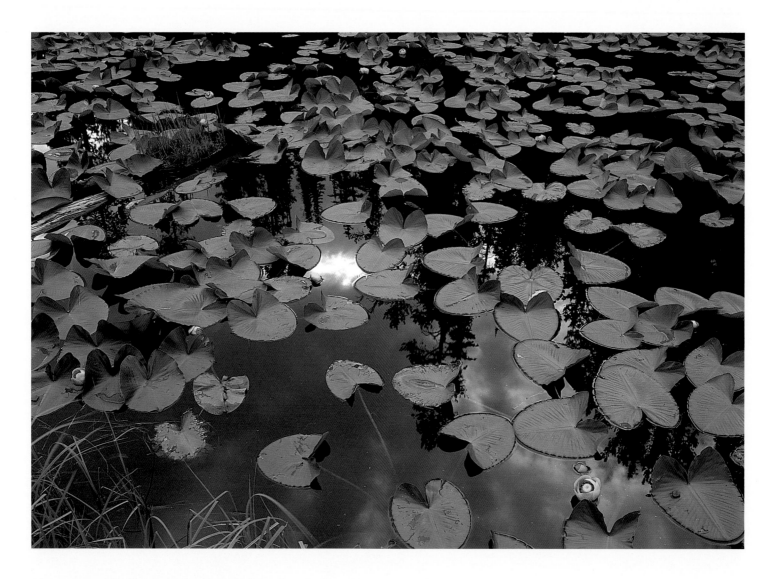

Trees surround a lily-covered pond and the sun peers through storm clouds
to etch their shapes on the surface of the lake.

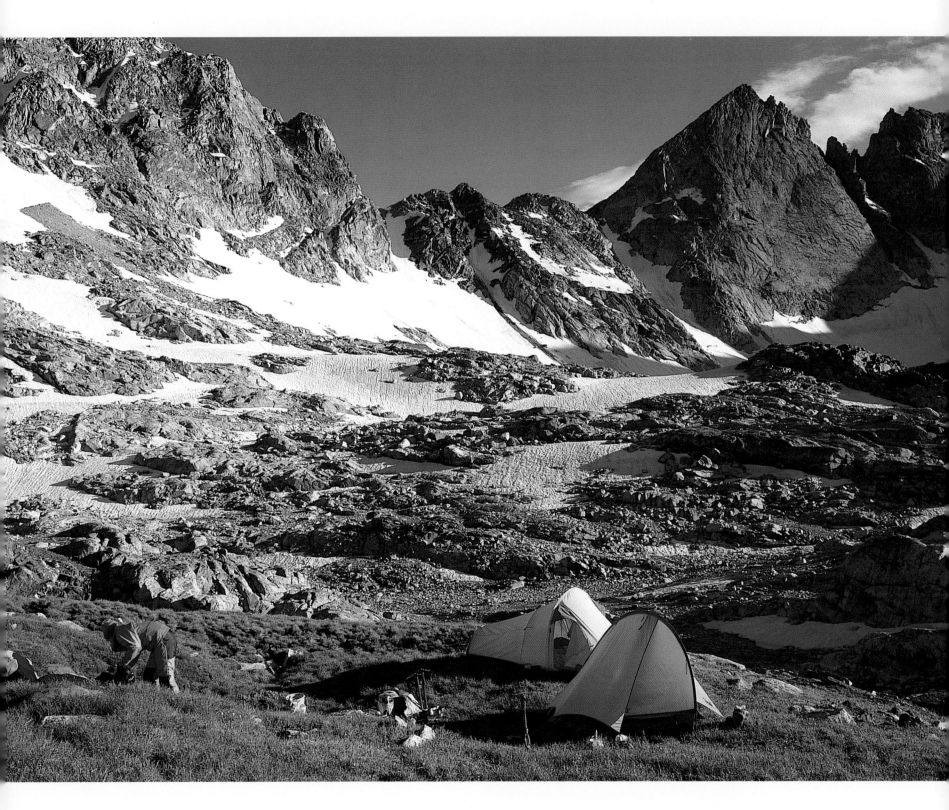

High camp at the head of the Peak Lake drainage in the Wind River Mountains. Mt. Arrowhead knifes its way skyward in the background.

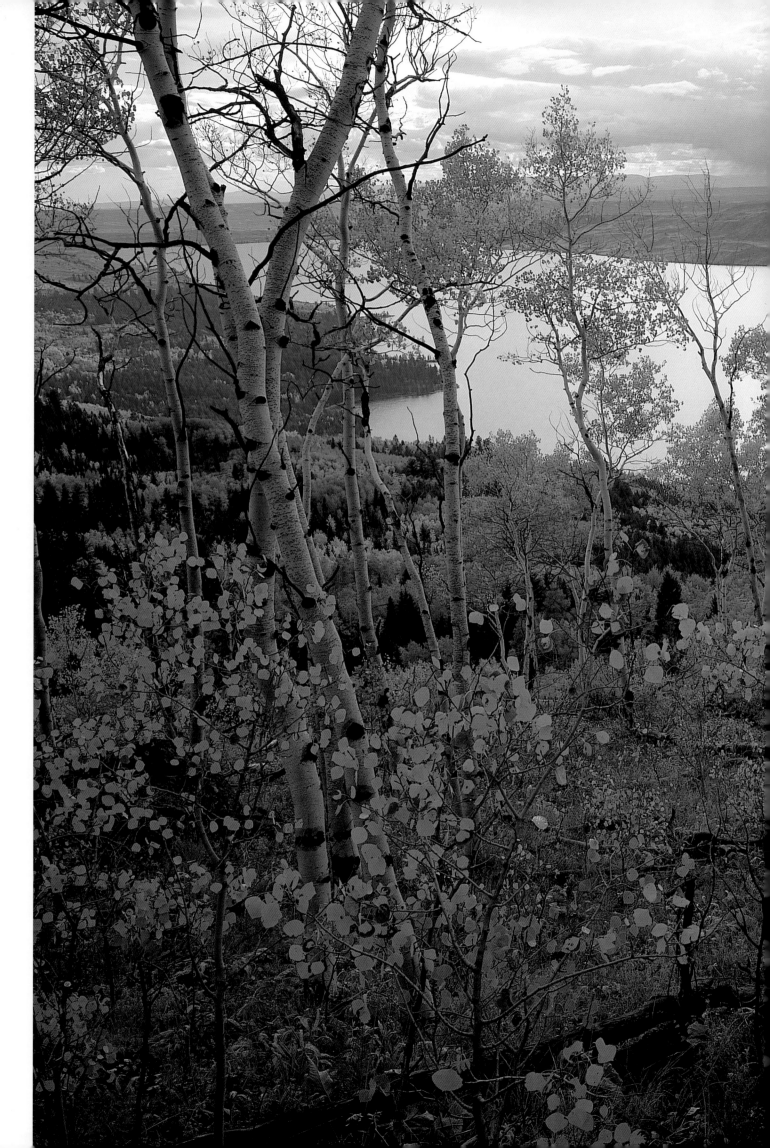

Dark clouds roll up against the foothills of the Wind River Mountains as autumn sets itself against the tide of winter.

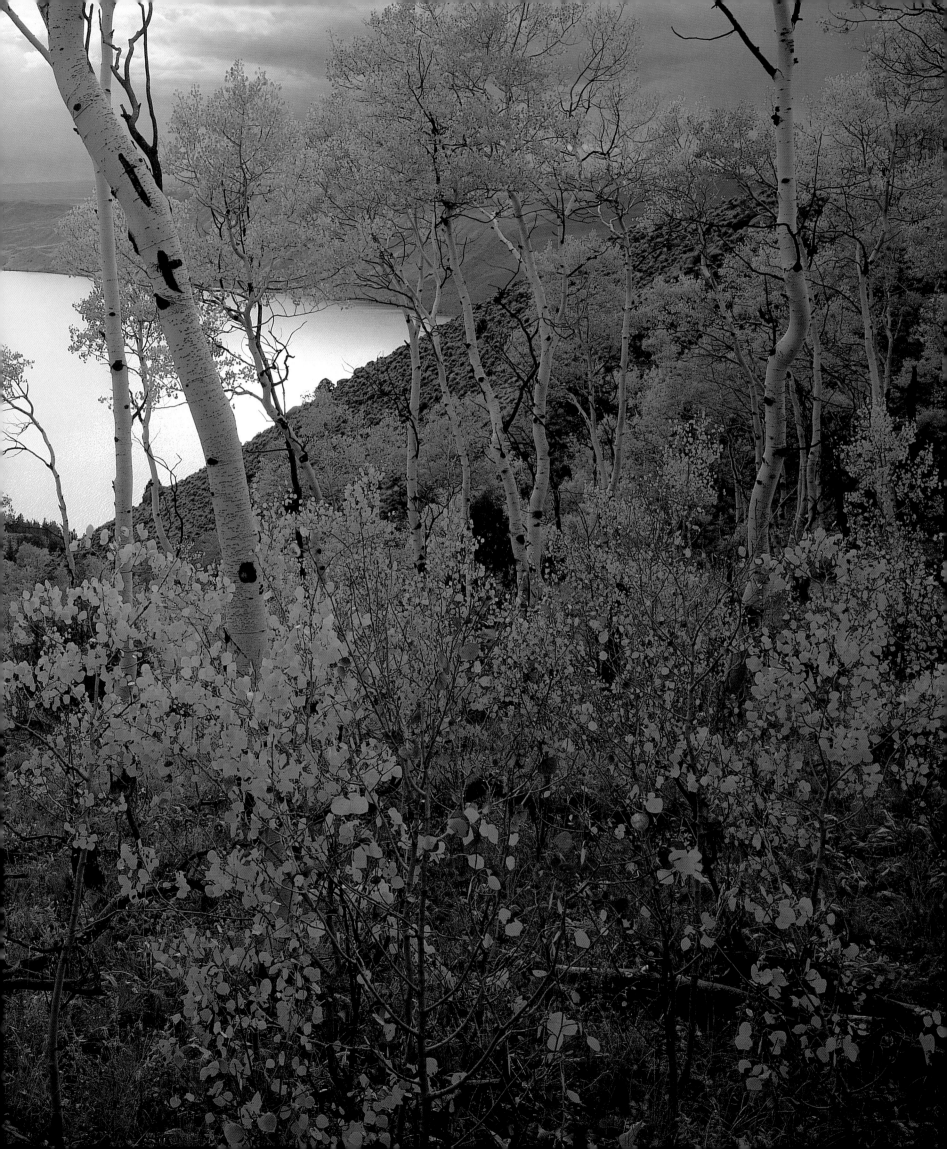

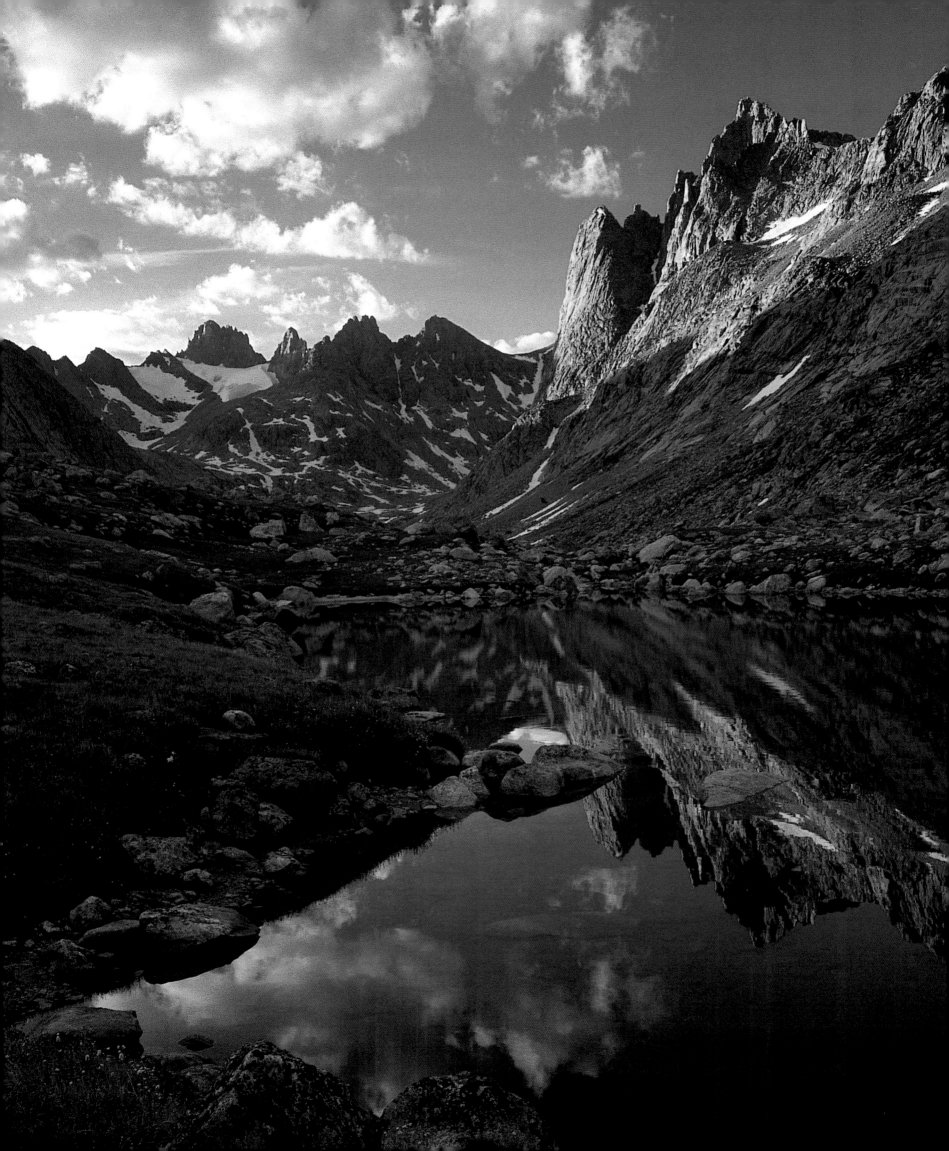

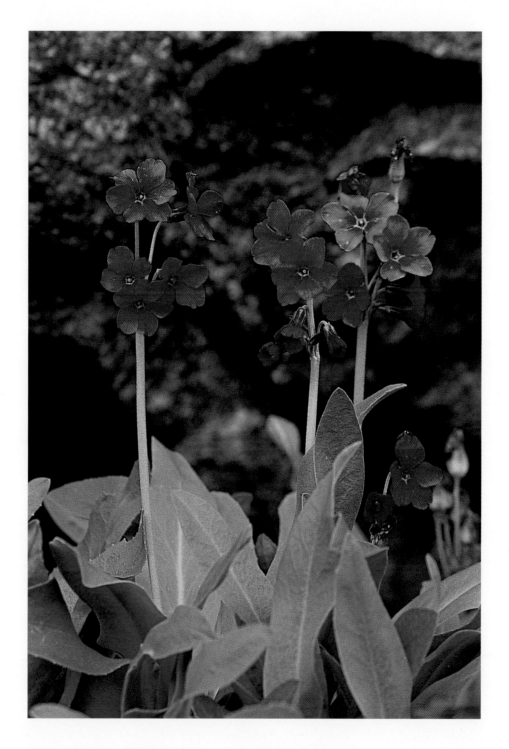

ABOVE: Known as Parry's primrose, this wildflower grows in high, moist environments.

FACING PAGE: The peaks that frame the headwall of Titcomb Basin reflect brilliantly in a small alpine tarn at their feet.

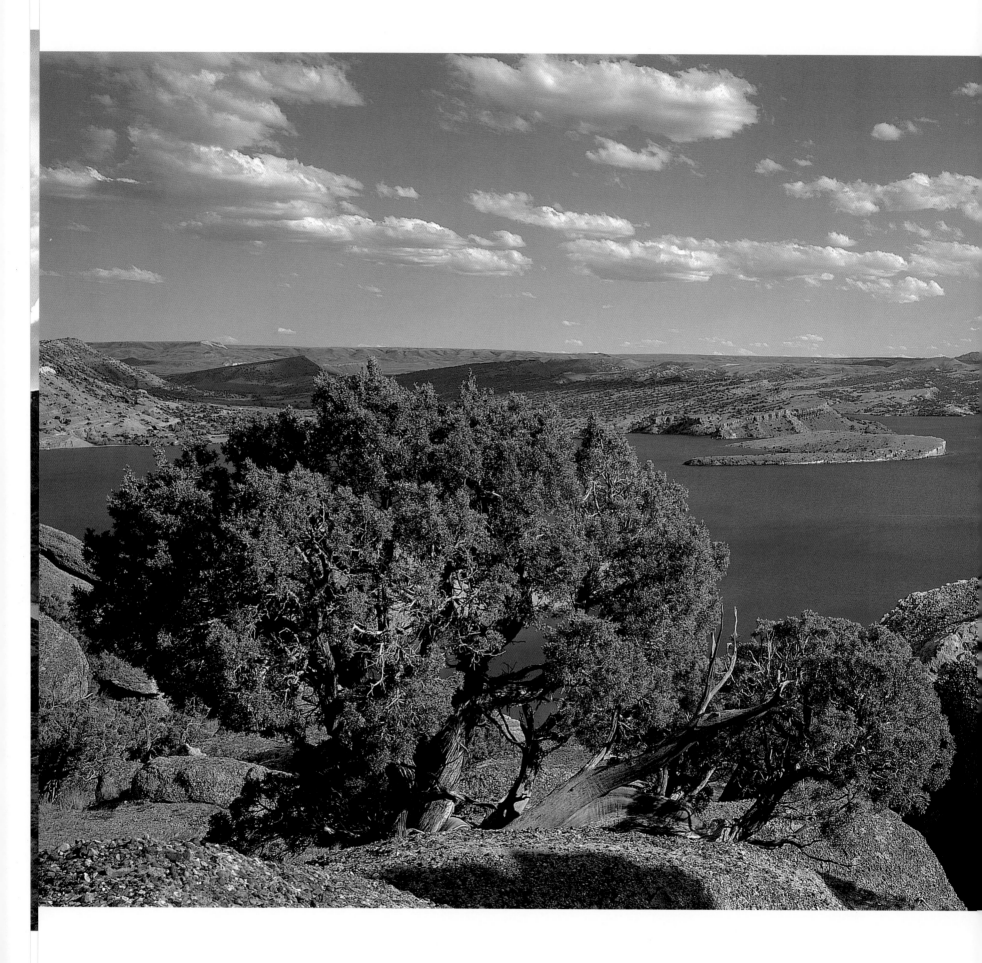

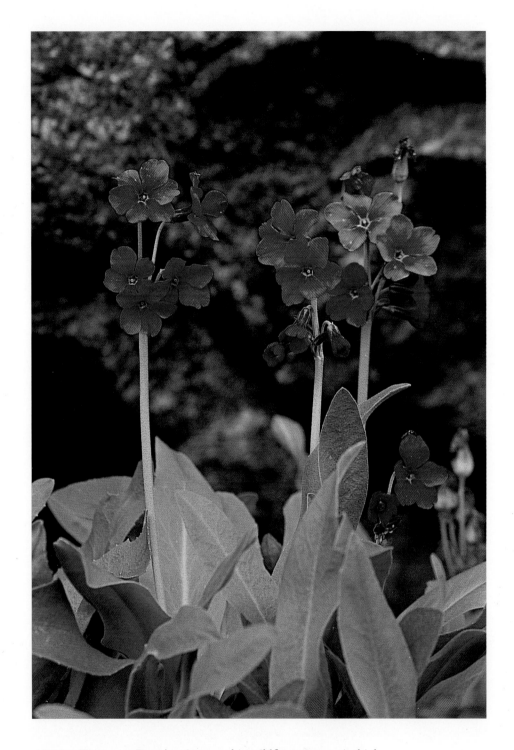

ABOVE: Known as Parry's primrose, this wildflower grows in high, moist environments.

FACING PAGE: The peaks that frame the headwall of Titcomb Basin reflect brilliantly in a small alpine tarn at their feet.

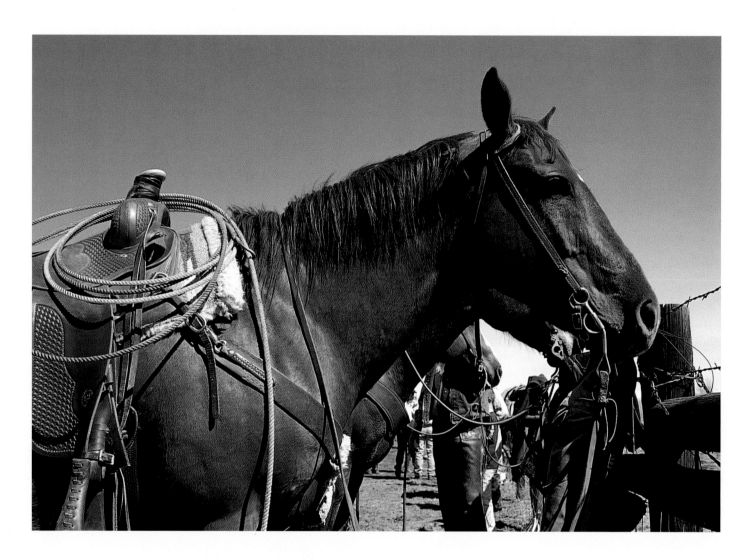

ABOVE: These horses await the spring branding. Cattle ranching is still a major industry in most parts of Wyoming, and spring branding is usually a time for the family and friends of the ranchers to come together.

RIGHT: An old wagon frame recalls the past on a hill in the Red Wall Country south of Mayoworth.

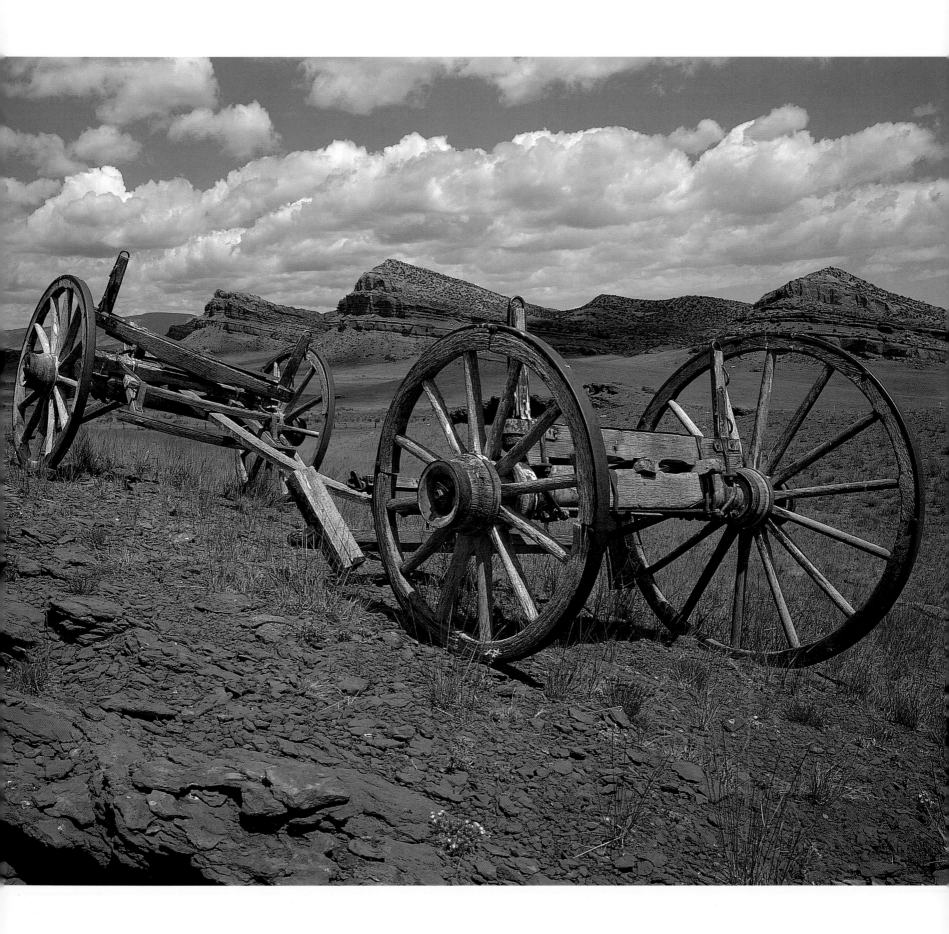

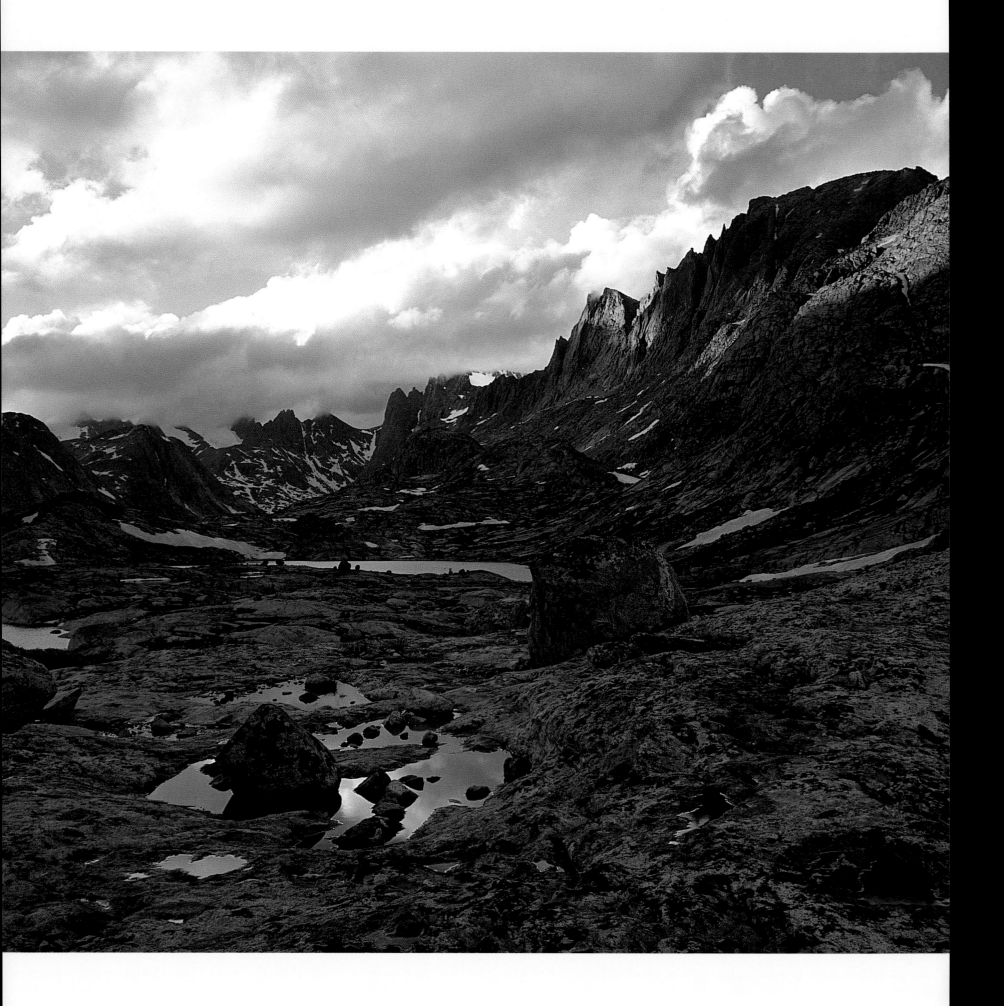

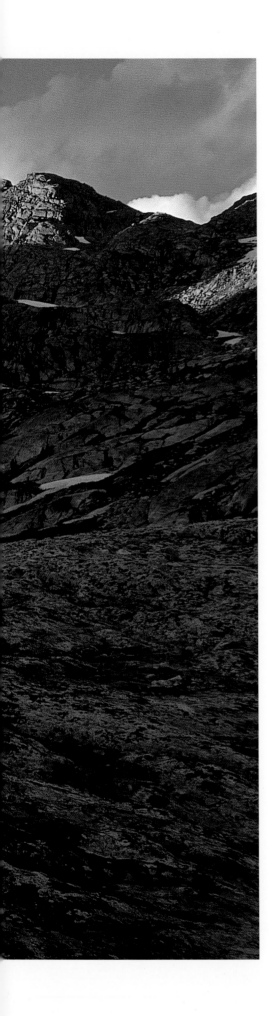

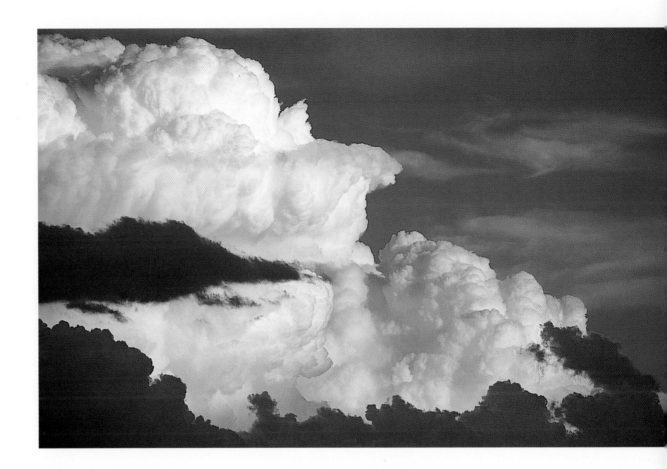

ABOVE: Cumulonimbus clouds signal a major storm front moving through an area. This one advances slowly over Sublette County in northwestern Wyoming.

LEFT: The drama unfolds as storm clouds clear after a dismal and dreary day in Titcomb Basin. This part of Wyoming is awash in special beauty and incredible climbing.

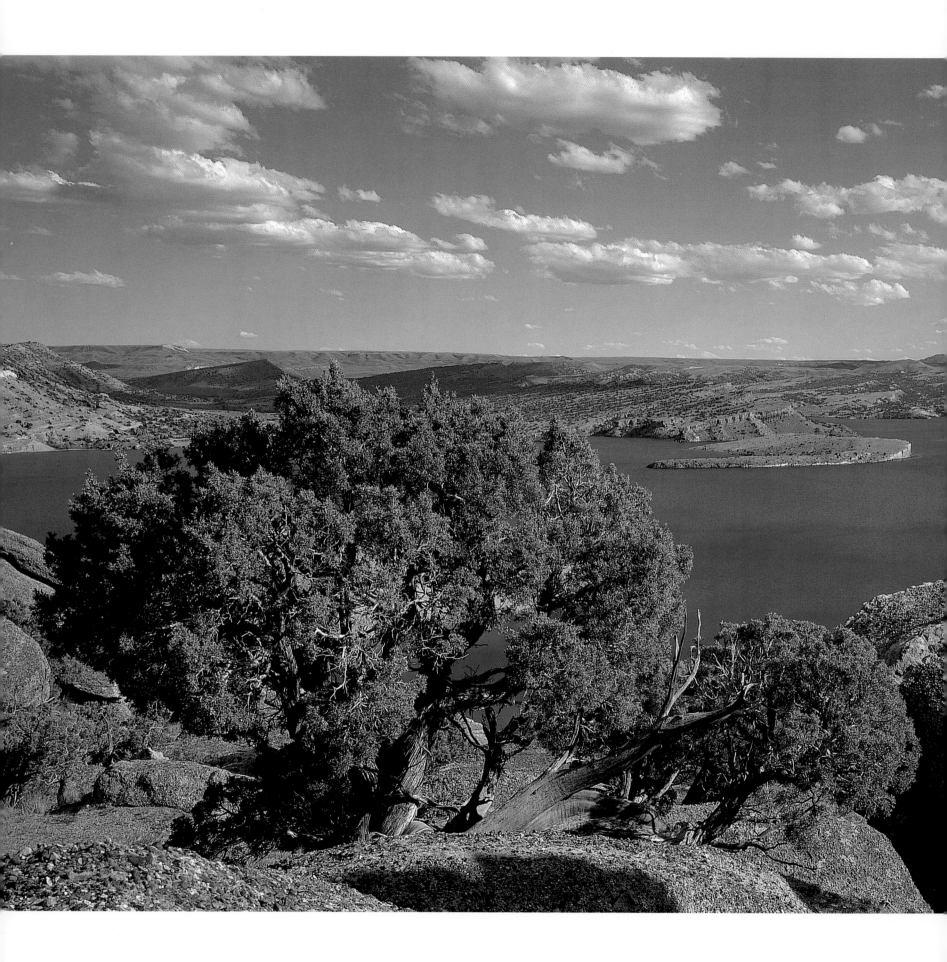

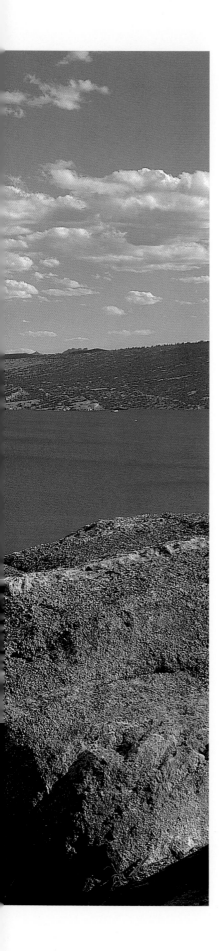

LEFT: Alcova Reservoir is one of the many water projects in the North Platte River drainage. In this dry and arid region of Wyoming, water is a precious commodity and is parceled out slowly in the summer months. The hillsides above the reservoir are dotted with summer homes and the reservoir itself is popular with both boaters and anglers.

BELOW: The lush green vegetation on the banks of the Middle Fork of the Powder River near Kaycee belies the fact that this is an area of the state that receives very little rainfall.

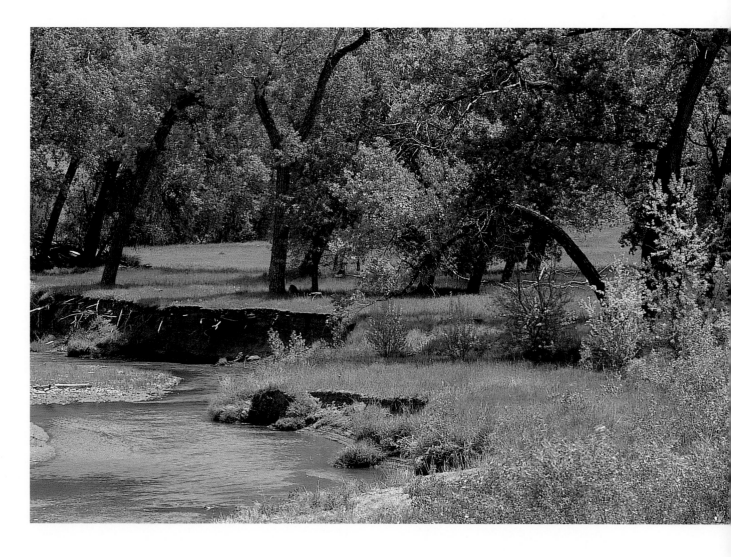

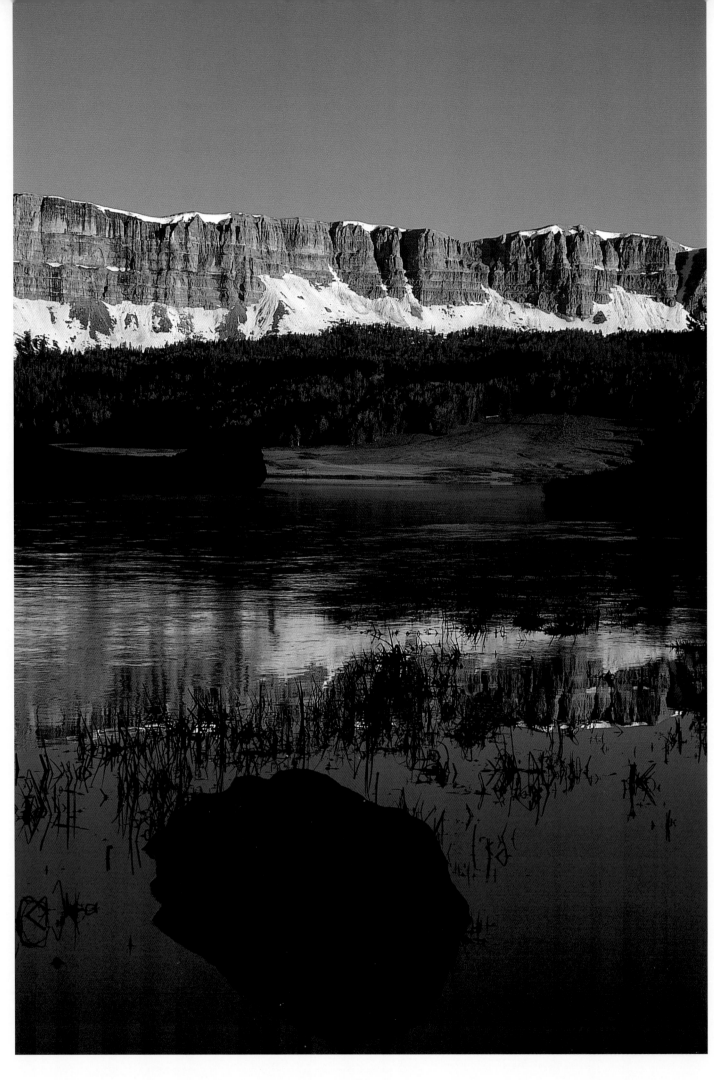

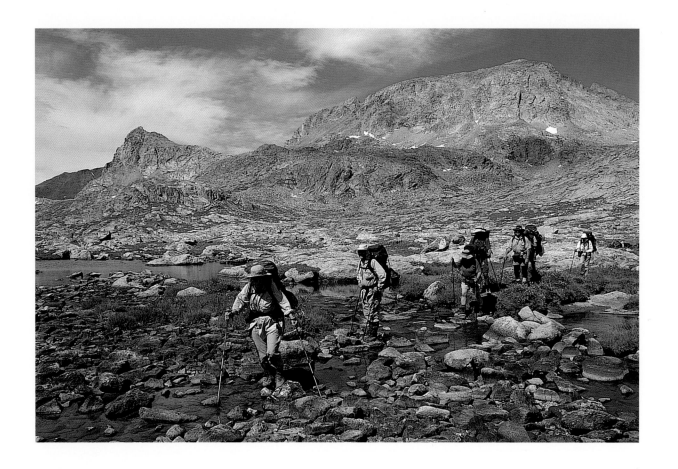

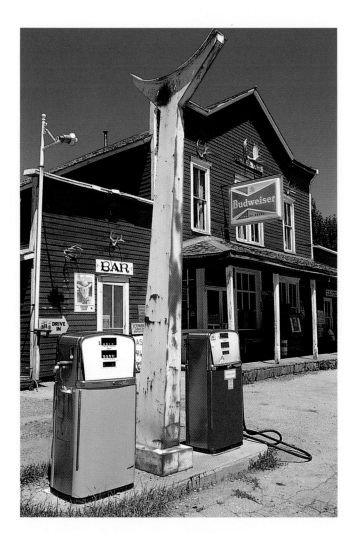

ABOVE: Members of the Sierra Club on a backpacking photo trip cross a stream near Elbow Lake.

LEFT: The Aladdin General Store was built by Bill Robinson in 1892. Old but still in-use gas pumps stand outside this historic building in the far northeastern part of Wyoming.

FACING PAGE: The Breccia Cliffs reflected in Brooks Lake. This large subalpine lake is located in the Shoshone National Forest and is at the southern terminus of the Absaroka Range, one of the remotest in Wyoming and prime grizzly bear habitat within the Greater Yellowstone Ecosystem.

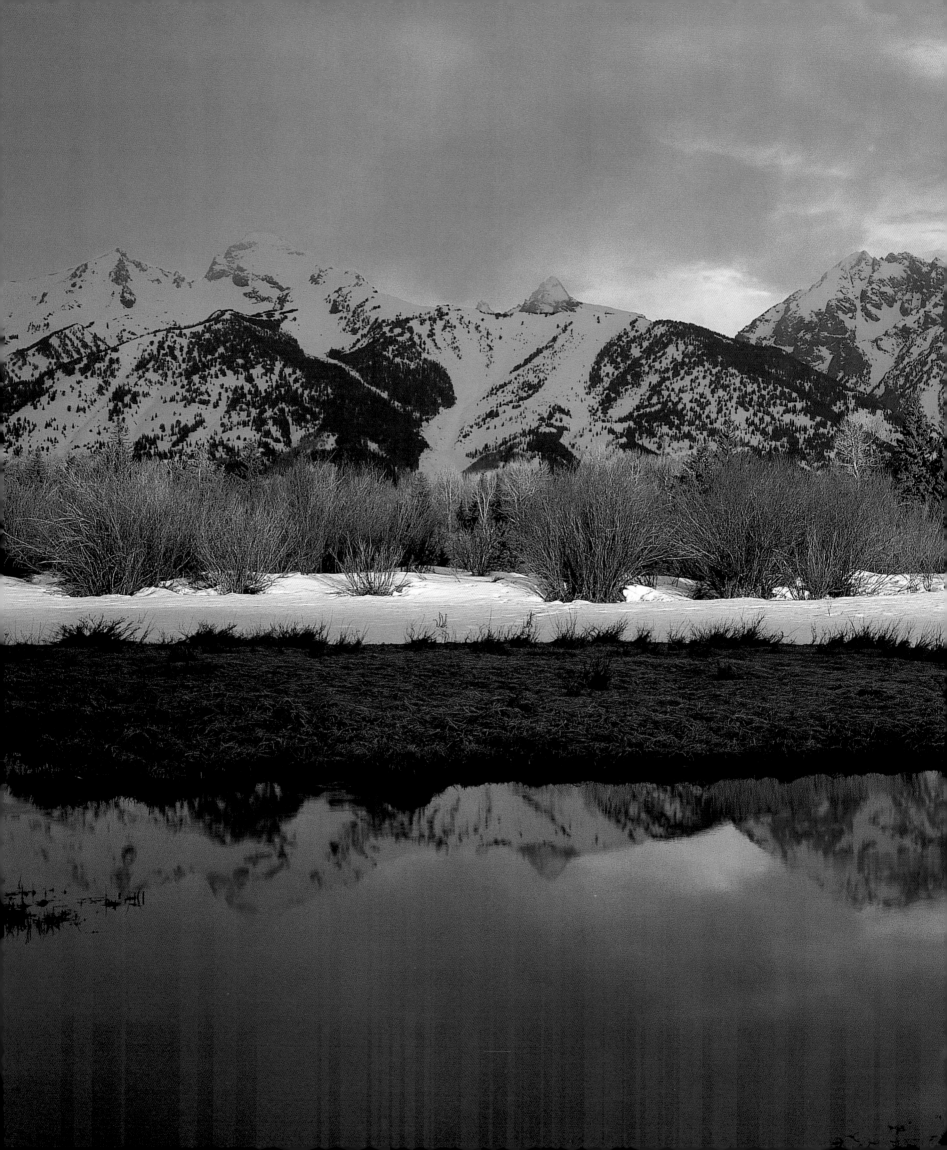

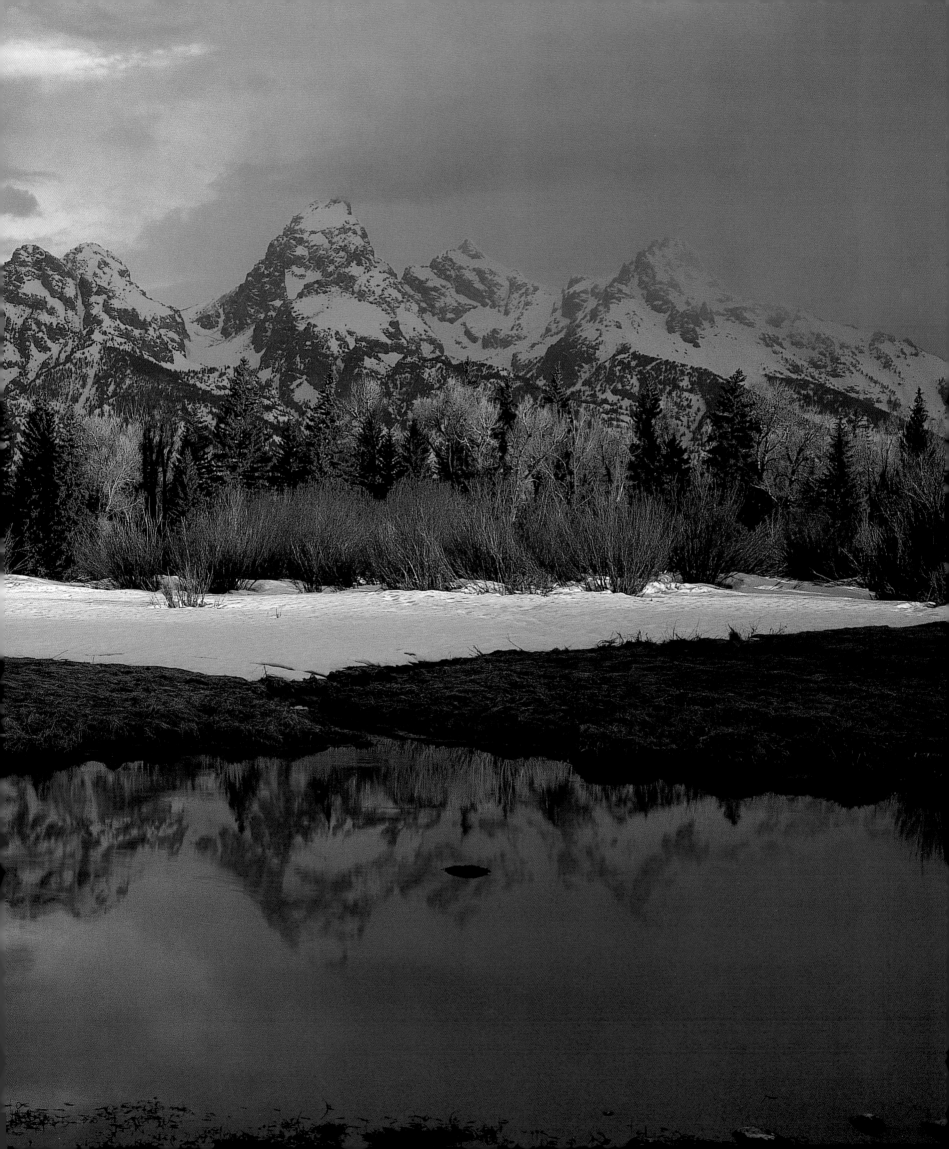

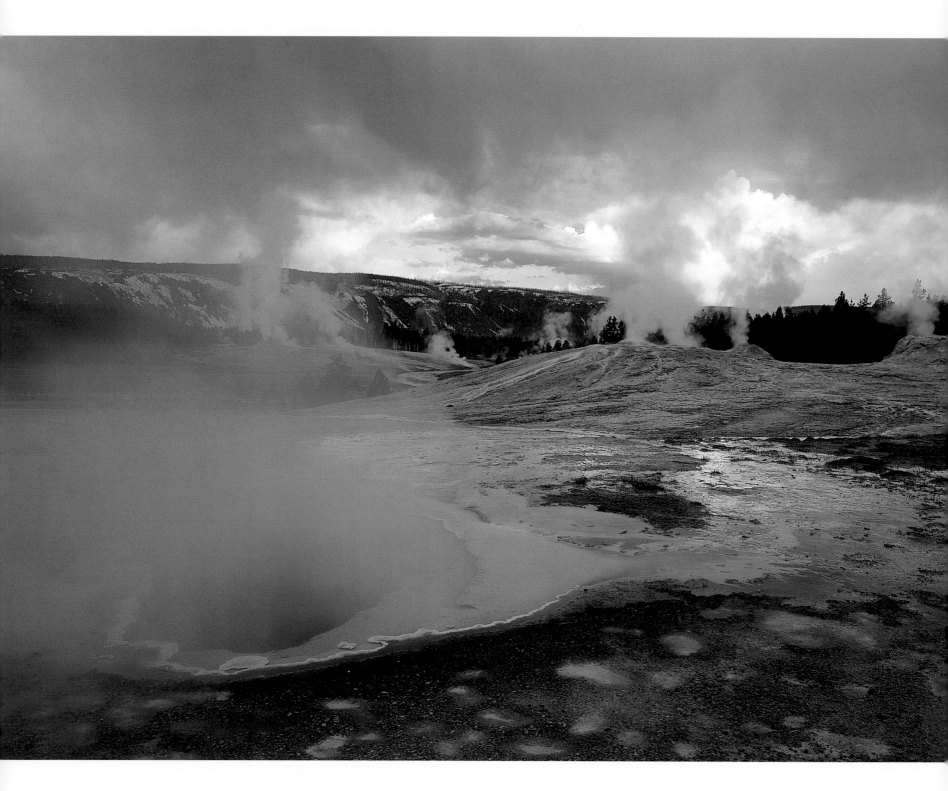

ABOVE: A spring storm gathers over Heart Spring and the Lion Geyser Group
on Geyser Hill in the Upper Geyser Basin of Yellowstone National Park.

PRECEDING PAGES: Blacktail Ponds reflect a spring dusting on the Tetons
in Grand Teton National Park.

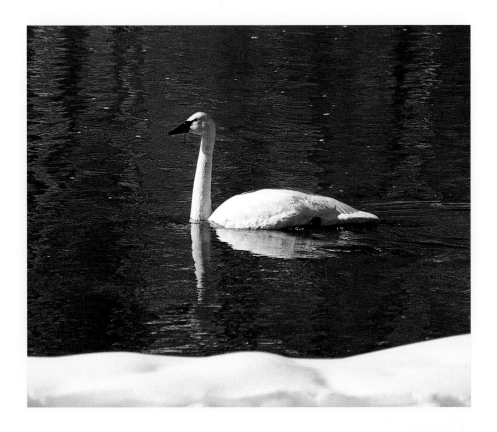

ABOVE: Trumpeter swans have made a dramatic comeback from the brink of extinction and can be found year-round in the greater Yellowstone area.

RIGHT: A sun-star shines through a forest of snow-flocked conifers near Blackrock Pass in the Bridger-Teton National Forest.

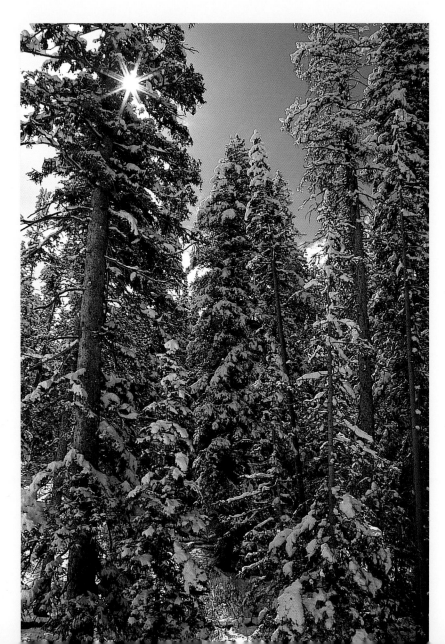

RIGHT: Climbers settle in for the night atop Dinwoody Pass (called Bonney Pass on some maps). They will begin their climb of Wyoming's tallest mountain, 13,804-foot Gannett Peak seen in the background, early in the morning. PHOTO BY JED CONKLIN

BELOW: Splitleaf Indian paintbrush is but one of several species of paintbrush that grow in abundance in many parts of Wyoming. One species, Wyoming Indian paintbrush, is the state flower of Wyoming.

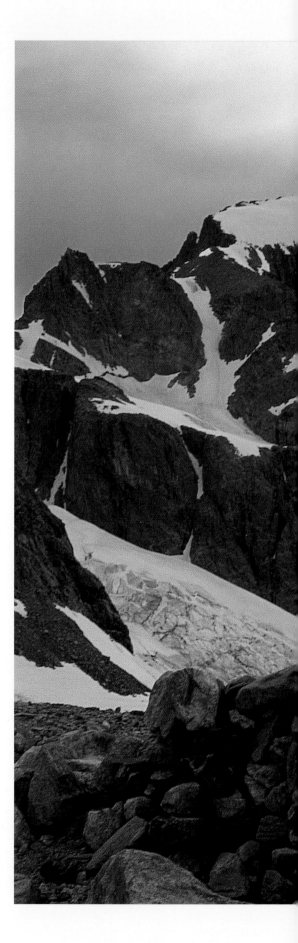

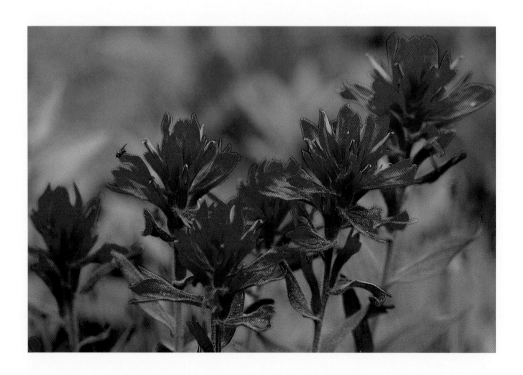

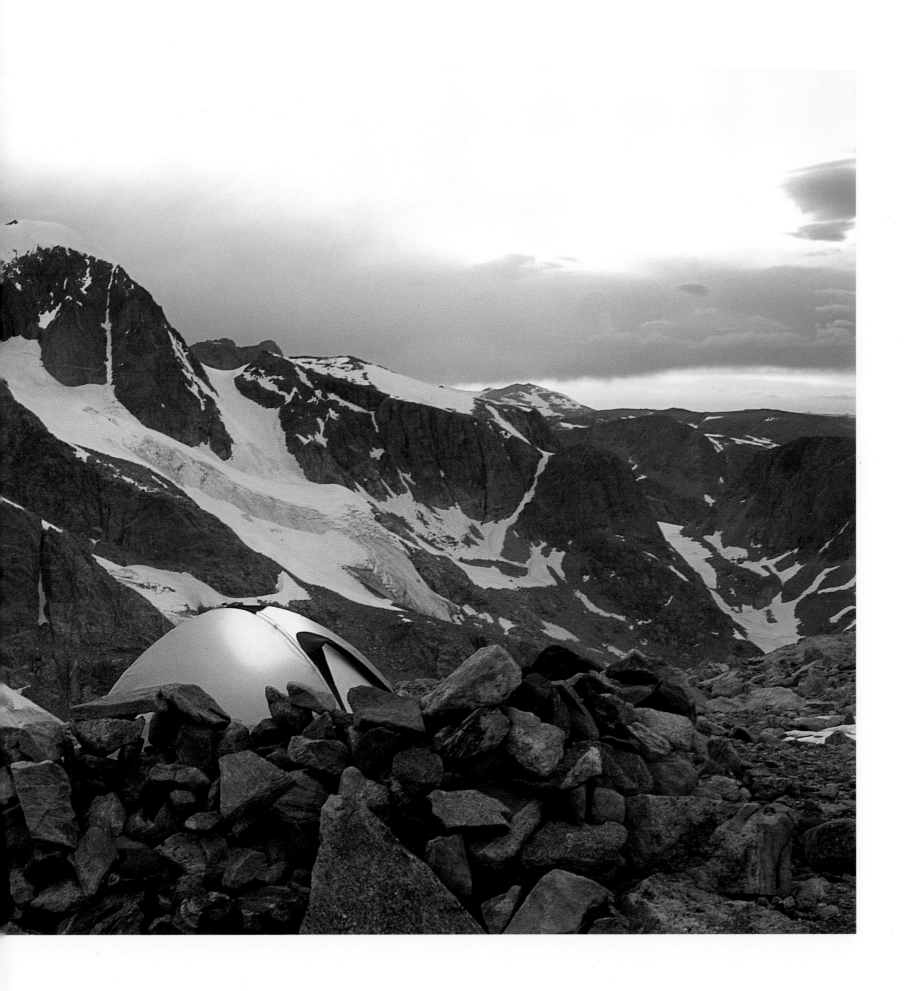

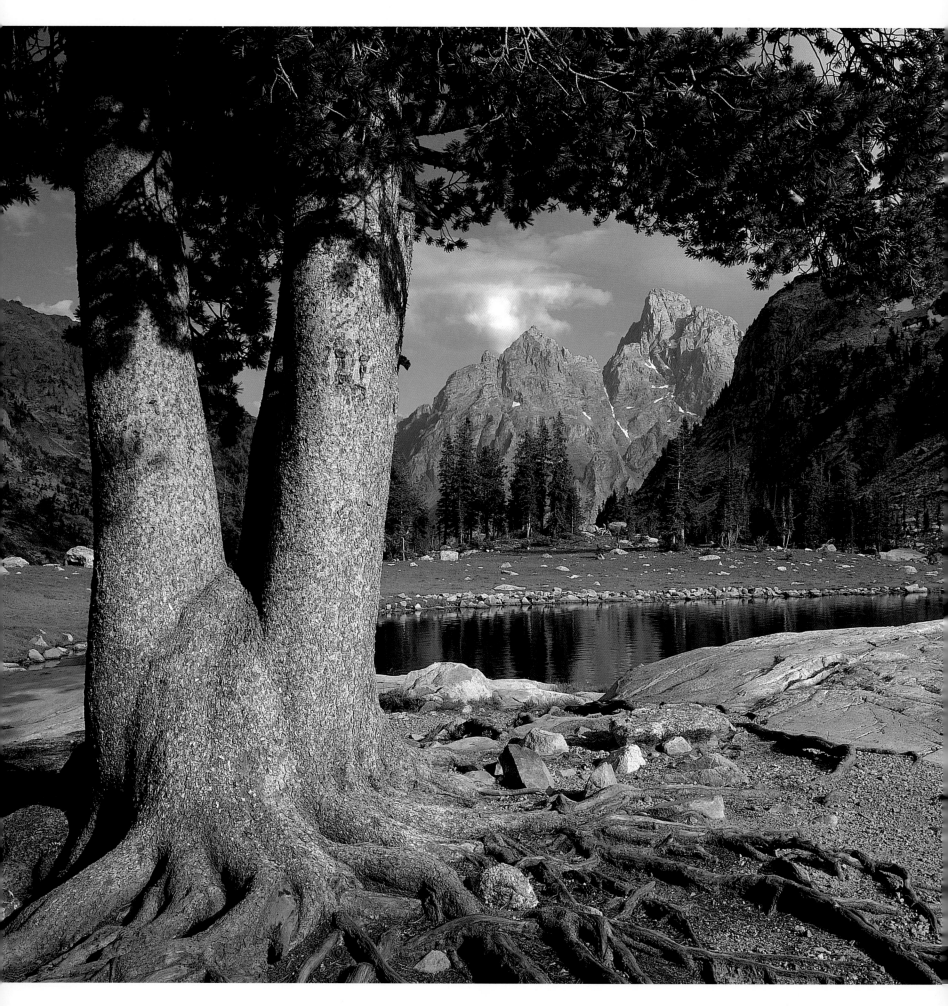

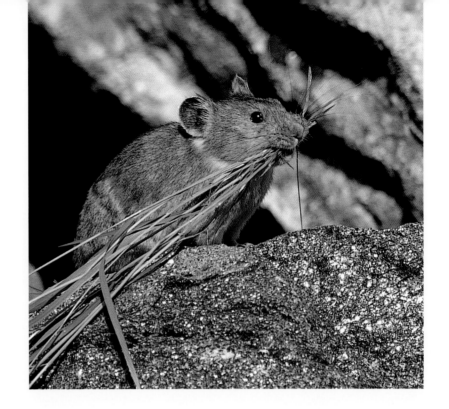

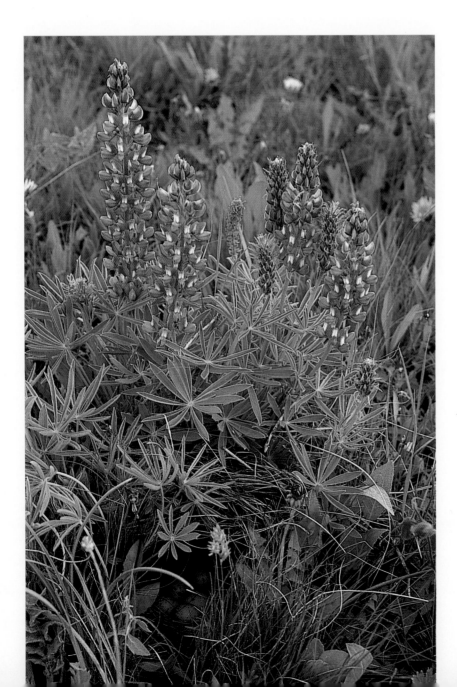

ABOVE: The American pika is a strong contender for the Rockies' cutest mammal. Pikas live on talus slopes and collect food from the surrounding area.

LEFT: Look closely to see the nest and eggs of a western meadowlark at the base of this lupine. The western meadowlark is the state bird of Wyoming.

FACING PAGE: The Grand Teton peers above the treeline on the shore of Lake Solitude. This beautiful alpine gem is located at the head of the north fork of Cascade Canyon in Grand Teton National Park.

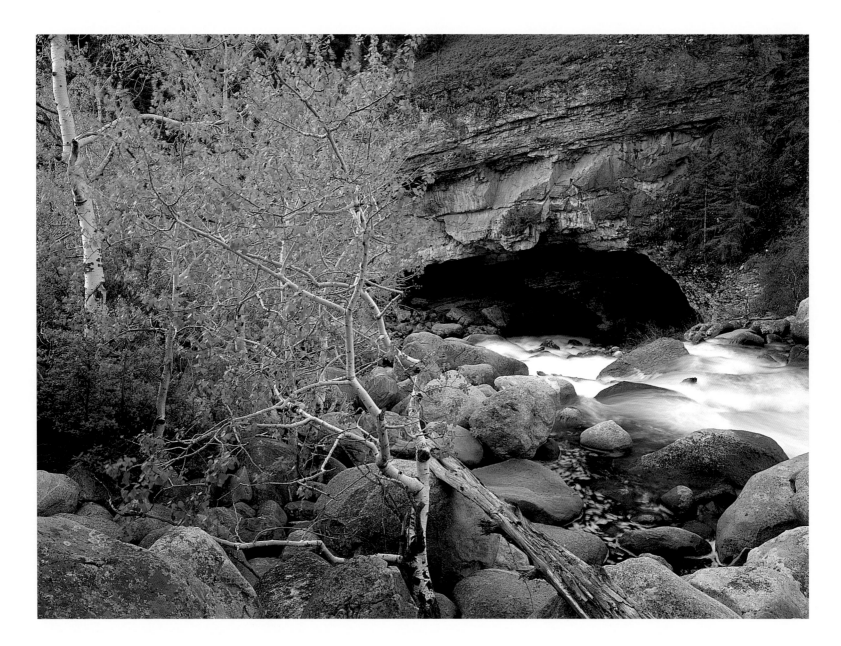

ABOVE: This unique quirk of geology in Sinks Canyon State Park is called the "Sinks." The rushing waters of Middle Popo Agie River pour into this large sinkhole and reappear 0.4 mile downstream at a place known as the "Rise."

FACING PAGE: Storm clouds dance lazily over the lush foothills of the eastern slopes of the Bighorn Mountains near Story.

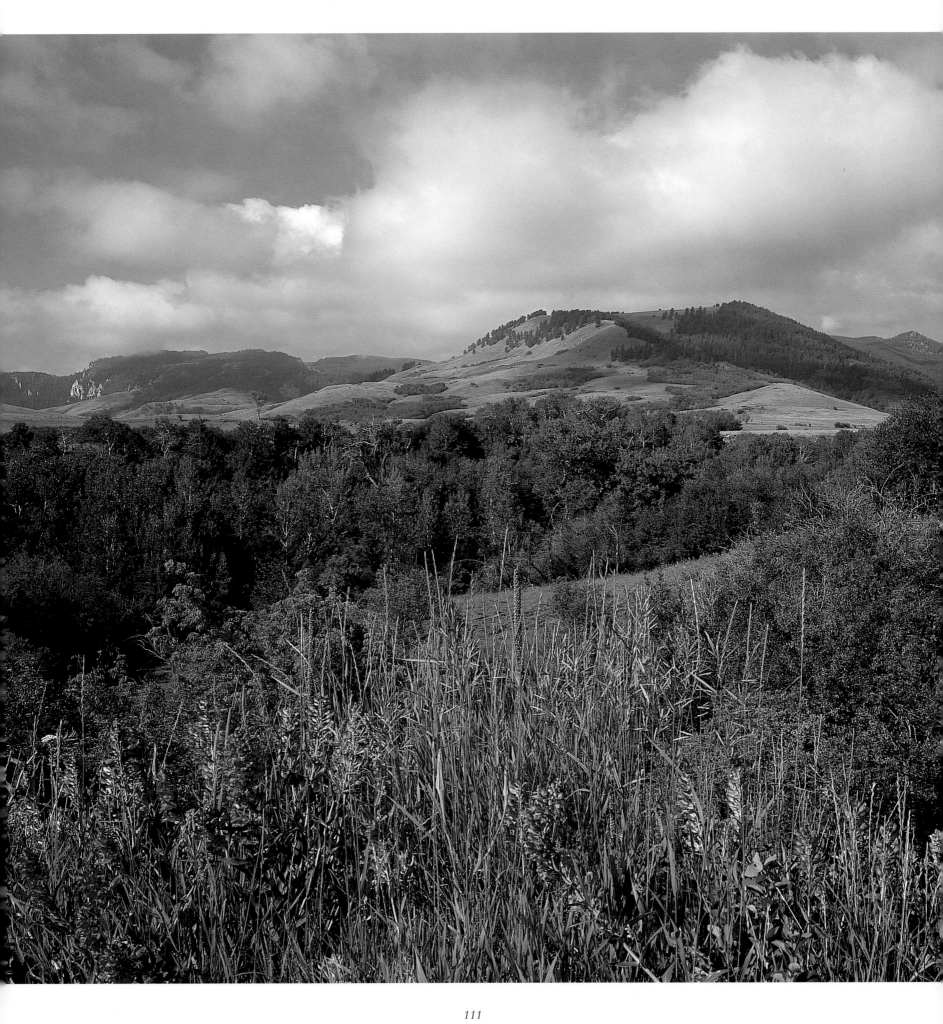

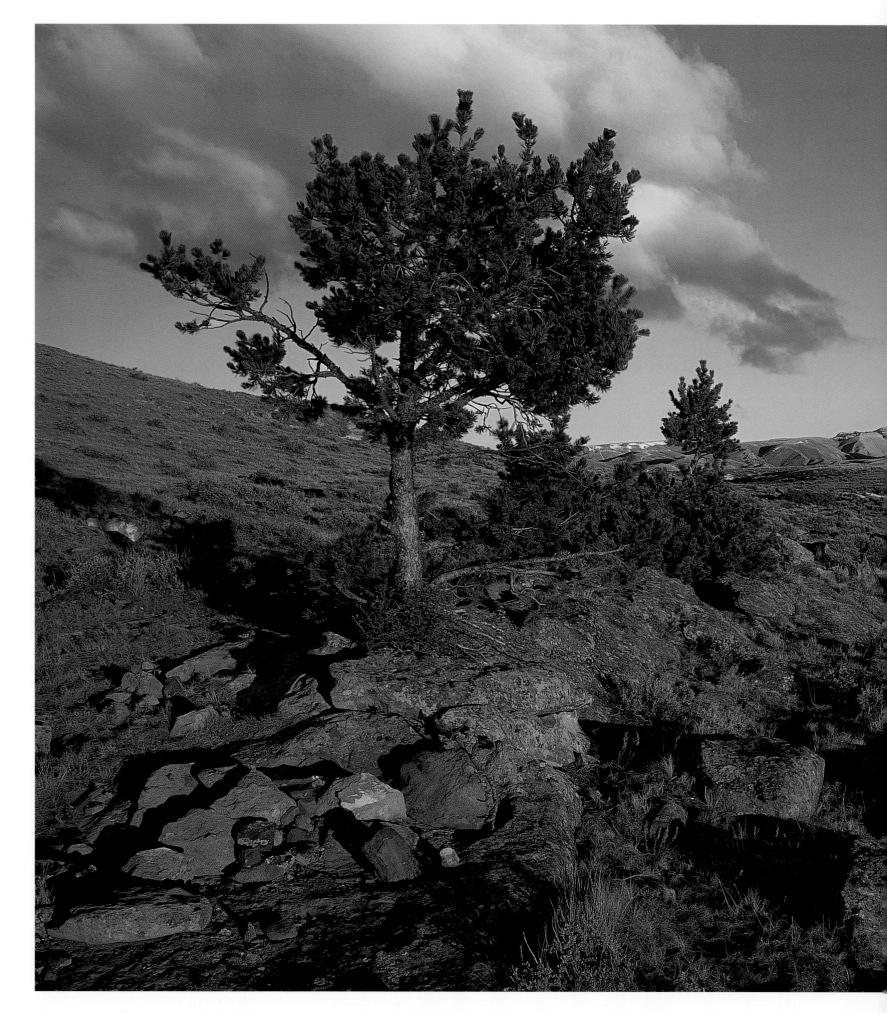

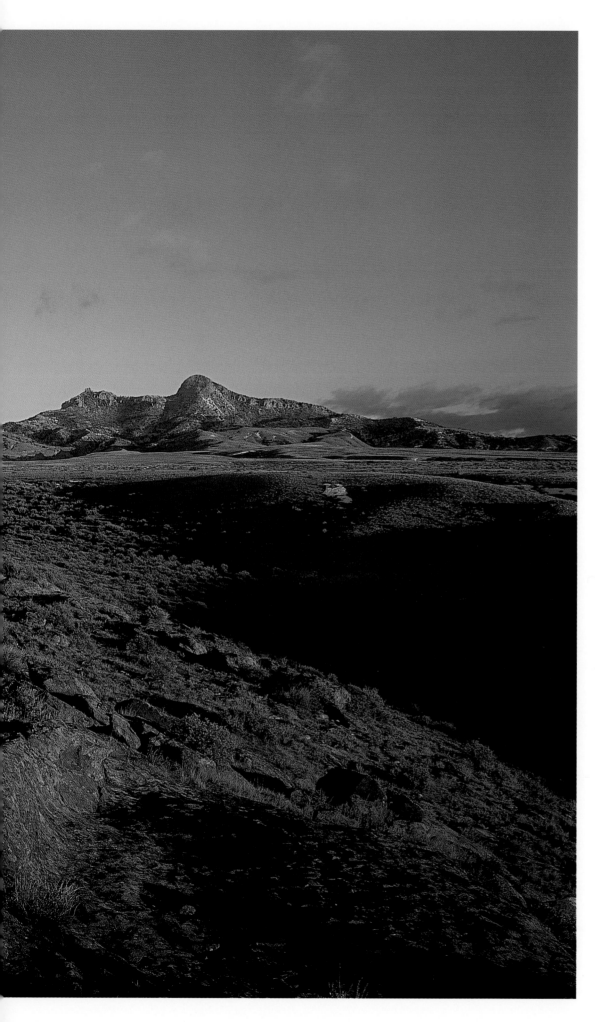

Heart Mountain north of Cody was an important Native American ceremonial site. Its distinct outline can be seen for miles out into the Bighorn Basin.

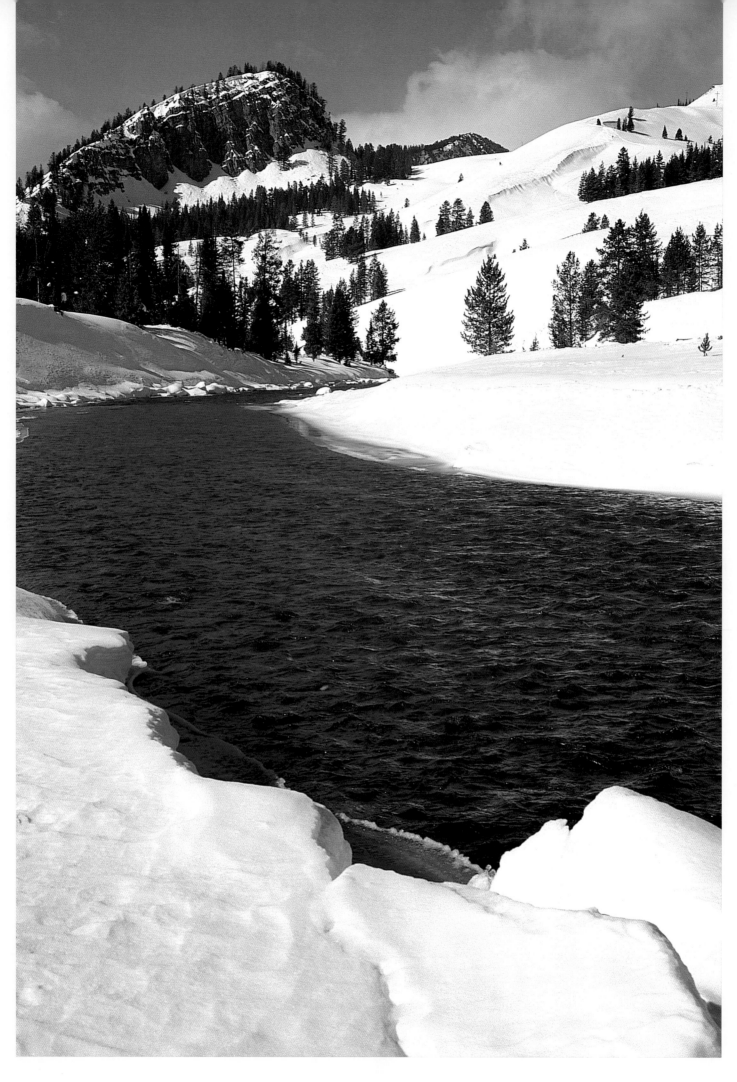

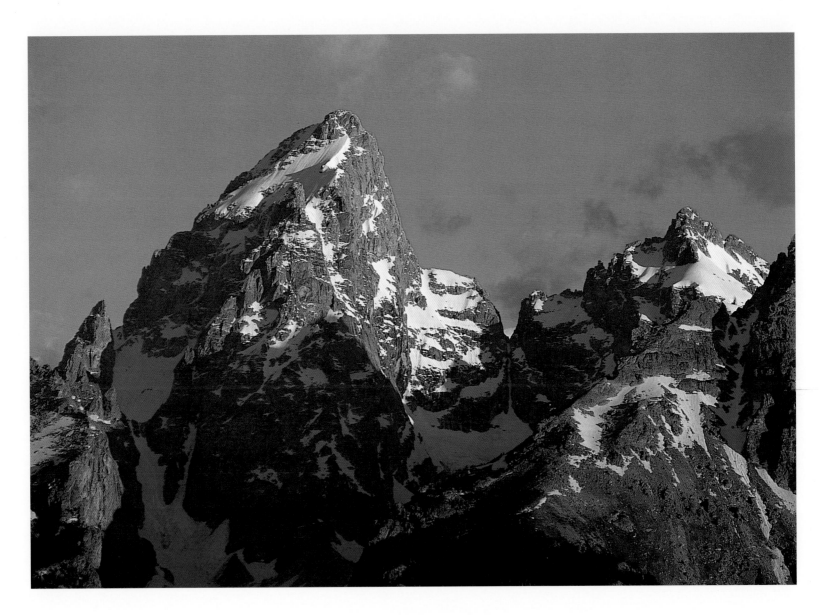

ABOVE: The Grand Teton rises to 13,770 feet. The Teton Range receives an average annual snowfall of 191 inches.

FACING PAGE: The Hoback River flows through Hoback Canyon on its way to meet up with the Snake River just south of Jackson. Highway 189/191 passes through this beautiful canyon, which can be icy and treacherous during the long winter months.

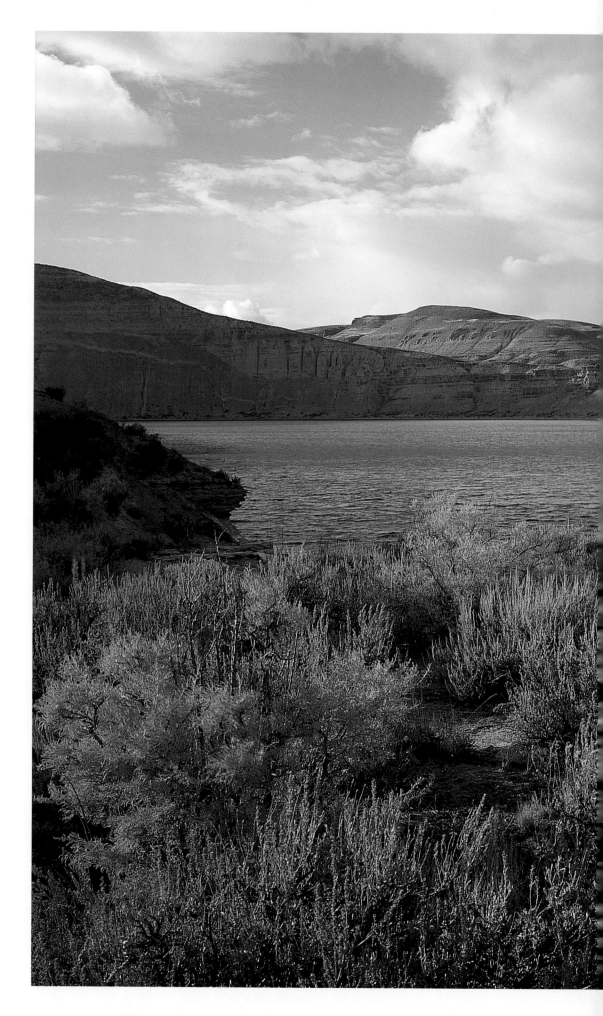

Flaming Gorge National Recreation Area
south of Rock Springs is a spectacular play-
ground in the southern part of the state.
Flaming Gorge Reservoir, formed by the
damming of the Green River, is a boater's
and angler's paradise.

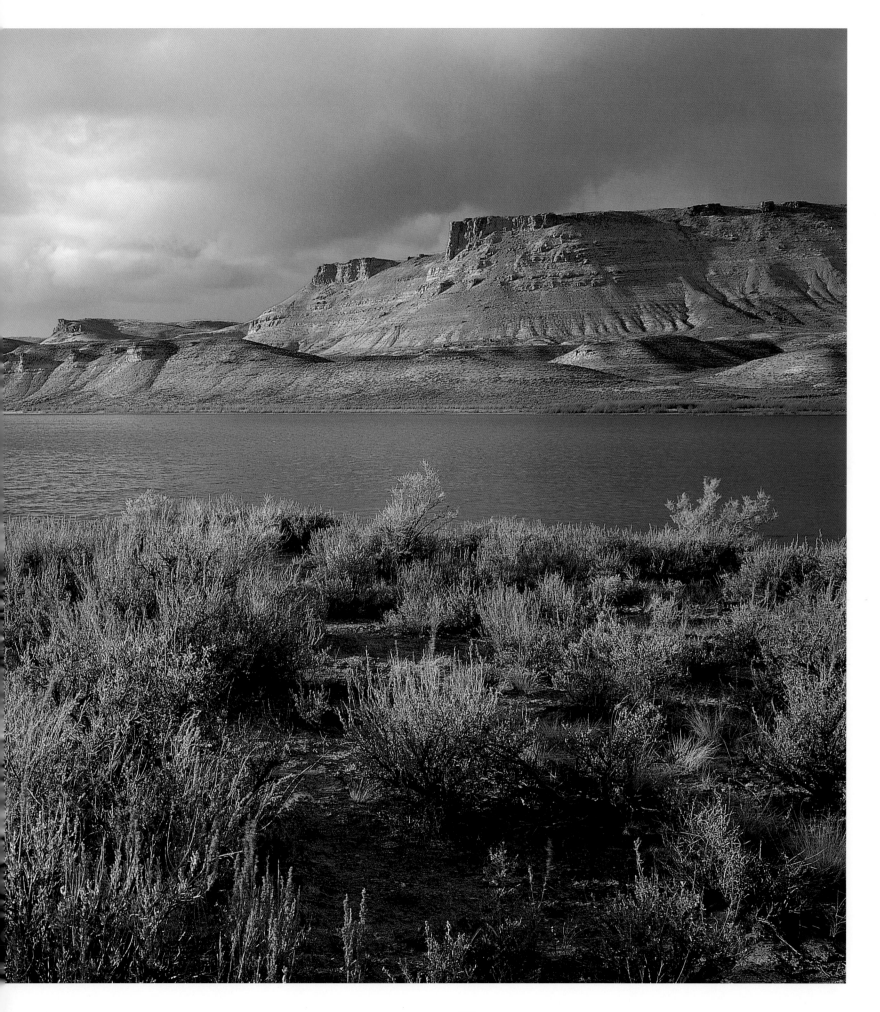

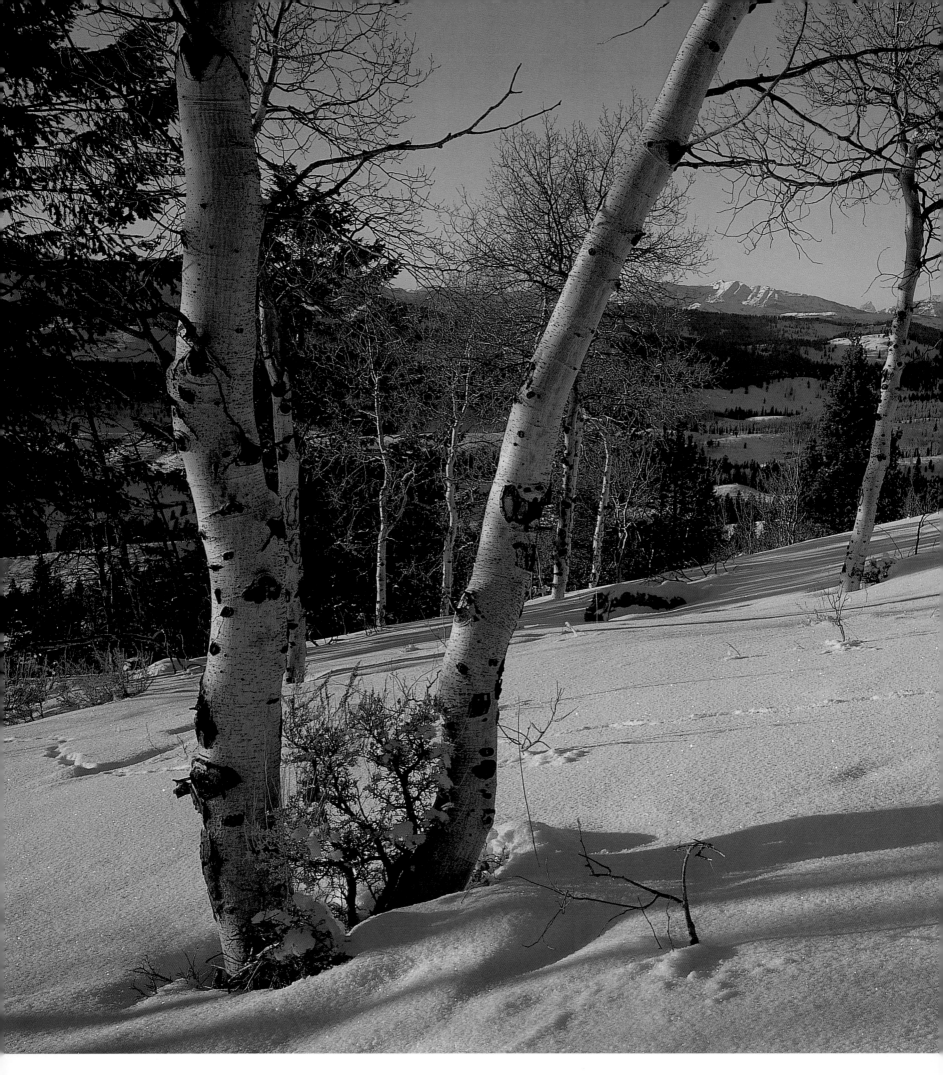

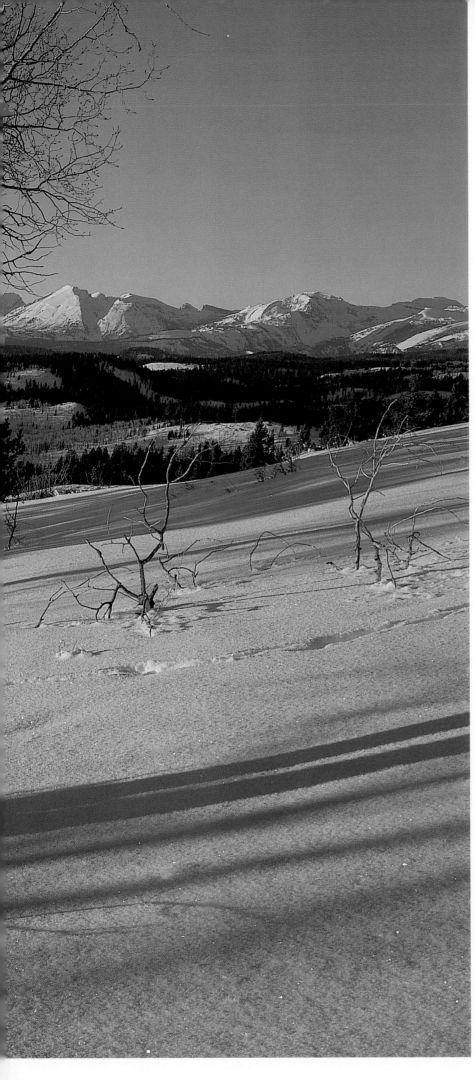

The long shadows of winter gently caress the aspen-covered slopes of the Gros Ventre Range. This view came via a steep snowshoe climb near "The Rim" in Sublette County.

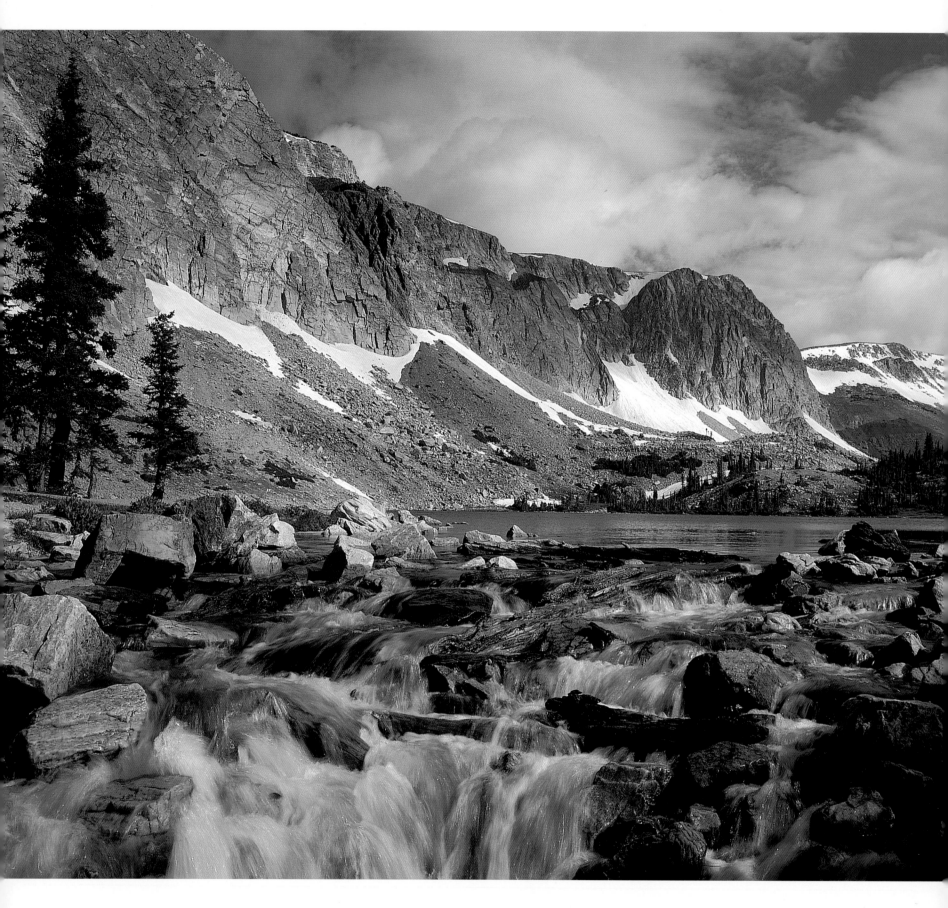

South French Creek spills out of Lake Marie in the Snowy Range. Lake Marie is named for Mary Bellamy, who in 1910 was the first woman elected to the Wyoming legislature. She helped lead the suffrage drive that resulted in the passage of the Nineteenth Amendment to the Constitution, which gives women the right to vote. Behind the lake, Medicine Bow Peak rises to an elevation of 12,013 feet, making it the highest point in southern Wyoming.